Digital
Photo Art

Transform Your Images with Traditional & Contemporary Art Techniques

Book Design: Sandy Knight
Cover Design: Barbara Zaretsky
Editorial Assistance: Haley Pritchard and Delores Gosnell

Library of Congress Cataloging-in-Publication Data

Airey, Theresa.
 Digital photo art : transform your images with traditional & contemporary
art techniques / Theresa Airey.
 p. cm.
 Includes index.
 ISBN 1-57990-580-3 (pbk.)
 1. Photography--Retouching--Data processing. 2. Photography--Digital
techniques. 3. Photography, Artistic. 4. Computer graphics. 5. Image
processing--Digital techniques. I. Title.
TR310.A37 2005
776--dc22

2004022443

10 9 8 7 6 5 4 3 2

Published by Lark Books, A Division of
Sterling Publishing Co., Inc.
387 Park Avenue South, New York, N.Y. 10016

Distributed in Canada by Sterling Publishing,
c/o Canadian Manda Group, 165 Dufferin Street, Toronto, Ontario, Canada M6K 3H6

Distributed in the United Kingdom by GMC Distribution Services,
Castle Place, 166 High Street, Lewes, East Sussex, England BN7 1XU

Distributed in Australia by Capricorn Link (Australia) Pty Ltd., P.O. Box 704, Windsor, NSW 2756 Australia

If you have questions or comments about this book, please contact:
Lark Books, 67 Broadway, Asheville, NC 28801, (828) 253-0467, www.larkbooks.com

Manufactured in China

ISBN 13: 978-1-57990-580-4
ISBN 10: 1-57990-580-3

For information about custom editions, special sales, premium and corporate purchases, please contact Sterling Special
Sales Department at 800-805-5489 or specialsales@sterlingpub.com.

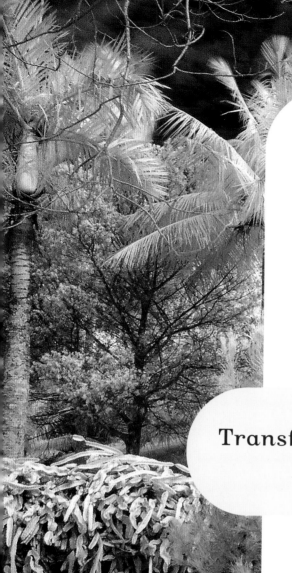

Digital
Photo Art

Transform Your Images with Traditional & Contemporary Art Techniques

by Theresa Airey

I wish to dedicate this book to my husband, Don, who has always encouraged me to follow my dreams and my heart. You have always been my touchstone-- my rock.
With all my love,
Theresa,

LARK BOOKS

A Division of Sterling Publishing Co., Inc.
New York

Table of Contents

Acknowledgements

I wish to thank Marti Saltzman of Lark Books for encouraging me and for having faith in me to do this book. Her positive energy was a source of inspiration. I also wish to thank Haley Pritchard for being so insightful and doing an excellent job of editing. I thank her for her talent and her patience. I especially wish to thank Sandy Knight, the book designer, for her unique and creative vision in laying out the images and information. Her skills made *Digital Photo Art* an artistic creation in itself. I would like to thank all of my digital sponsors for sending me supplies and new softwares for use in putting this book together. I appreciate your cooperation and enjoy working with your very creative products.

"Cyber Gigabit" Hugs to:

* Auto FX Software (Mystical Lighting, Photo/Graphic Edges 6.0 (PGE 6), AutoEye 2.0)
* nik multimedia, Inc. (nik Color Efex Pro, nik Sharpener Pro)
* Synthetik Software (Studio Artist 3.0)
* Wacom Technology Corporation (Wacom Intuous Tablets)

I wish to thank the following art suppliers and/or manufacturing companies for sending me art materials to try out and to use in the book.

"Medium" Hugs to:

* Ampersand Art Supply * ColArt Americas Inc. * Daler-Rowney Limited
* Dick Blick Art Materials * Faber-Castell USA, Inc. * Golden Artist Colors, Inc.
* Hiromi Paper International * HK Holbein * Jacquard Products
* Shiva (made by Jack Richeson & Co., Inc.) * Jo Sonja's Inc.
* Lazertran LLC USA * Liquitex Artist Materials * Savoir-Faire
* Strathmore Artist Papers

I wish to thank the participants in the gallery for their contribution to this book. Their vision, talent, and willingness to share are to be applauded. Their creative talents and skills are the forerunners for the next generation of digital artists.

* Leslye Bloom
* Dan Burkholder
* Danny Conant
* Barbara Ellison
* David Julian
* Ian Macdonald-Smith
* John Reuter
* Carol Tipping
* Anna Tomczak

Illustration Credits

* Adobe Photoshop screen captures appear courtesy of Adobe Systems Incorporated
* Auto FX Photo/Graphic Edges screen captures appear courtesy of Auto FX Software
* Studio Artist screen captures appear courtesy of Synthetik Software, Inc.
* nik Color Efex Pro screen captures appear courtesy of nik multimedia, Inc.

Introduction

This is a book written for the artistic photographer, or anyone who wants to become one. Herein lies information and, hopefully, inspiration for those who want to go beyond a basic photographic digital print. Many of the projects I've included show you how to "do what you used to do" in the darkroom, or with films and materials that are becoming scarce and, in some cases, are no longer available.

Use this book as a guide to materials and techniques, and as a source for creative ideas. Cross the boundaries of painting, printmaking, drawing, photography, and digital art by using the computer as a tool to begin to integrate, orchestrate, and create new images.

Open your eyes, free your mind, and expand your artistic vision!

The creative process starts with "what if." I hope that the various projects and techniques in this book will sprout some "what-ifs" for you—what if you do it this way? What if you do it that way? What if you add something different? The work I've included here is meant to inspire you to go further on your own creative path!

I have been a photographer, artist, author, and teacher for over 20 years. Above all else, I am an image-maker. I enjoy the process of capturing an image, but I absolutely love making the print. I revel in selecting the perfect paper, the ink color, the scale of the image, and the most appropriate medium to translate my vision into print. I prefer to create an image that represents what I felt rather than what I saw, and I don't mind crossing boundaries and mediums to get the effect that I want. I am anything but a purist. I do, however, make it a rule to always use high-end archival materials in my work.

Even though the latest printer technologies produce amazingly accurate color, I still prefer, for the most part, to color the images myself. Sometimes I aim to produce the same colors that existed in the original image, but the fact that I've colored or painted the image with my own hand creates a different look, a different feel, and a richer print. Other times, I'll use computer software to render my image uniquely, applying paint-like texture or surreal software filters to achieve the emotional tone in the piece that I'm aiming for. I like to take the image out of the photographic arena and into a more dreamlike, romantic realm.

For me, the digital revolution has been a marvelous opportunity to expand my photographic vision. It has inspired me to take my photos to another level. I can capture a digital image, manipulate it with computer software, print it, do a photo transfer onto a surface of my choice, paint on it, then scan it right back into the computer for more fun! Mix and match traditional and contemporary art techniques to your heart's content. The possibilities are endless.

By reviewing the old, we learn the new. —Chinese Proverb

Artist Materials for the Photographer

Many photographers would love to go beyond the straight, printed version of their work and try a more creative approach, but they just aren't familiar enough with the materials available to them to put their ideas into form. They may not have had the benefit of art, color, or painting classes. This chapter provides a quick overview of art mediums and materials for just such a person—as well as for anyone else who would like to review the information!

Time is of the essence and, in today's busy world, we cannot always take the time to learn what we need to know in order to translate our ideas into form. Walking into an art store can be overwhelming with the wide array of paints and materials available to today's artist. With the basic knowledge provided here, you will be able to ask intelligent questions about products, or perhaps even know exactly which product you wish to purchase. Refer back to this chapter whenever you need to in order to get enough information to go into an art store and confidently ask for the product you need or get a substitute product that you know will work.

There are far too many brand names to list, discuss, and compare every one. Instead, I have listed the names of the basic materials and provided information about their properties and uses. When I mention a brand name, it is because I use it and know it to be archival and reliable. I do not mean to imply that other brands not mentioned here are not as good. There are many, many products out there that are worth trying out and experimenting with.

As in all fields, the old adage that you get what you pay for holds true. Cheaper products tend to be less archival and more difficult to use, or the colors change. If you buy inexpensive products, make sure the pigments are lightfast before you purchase them. "Student" grade, and sometimes the word "studio" in the name, implies that the paints are not professional-grade and contain less pigment. There is nothing wrong with purchasing the less expensive brands for experimenting as you learn. Then, when you feel more confident in the method or technique, buy the "good stuff" to do an archival piece.

Jargon of the Art World

Any field of endeavor has its own jargon. Not long ago, few people had ever heard of pixels, megabytes, interpolation, surfing the net, CDs, or DVDs. Now these words and terms are very common to those who are involved in the digital arena. The same goes for the art field. Two words that are commonly used among artists are *medium* and *media*. Their meanings are related, but they should not be used interchangeably. I have provided an explanation of the two terms below. (Refer to the glossary for additional details and terminology.)

medium

The word medium has several well-known meanings in the contemporary art world. It can refer to the type of art, such as sculpture, drawing, printing, or painting (i.e., what the art is comprised of or created from). It can also refer to the vehicle in which pigment is bound, such as the medium of water, which is used in watercolor, the medium of oil, used in oil paint, or the medium of egg yolk, used in tempera. It can also refer to an additive that can change the viscosity, the color, or the rate of paint drying, such as retarding medium or matte medium.

media

The word media is most often used when referring to the term "mixed media," which indicates that more than one medium was used in an art piece. A mixed media piece could contain paint, pastels, papers, clay, shells, leaves, etc. There is no limit to the combinations of materials that can be used in mixed media artwork.

Basic Terms and Materials

art boards

These are high quality wooden panels with surfaces prepared for a variety of mediums. There are several types, such as watercolor paper, acrylic-primed cotton canvas, or oil-primed Belgian linen. They are rigid and will not flex the paint film, thus preventing damage to the painting. Pintura makes a good wood painting support surfaced with an even textured canvas that has an acid free, all media priming. Theses boards come in oval and circle shapes, as well as the standard rectangle.

binder

Binder is a substance that is mixed with pigment to make paint. It holds the pigment particles together, allowing the paint stick to the substrate. (See the Paint Binders section on page 14 for more details.)

canvas

The word canvas does not always refer to a particular fabric. It is more of a generic term used to refer to any fabric that has been gessoed and is used as a substrate for a painting. The "canvas" could actually be cotton, burlap, linen, paper, or a synthetic fabric. There are some new developments in canvases that make life a little easier. Traditionally, one would buy unprimed canvas, gesso it, and then stretch it onto wooden frames. Today, you can either purchase the canvas already gessoed and stretched onto a frame, just plain gessoed, or gessoed and adhered to heavy wooden backings. The gessoed canvas adhered to a heavy wooden panel is great for use with image transfers combined with mixed media. You can use a variety of mediums on canvas—not just oils—such as pastels, watercolors, acrylics, or collage.

gesso

Gesso is a ground that is made from animal glue, such as rabbit skin glue, mixed with a white chalk or powder substance—usually a crushed marble and titanium white pigment. It is used to coat your substrate surface before oil paint is applied. You can make gesso yourself and paint it onto a piece of cloth, or buy the gesso already made and paint it onto your canvas. There are an enormous number of recipes found in painting and art material books with step-by-step directions for making and applying gesso, and for stretching your own canvases. You can also buy pre-coated, stretched canvas panels already gessoed, as well as pre-coated gessoed canvas on a roll.

Note: Liquitex now makes a clear gesso upon which you can paint with oils, alkyds, and acrylics. This gesso has no white pigment, which makes it easy to coat a paper that already has an image on it—like an ink jet print—and paint over it with oil paints if you wish.

Caution: The ink jet coated canvas and linen available for desktop printing is not always impervious to oil paints. These substrates are meant to be printed upon to simulate the look of an oil painting—most are not meant to actually be painted upon with oil paints. You can test any substrate to see if it will take oil paint by placing a drop of oil (such as vegetable oil or baby oil) on the substrate surface. Wait a minimum of 12 hours, then check the back of the substrate. If it has an oil mark on the back, the oil has penetrated the coating and your substrate is not impervious to oil.

ground

Ground is a barrier applied to the surface upon which a painting will be made. This barrier (made of glue size, gelatin, or gesso) prevents acids from deteriorating the fibers of the receptor-like paper, linen, or canvas. The ground also creates a surface that will accept paint, and one upon which the paint will adhere. The white surface also enhances the color of the paint, especially transparent paint that depends on the white for its brilliance. Acrylic-based ground can be used for acrylic, oil, alkyd, and other paints. Golden Artist Colors, Inc. makes an acrylic ground (100% acrylic polymer emulsion) that is designed for pastels and chalks and provides a tooth similar to that of pastel papers.

Note: You can use oil paint on an acrylic-based ground, but you cannot use acrylic paint on an oil-based ground, as the oil will eventually cause the acrylic paint to separate.

paint

Paint consists of two basic ingredients: pigments (coloring material) and a binder to hold everything together. When buying paints (or, for that matter, any artist supply) make sure you purchase the highest quality to insure your work of art is archival. The highest quality paints will not have fugitive colors, which means that their colors are stable and will not change hues over time. If you use cheaper paints you will find that an area painted pink could be purple or blue by the next month. Student grade paints are meant for practicing and learning. Paintings accomplished with these paints will not last over time.

pigment

Pigment is a material that possesses color. Some pigments come from vegetables (organic), some from minerals and metal sources such as chromes, cobalts, and cadmiums (inorganic). Still others come from rocks and semi-precious stones such as Lapis, from iron oxides like Mars black, or from the earth like ochres and siennas. Today, some pigments are made synthetically. Pigment is ground into a powder and dispersed into a medium to give it color.

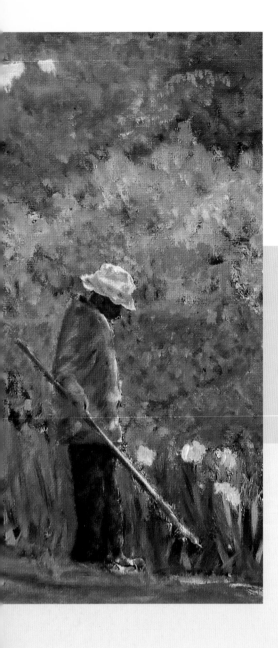

Paint Binders

Oil Paint Binder: Linseed oil is traditionally the binder in oil paints.

Acrylic Paint Binder: A synthetic substance called acrylic polymer emulsion is the binder used in acrylic paints. It is water-soluble when wet and yields a flexible, waterproof film when dry.

Watercolor Paint Binder: Gum arabic is the binder used in watercolor paints. Sometimes glycerin is added to improve moisture.

All About Oils

Oil paint is pigment mixed with a vegetable oil. The most common oil used is linseed oil, but it can be poppy seed, safflower, or others. The oil makes the pigment brushable. Each pigment requires different amounts of oil. Oil also retards the drying time, which will vary from pigment to pigment. Oil paint dries through oxidation rather than evaporation, and the thicker the paint has been applied, the longer it will take to dry. Oil paint is sold in tubes, cans, and jars with varying grades, from student to professional.

Water Miscible Oil Paints and Mediums

Archival Oils: Made in Australia, this was the first brand of oil paint designed to overcome the problem of bridling and cracking. It contains a patented synthetic resin plasticizer that allows the paint film to contract and expand with the substrate.

Grumbacher's Artist's Oil Colors: These are water miscible and can be used with either oil mediums or water. With these paints, you can clean up with just soap and water.

Grumbacher's Oil Painting Mediums: Quickdry medium, and Linseed Oil medium can both be used with conventional oil paints, but will not make them water miscible. (See page 16 for more about mediums.)

Winsor & Newton's Artisan Water Mixable Oils: These oil colors can be mixed with water, and clean up is done easily with soap and water. These paints have their own mediums, such as Artisan Water Mixable Painting Medium, Artisan Water Mixable Stand Oil, Artisan Water Mixable Linseed Oil, and Artisan Water Mixable Impasto Medium.

> ***Note:*** These mediums are designed specifically for use with water mixable oils. They should not be used with conventional oil paints and should not be mixed with each other. One medium at a time!

Transparent Oil Colors

Permasol Transparent Oil Colors: Made by Shiva, these are vibrant, intense colors that are transparent straight out of the tube. They can be used as glazes, or can be combined with traditional oil paint. As a glaze, they can be applied straight over dried oil colors. They can also be combined to make different colors.

> **Note:** The Permasol White (combination of zinc ad titanium oxide) is actually the only transparent white currently on the market.

Marshall's Photo Oils: These transparent oil colors are made for coloring on photographs. Because they are transparent, they allow the details of the photograph to show through. These can be used on canvas, as well.

Oil Pastels

Oil pastels are a mixture of oil and wax. They are a bit like crayons—very creamy and smooth. I like to use Sennelier oil pastels; they are truly like painting with a creamy lipstick. If you like working with your fingers rather than a brush, as I often do, this may be your medium. However, if your hands tend to get hot, painting with oil pastels can get really messy.

Oil Sticks

An oil stick is a combination of pigment, a binder such as safflower oil, and a high quality wax. The difference between oil pastels and oil sticks is that oil sticks contain siccative oil and driers, and they are low in acid. Oil pastels never really dry, whereas oil sticks will dry in a few days. Because of the driers they contain, the oil sticks will form a skin over the tip that must be peeled away before each use. This can be a good thing as well as a nuisance. Shiva was the only company that produced oil sticks until 1990, but now there are three more brands available: Winsor & Newton, Sennelier, and R&F Handmade Paints.

Mediums

Mediums can be mixed with paints to change their characteristics. You can make the paint glossy or flat, affect the drying time, or change the paint's consistency. Paint can be used straight from the tube. Mediums, however, give the artist more control over the paint.

Mediums come in two forms: one is a thick gel and the other is a heavy oil. Golden Artist Colors, Inc. makes a wonderful line of textured pumice gels that I like to use to build up textures in my collage work. Liquitex has an iridescent medium that you can add to acrylic paints to create a metallic look that can be very useful.

Oil Paint Mediums

Linseed Oil: Linseed oil comes from flax plant. When linseed oil dries, it dries by oxidation, which takes a long amount of time, enabling the paint to remain "open," or workable. Once it dries, it is not reversible. The main drawback with linseed oil is that, after a period of time, it will yellow and turn brittle, which in turn cracks the paint.

Oil is pressed from the seeds using two methods: hot pressed uses very high temperatures and pressure; cold pressed is done with less heat. Cold-pressed linseed oil is very expensive, but offers superior paint film strength, handling, and color brilliance. It is making a strong comeback in today's painting arena. Alkali-refined linseed oil is an acid-free oil and is second best to cold-pressed oils in the production of oil paint. Linseed oil as an independent medium thins the paint, but also acts as a binder for the pigment.

Stand Oil: This is a heavy oil made by heating oil in an airtight container (linseed oil for painting mediums). The viscosity of oil can be thickened through the application of heat. It will actually go though a molecular change, which will polymerize it. When this occurs, it is known as "stand oil." Stand oil is slow drying and, when it is dried, it will yellow less and is more flexible then the raw oil. It is extremely thick and, when used as a medium, it has a shiny, polished look that makes it good to use when mixing with glazing formulas. It allows paint to dry smooth, without brush marks, and it also makes oil paint more transparent with little yellowing or cracking.

Sun-Bleached and Sun-Thickened Oils: These oils are ranked the best and purest form of the bodied painting mediums. Linseed oil and water are mixed equally and exposed to sunlight for several weeks. As the oil and water separate, the oil is bleached and cleaned and floats to the top. When it reaches the top and is exposed to the air, oxidation takes place and it becomes heavier. Because it is partially oxidized, it will dry faster.

Safflower Oil: This is a light drying oil from India. It does not yellow with age and many artists prefer it to linseed oil. Because of its light color and non-yellowing qualities, it mixes well with white.

Poppyseed Oil: Poppyseed oil is a pale drying oil that comes from poppy seeds. It takes longer to dry and is not as durable as safflower and linseed oils are. It is pale in color and, therefore, mixes well with whites. It also makes the paint very velvety and smooth to work with.

Venice Turpentine: Even though it is called a turpentine, it is actually a very thick medium that comes from the European larch tree (true turpentine comes from the pine tree). Venice turpentine will give the paint film added strength, and it can be used with impasto (a technique involving very thick application of paint). It dries quickly and can mixed with any oil color.

Flemish Medium: Flemish medium consists of copal resin, linseed oil, and turpentine. It makes the colors brighter and the paint dry harder. Because of its deep golden color, and because it contains copal resin, Flemish medium will darken colors over time. For this reason, it is only good for use with dark-colored paints.

Oleopasto: This medium is an alkyd-based resin that contains silica. It is used to make paint very thick. Oleopasto will slightly saturate or deepen the colors with which it is used.

Dorland's Wax Medium: This medium makes oil pants more translucent and more brilliant in color. It can be used as a final coat on dry paintings, metal sculpture, and wood cravings, and can be thinned with turpentine.

Shiva's Painting Medium, Light: This very light painting medium provides good consistency to oil paints and, after drying, the paint remains flexible with no cracking.

Copal Painting Medium: Copal painting medium speeds the drying time of oil paint, but use it sparingly. It can cause yellowing when used in excess.

Drying Agents

Certain colors (such as ivory black, lampblack, vermilion, and ultramarine blue) slow down the drying process of oil paints. Drying agents such as Courtrai Dark Siccative and Courtrai Pale Siccative are used to speed up the drying process.

Note: Driers tend to weaken paint films, so use them sparingly.

Acrylic Paints

Acrylic paint is one of the synthetic resin products developed in Germany by Otto Rohm around the turn of the 20th century; another of his contributions to the world is Plexiglas. Acrylic paints use the same pigments found in oil paints, but the binder used is an acrylic polymer suspended in a water base, hence the name "acrylics." As the water in the paint evaporates the paint dries to a strong, flexible, permanent film that will not crack or flake off. The paint dries very rapidly and, once dry, it is not affected by humidity or rapid changes in temperature. I especially like the acrylic paints made by Golden Artist Colors, Inc.

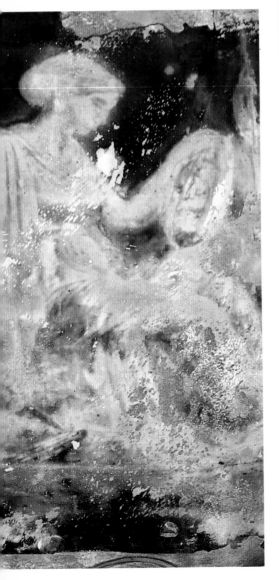

Acrylic Paint Mediums

Gloss Medium: This medium thins the consistency of the paint. If you add a lot of it, you can make nice glazes—it dries glossy. You can also apply it to the surface of the print or painting before applying the paint, making the surface less absorbent so the paint will glide on better. You can use it as a varnish after the paint has dried. Acrylic gloss mediums will never be as glossy or shiny as oil gloss mediums.

Matte Medium: This medium also thins the consistency of the paint, but dries to a flat finish. Matte and gloss medium can be mixed to give a luster, or satin, finish when dried. I use both Golden Artist Colors' gel mediums and Liquitex mediums.

Hint: Matte medium can be used as glue for collaging, but it cannot be used as a varnish, as it will cause fogginess over the darker colors. I buy large jars of acrylic matte medium and use it both for my paint and for gluing papers onto my images.

Golden Artist Colors' Acrylic Glazing Liquid: This is a really handy medium. You can mix the glazing liquid with acrylic paint to make glazes or to slow down drying time, giving you more time to mix and glaze.

Liquitex Iridescent Pearlescent Medium: This medium creates metallic effects when added to acrylic paint. It can be diluted to use on fabrics.

> *Caution: Do not mix Liquitex Iridescent Pearlescent medium with turpentine or oils.*

Liquitex Fabric Medium: This medium will make acrylic fabric paint flow better and be easier to use.

Retarding Medium: This very thick and gummy medium retards the drying time of the paint. I prefer Liquitex Slow-Dri Blending Fluid Medium. It is not as gummy as other brands, and can also be used to make the paint transparent. Be sure to allow at least three days for the paint to dry before varnishing.

> *Caution: Always read the labels to be sure you are adding the correct amount of medium to the paint. Too much retarding medium can affect the final finish of the paint and lessen its adhesiveness.*

Gel Medium: Gel mediums add texture to acrylic paints. Golden Artist Colors has three pumice gels: Fine Pumice Gel, Coarse Pumice Gel, and Extra Coarse Pumice Gel. All three will add a granular texture to the paint. It dries very hard and is great for added dimension.

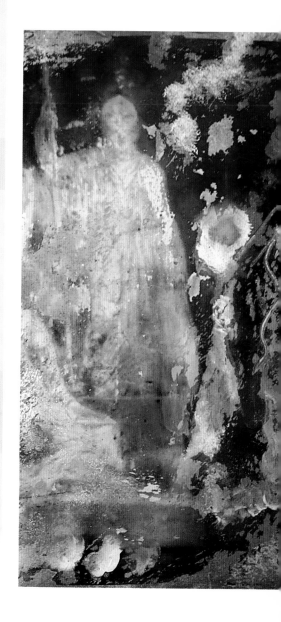

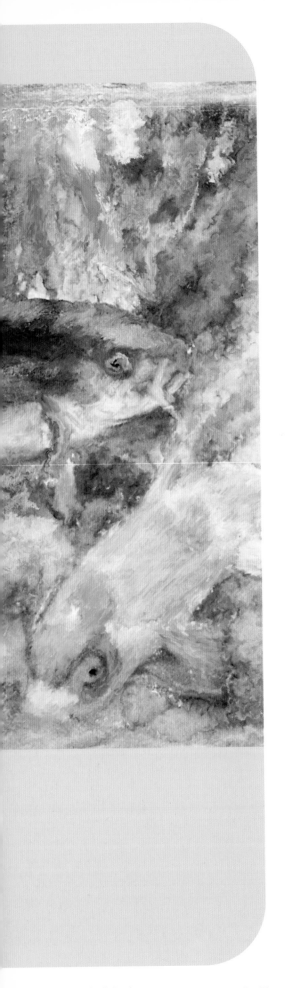

Alkyd Paints

Alkyd paints are pigments and oil mixed with a binder that's an oil-modified alkyd resin, which is a synthetic resin. The name "alkyd" was originally "alcid"—a combination of the words alcohol and acid. Alkyd paints have a drying time that is faster then oils, but slower than acrylics. It is believed that they yellow less over time than oil paints do, but it is still too soon to tell.

Alkyd paints handle the same as oil paints except for that they dry very quickly and each color dries at the same speed. This means that any color can be applied on top of another without fear of cracking. When alkyd paints dry, they form a stronger paint film than oils do and, with the synthetic polymer as a binder, the paint is very flexible.

Caution: Because alkyd paints and mediums contain solvents, they are more hazardous than oil paints. You should always use ventilation when working with them.

Alkyd Gels and Mediums

Alkyd mediums dry very quickly and they increase the transparency of the colors. They are great to use in glazing techniques, as they give a very polished finished.

Grumbacher Alkyd Painting Medium: This alkyd medium can be used with either alkyd or oil paints. It can be mixed easily for the consistency you desire, and is great for making oil or alkyd paints transparent, or as a glaze.

Liquin: Liquin is the most used alkyd gel. It is used in place of natural oils because it dries more quickly and yellows less. Liquin can be used with both oils and alkyd paints. It has a cloudy appearance but, when mixed with oil or alkyd paint, it becomes clear. There are many alkyd gels on the market. Some have more odor than others, and some people are more allergic to one brand over another. When working with any of these gels, good ventilation is recommended.

Wingel: This oil-modified alkyd resin produces a non-yellowing, non-cracking coating, and can be mixed with either oil or alkyd paints to increase the gloss and the speed of drying. It is thicker than Liquin, and adds body to the paint. It is also good for glazes, and can be thinned with rectified turpentine. Wingel is excellent for making paint translucent.

Egg Tempera

Egg tempera is a paint that is a mixture of water and pigment, using egg yolk as the binder. Mixing and blending of colors is done with water. This paint dries extremely fast, but continues to dry for about a year. It is easily damaged by scratching, and can also be damaged by water. Though egg tempera is a water-based paint, it is not considered to be transparent.

Tempera Mediums

Tempera medium consists of oil, egg, and water. It can be added and mixed to the tempera paint right on the palette.

> **Hint:** Adding about eight drops of tempera medium to a tablespoon of paint will give you a matte look; adding around five drops will render a glossy look.

Gouache

Pronounced "gwash," gouache paints are very much like watercolors, only thicker. A chalky substance is added to the pigments, which makes the paint opaque. The binder in gouache paint can be gum or acrylic. Blending is done with water. It dries rapidly to a matte finish. These are water-based paints but, as with egg tempera, they are not considered to be transparent. Winsor & Newton make very good gouache paint. I also use Jo Sonja's Artist Gouache Colors, made by Chroma. They make a great selection of iridescent paints in addition to their regular colors.

(figure 1) Here, I am mixing gouache paint with watercolor medium to make the paint more transparent and less opaque When you wish your gouache paints to be opaque and flat, mix with water only. When you wish to use them as a "watercolor" paint, mix with watercolor medium.

(figure 2) In this painting, I used gouache paints as watercolor paints by mixing them with a watercolor medium. The Pale Gold Micacious Gouache, when mixed with watercolor medium, highlights the fins and seaweed with a transparent glow.

(figure 3) Here I am applying a "watercolor" gouache paint to the seaweed in the image.

figure 1

figure 2

figure 3

Casein

Casein paints are very similar to gouache but, instead of a gum or acrylic binder, casein is used. Casein is a substance derived from milk curd. These paints can be mixed and blended with water. Shiva makes a beautiful line of casein paints. Like egg tempera and gouache, these water-based paints are not considered to be transparent. Casein paints are used extensively in murals, and as waterproof poster colors.

Casein Mediums and Varnishes

Casein Emulsion: Casein emulsion is the base in to which the dry pigments are ground. It can be bought separately and mixed with the casein paint to improve flow or brush-ability. It can also be used to make a thin wash (a transparent layer of color). You can make a wash from just plain casein paint and water, but casein emulsion makes the paint glide on easier to create a smoother, more superior wash.

Casein Varnish: Casein varnish is a pure, shellac-based finish that can be applied once the paint is thoroughly dry. It gives a high-gloss final protective coat that is impervious to moisture.

Matte Varnish: This is a permanent varnish used to protect the surface of a casein painting. It will even out to a matte sheen.

High Gloss Varnish: This permanent varnish protects the surface of the casein paint and gives a clear high-gloss sheen.

Watercolor Paints

Watercolor paints are pigments mixed with water and binders. The binder is gum arabic, sometimes combined with glycerin. These water-based paints are considered to be transparent.

Watercolor Mediums

Gum Arabic: Gum arabic is one of the ingredients in watercolor paints, however, additional gum arabic can be added to the paint to keep it from spreading while you're working. Plus, it adds brilliance to the paint and keeps dark colors from lightening after they dry.

Wetting Agent: This medium essentially makes your water wetter! It helps make the surface of the paper more receptive to the water and prevents beading. One such wetting agent is Daniel Smith Oxgall Liquid.

Glycerin: Adding additional glycerin makes watercolor paints more soluble and they brush on easier.

Watercolor Gel: This is a mixture of gum arabic and silica, which thickens watercolor paint.

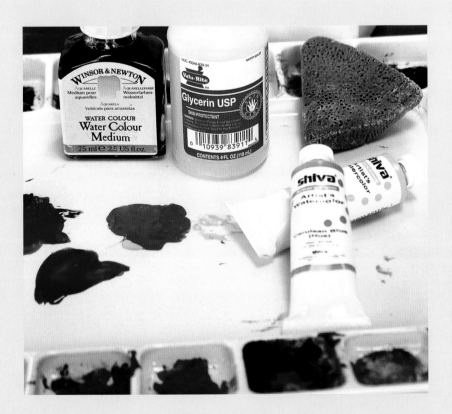

Pastels

Pastels are made from chalk, pigment, and a binder—usually a gum traga-canth. They can be brushed over with water or turpentine to get a flow of color. Pastels come in hard sticks, soft sticks, and in pencil form.

> **Note:** There are many recipes out there for making your own pastels—use your favorite search engine on the Internet and see what you can find!

Soft Pastels

Soft pastels are easily applied and blended, and they need no medium. They are water-soluble and can be wetted to create a flow of color. Because they contain no binding agent, they are fragile and are easily broken. The biggest drawback is the fine powdery dust given off when working. It may bother people who have allergies. Caution should be used, and a respiratory mask worn, if the dust bothers you.

I like to use Rembrandt's soft pastels. They are made with a fine kaolin (China clay) binder and go on very smoothly. The Winsor & Newton brand is also very good; they have some great colors. Sennelier soft pastels are very soft—a bit too soft for many of the ink jet coated papers. They do, however, work great on very toothy pastel paper.

Hard Pastels

Hard pastels are made with less pigment than the soft pastels, and they contain a binder. They have a firmer consistency and can be sharpened with a knife or blade. They do not crumble or break as easily as the soft pastels. I use them for drawing lines or details in a painting.

Art Pencils

Pastel Pencils

Pastel pencils are a combination of pigment, chalk, and a binder encased in a wooden tube. They can be hard, medium, or soft according to the amount of binder used, and this varies with each brand. I like the Conté pastel pencils because they are not too hard or too soft, and I can use them on ink jet papers, artist watercolor papers, or photographic papers.

Oil Pencils

Oil pencils are a combination of pigment, oil, and wax.

Marshall Oil Pencils: These have a higher amount of oil than the other oil pencils on the market, which makes blending very even and easy. They

will work on semi-matte, matte, and rough-surfaced photographic papers, as well as on some ink jet coated papers. Because they can be sharpened to a tiny point, you can use them in combination with other mediums to add definition or color to a small area. Marshall oil pencils are more water miscible than many other brands because they do not have as much of a wax base. The waxier oil pencils do not give an even flow of color when water is applied. Marshall oil pencils can be used the same as a watercolor pencil.

Walnut Hollow Farm Oil Pencils: These come in a large variety of colors, but consist of more wax than oil, so they don't blend as well as the Marshall oil pencils. They work well for heavy color techniques and for getting color into small areas.

Berol Prismacolor Pencils: These pencils consist of pigment in a hard wax base. The wax makes them easy to apply—the more wax, the smoother and more fluid they feel, and the easier they glide across the surface of your paper. These pencils come in a large assortment of 72 colors. Each color is formulated differently; some have more wax than others. They are hard to blend with your finger or a tissue.

> **Hint:** One blending technique is rubbing with a plastic eraser, very gently in a circular motion, until the eraser picks up color. This is tricky because if you rub too hard, you will erase the color rather than blending it. You could also try layering or crosshatching as your blending technique:
>
> ❊ **Layering:** This color blending technique is basically just putting one color on top of the other so that the colors influence each other. If a dark color such as brown is applied first, and then another more transparent color, such as yellow, is applied on top of it, the yellow color would become a brownish-yellow because of the dark undertone.
>
> ❊ **Crosshatching:** This is a technique where lines of color are applied to crisscross each other at an angle and form a singular shade. For example, if yellow and red are crosshatched, where they cross appears orange. You can, of course, use more than two colors when blending color with crosshatching.

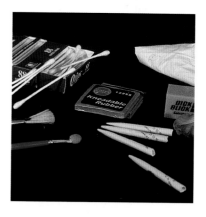

Watercolor Pencils

Watercolor pencils are comprised of pigment, a binder to hold the pigment together, clay to give them opacity, and wax to make them easy to apply. There are many watercolor pencil brands from which to choose. Basically, they are all made the same way, but each set has a different array of colors. Faber-Castell's Albrecht Dürer Artists' Watercolour Pencils are my favorite. They have added an emulsifier, which makes them glide onto the paper. Prismacolor watercolor pencils are also a good choice.

CROSS-HATCHING

Wax Medium: the Encaustic Process

Encaustic paints consist of beeswax, pigment, and a bit of resin. They are brushed on hot and fused with heat, often via a hair dryer. R&F Handmade Paints makes a beautiful line of encaustic paints.

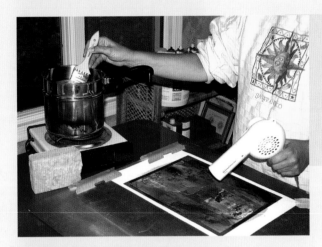

Note: A hair dryer works very well for manipulating the wax during the encaustic painting process but, since one hand is holding the blow dryer and the other hand is holding the paintbrush, it is wise to tape your print down before you begin so that it doesn't fly away.

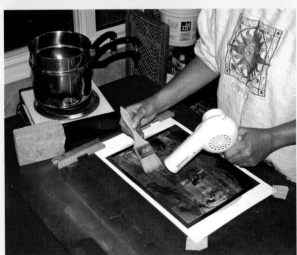

Solvents and Thinners

A solvent is a substance that dissolves another substance. A thinner is a liquid that mixes with paint or varnish to reduce its thickness. Solvents are used both as thinners and dissolvers in oil painting so, essentially, the terms are interchangeable. They also speed up the drying time of the paints they are mixed with. There are many kinds to choose from, such as mineral spirits, gum turpentine, and citrus paint thinners.

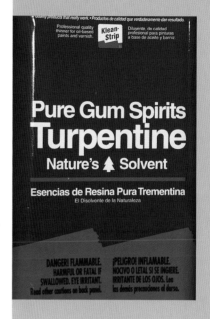

Caution: Turpentine, mineral spirits, odorless mineral spirits, and citrus thinner are all toxic. Odorless mineral spirits is the safest of these because the aromatic hydrocarbons have been removed. Even so, good ventilation is extremely important when using any solvent or thinner.

To Reduce Inhalation:

* *Keep the containers closed when you are not using them.*

* *Do not eat, drink, or smoke while working.*

* *Use only the smallest amount of solvent/thinner possible.*

* *Consider using a product called Nox-Out Air Purifier, which is a molecular absorber that removes harmful airborne fumes. It absorbs the chemical fumes like a magnet and locks them in. It should be positioned within 18 inches of the solvent/thinner container and will last about six months before you need a new one.*

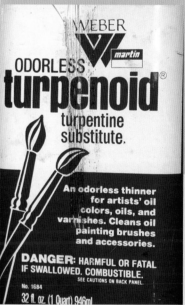

Mineral Spirits: This non-volatile solvent is made from petroleum and can be used in thinning both oil and alkyd paints. It is not good for mixing with mediums, but it's great for cleaning brushes and equipment.

Turpentine: Turpentine is the most common thinner used in oil painting. It is made from the sap of pine trees.

Turpentine, pure gum turpentine, rectified turpentine (double distilled and highly refined), pure spirits of gum turpentine, etc., all have the same basic properties. Turpentine can be used as both a thinner and a solvent.

Note: Venice turpentine is not regular turpentine; it is a medium that will give the oil paint film added strength and can be used with impasto. It dries quickly and can be mixed with any oil color (see page 17).

Hint: If you have an allergy to turpentine, or you just prefer to avoid the odor, use mineral spirits for thinning your paints and cleaning up. Mineral spirits can be used in reducing most alkyd and oil paints, varnishes, and enamels. You might also try Martin Weber Odorless Turpenoid (see page 28).

Odorless Turpentines and Mineral Spirits

Martin Weber Odorless Turpenoid: This is an odorless, hypoallergenic turpentine. It has the same properties as regular turpentine without the odor. It is classified as a petroleum hydrocarbon and is basically odorless mineral spirits.

Shiva Signa-Turp Odorless Thinner: This thinner is a colorless turpentine substitute that has the same properties of turpentine but not its odor.

Rectified Turpentine: This is a popular solvent that, when mixed with oil paints, makes the paints creamier. I use a cheaper brand for cleaning up.

Odorless Mineral Spirits: Refined and purified from petroleum, odorless mineral spirits will evaporate completely in the air. It is great for people who are allergic to turpentine.

> *Caution: Be aware that, just because a turpentine substitute has no odor, does not mean that it is non-toxic. Practice the same caution (good ventilation) as you would with the more odorous solvents/thinners. And always read the labels!*

Citrus Thinner: This is a citrus distillate and a byproduct of manufacturing citrus peel liquor. It can be used to thin paints and clean brushes. Grumbacher's citrus thinner is called Grumtine. It is a stronger solvent than turpentine and has a pleasant citrus smell. It speeds up the drying time of oil paints.

Non-Toxic, Non Flammable Solvents and Thinners

Turpentine Natural: This turpentine is made from citrus products and is non-toxic and non-flammable. It is roughly twice the price of normal turpentine, but worth it. It can be used with both oil and alkyd paints.

Non-Toxic, Non-Flammable, and Non-Combustible Solvents and Thinners

Note: If mixing turpentine natural with oil paints, keep the ratio under 50/50 (i.e., there should be more oil paint than turpentine natural in the mix).

Safe Solve: This solvent will thin oil paint and clean brushes. It contains 10% alkali-refined linseed oil, and has a pleasant odor, but it is expensive.

Safe Klean: This non-toxic medium will dissolve damar crystals (in place of pure gum turpentine or mineral spirits to make varnish) and is non-flammable and non-combustible.

Spike Lavender Oil: Spike lavender oil works very well, but is very expensive. It comes from distilling the male lavender flower. Spike lavender oil, when added to the paint, will make it creamier and easier to work with. You can mix spike lavender oil with odorless mineral spirits to reduce its diluting power.

Whatever solvents or thinners you buy, always buy artist/professional grade. Sometimes the less expensive grades (found in hardware stores) have various additives that you do not want in your paints. It's better to pay a bit more and get quality products.

Caution: Never use kerosene for thinning your paints or cleaning your brushes. It leaves an oily film on everything.

Varnishes

Varnishes protect paintings from atmospheric pollutants. They also even out the finish on the painting surface. Even acrylic paints should be varnished. Varnishes can be painted on or sprayed on. It is far better to give the painting two or three thin coats than one heavy coat. Try to apply the varnish in a dust-free area (don't let the cat or dog in).

> **Caution:** *Never apply varnish on a humid or damp day. Moisture will get trapped under the varnish and cause a bluish white film called "bloom" to form on the surface.*

Oil Painting Varnishes

There are two types of oil paint varnishes: natural (damar and mastic), and synthetic (acrylics and ketone). They both come in various finishes, such as glossy, matte, and luster.

Natural Damar Varnish: Natural damar varnish is a mix of damar resin, and turpentine or mineral spirits. It does add an overall hint of yellow to the colors, but it will not crack.

Natural Mastic Varnish: This varnish is a mix of mastic resin and turpentine. It dries to a high gloss. I don't use this one because it can darken and crack. I prefer the synthetic varnishes, as they are non-yellowing, do not crack, and many of the newer synthetic varnishes contain a UV inhibitor.

Shiva Damar Varnish: This natural varnish has a moderate to high gloss and increases the brilliancy of the colors.

Blair Spray Damar Varnish: This is 100% damar varnish, whereas most other spray varnishes on the market are now acrylic. It comes in a spray can, so thin, uniform coats are easy to apply. It is available in matte or gloss.

Winsor & Newton Conserv-Art Removable Varnish: This can be used on oil, acrylic, or alkyd paint colors. It provides a non-yellowing film that does not crack or bloom, and can be removed with turpentine or mineral spirits.

> **Note:** Make sure that oil paint is thoroughly dry before coating or spraying it with a varnish. A thickly painted oil painting can take up to two years to dry completely.

Varnishes for Ink Jet Prints

PremierArt Print Shield: This varnish, from Premier Imaging Products, offers protection from light, water, moisture, airborne contaminants and even fingerprints. It gives ink jet prints significant increases in print permanence ratings. This spray is excellent for all ink jet prints made with archival inks.

Lyson Print Guard: This spray also offers protection against contaminants, light, water, and moisture, plus it gives OEM inks (standard non-archival inks) up to 38% more stability.

Lumijet ImageShield: This is a very good spray created for ink jet prints. It seals the surface with a non-yellowing, non-visible coat. It has UV inhibitors, which protect the prints from light and air contaminants.

Varnishes for Acrylic Painting

Liquitex High Gloss Varnish: This 100% acrylic polymer varnish is water-soluble, which allows it to be thinned. It increases transparency and gloss and makes the paint glide on easier. It also makes an excellent adhesive for collage. Liquitex High Gloss and Liquitex Matte Medium can be mixed together for a semi-gloss or satin medium.

Golden Varnish with UVLS (Ultra Violet Light Stabilizers): This is a water-borne acrylic polymer varnish that dries to a protective coat as a final sealant. This varnish can be removed with ammonia for restoration purposes.

Jo Sonja's Polyurethane Water Based Varnish — This varnish gives a very strong finishing coat that is chemical, heat, and abrasion resistant. It is clear and non-yellowing, comes in either matte or gloss finish, and can be cleaned up with water. I use this for both acrylic and gouache paintings.

Blair Spray-Var: This is a non-yellowing protection for both acrylic and oil paint. It is available in high-gloss or matte finish.

Casein Varnish

Shiva Casein Varnish: This is a pure shellac-based clear finish.

Spray Fixatives

A spray fixative is a diluted solution of varnish in an aerosol spray can that can be sprayed onto the surface of a print to protect it from air pollutants. If the print is hand colored, or you are spraying a pastel rendering, watercolor, or mixed media piece, the spray fixative will not only protect the image from pollutants, but will also adhere pigment (such as pastel) to the surface and protect it from smearing. These spray fixatives come in two types: workable fixative and final fixative.

Workable Fixatives

A workable fixative is a weak solution of acrylic or varnish that sets the pigments to the surface of the paper. However, you can still go back into the image and rework the colors. It allows you to add or remove color while adding some protection from smearing.

Final Fixatives

Final fixatives have a higher amount of varnish or acrylic in the spray. Once a final fixative has been applied, you cannot go back and rework the colors, as they are permanently set. Final fixatives come in matte, glossy, luster, and semi-matte.

Brands of Sprays

Shiva Crystal Clear Matte Finish: Use a light coat as a fixative for pastel, charcoal, or pencil. When more than one coat is applied it becomes a matte varnish. Hold at least 15 inches away and give a very light coat. This spray can be very wet when applied if held too close to the print. Caution should be used, as heavy application can dissolve pastels.

Shiva Crystal Clear Gloss Finish: This is a final fixative for protective coating. It can be used on watercolor, pencil, pastel, charcoal, and colored ink renderings. Apply in light coats, waiting until the first coat has dried before spraying the second. Again this goes on wet, so be careful.

Blair Spray Fixative No Odor: This dries to a matte finish and is for use with pastels. Spraying two separate light coats is better than one heavy coat.

Martin Weber Blue Label Fixatif Spray: This is a clear fixative made expressly for pastels and charcoal renderings. It offers the least change in tonal values, dries to a matte finish, and can be reworked.

Sennelier Lascaux Fix: This transparent, pure acrylic resin fixative is suitable for pastels. This spray also offers the least color change in pastels, but is very expensive. However, it does offer clear, permanent, waterproof protection for pastels, watercolors, chalks, charcoal, pencil, tempera, and acrylic paintings. You can also use it on ceramics, glass, metal, and photographs.

Sennelier Fixatif Pastels à L'huile: This is a vinyl resin and alcohol based fixative (specifically for use with oil pastels) that leaves a clear, glossy protective film.

Sennelier Fixatif Latour: This is an alcohol and synthetic resin based fixative. It is to be used on soft pastels, is non-yellowing, and dries to a matte finish.

Daler-Rowney Perfix: This is a low-odor fixative for pastels, charcoal, and crayons that affects little change in color.

Krylon Workable Fixative: This fixative is good for pastels. When you plan to rework the image, just use one light coat. To use it as a final finish, apply two light coats, making sure the first is dry before spraying the second. It dries matte and gives the finish a bit of a tooth.

Krylon Crystal Clear: It now comes with a UV protectant! This is an acrylic coating for a permanent, protective glossy finish. It will deepen the colors of pastels and can also be used as a final coat on glossy prints that have been painted with oil paints.

McDonald Pro-Tecta-Cote: This spray fixative has a built-in UV inhibitor. The Clear Gloss is a high gloss finish, and the Matte Special is a very nice semi-matte finish, not as matte as the plain Matte spray. The Matte is a very flat finish.

Brushes

Brushes are made with natural or synthetic hairs that are held together in a ferrule (see glossary), which is attached to the brush's handle. Synthetic hair brushes work just as well as natural hair brushes, and are far less expensive. Bristle brushes are made from hog hairs, and are very coarse and stiff. Flat hake brushes are made from sheep hair. They are inexpensive and long lasting. Softer brushes are used mostly with watercolor or fluid mediums, while coarser brushes tend to be used mostly with oil and acrylic mediums.

Brushes are a personal tool. Never lend your brushes out, as different people use them with different pressure and may ruin your brush tips. I prefer to use Sceptre brushes, made by Winsor & Newton. They are a blend of natural and synthetic hairs that are bound together in ferrules that do not corrode like the cupro-nickel ferrules do. This allows me to use them in chemical solutions like ammonium ferricyanide and selenium without worrying about corrosion. I use them for painting as well.

Hint: It is better to use a synthetic brush for painting with acrylics. They use less paint and the acrylic cleans off the brush more easily. The natural bristles will absorb too much water and become soft and floppy.

Use natural bristle brushes to paint with oils. The pigments are released easier and the oil paint is easier to clean out of natural bristles.

When painting with oil or alkyd paint, you can clean your brush off to use with a different color by dipping it in turpentine or mineral spirits and wiping it on a rag or paper towel. When you are finished painting, dip them into the turpentine or mineral spirits until no paint is seen in the brush hairs, then wash them with soap and warm water (not hot water). Shake them out and reshape the tip of the brush with your fingers. Always store your brushes with the tips pointing up.

There are screens that you can buy that fit into your can or jar of solvent, leaving an open space at the bottom. When you put the brush into the solvent, use the screen to gently knock off the paint. The paint falls to the bottom, leaving the top half of the solvent free of paint to be used throughout your painting session.

Protecting Your Skin

Protecting your skin from harm while working on your art is very important! The products listed below are just a few of the options available to help keep your skin safe.

Invisible Glove Barrier Cream: Use this protective cream before working with paints or printing inks. It creates a protective shield on your skin. After you've finished working, wash it off with soap and water.

Daniel Smith Cactus Brand Protective Cream: This cream protects hands against harmful solvents, inks, and paints. It also has oils and emollients that keep hands from drying out and cracking. The best part is that there is no greasy feeling.

Kerodex 71 Cream: This is a non-greasy, water-repellant protectant against chemistries used in wet work, such as film and print developers, stop bath, fixer, toners—almost anything you use in the darkroom. Rub a dab into your fingertips and hands, set it with cold water, then pat dry. After drying your hands, you can actually pick up a negative and not make a fingerprint. It lasts for about two hours, and you can purchase it at your local pharmacy.

Kerodex 52 Cream: Apply this cream the same as detailed above (for Kerodex 71 Cream), but this protects your hands against grease and oil.

Artist's Hand Soap: This soap is specially formulated to remove petroleum-based paint without harsh thinners.

Kiss-Off: This is a great little spot remover. It will take out oil paint, as well as wine, blood, grass stains, etc. You can purchase it at art stores and through art catalogs.

Winsor & Newton Brush Cleaner and Restorer: You can use this on both synthetic and natural brushes. It cleans off dried acrylics, oils, and alkyds without damaging brush fibers. It is non-toxic, biodegradable, and non-flammable, as well as having a low vapor.

Gloves in a Bottle: You can find this product at home improvement stores. It is a lotion that prevents material from being absorbed through the skin. It will last about 4 hours.

Visual
Perception

Often times we look at things without really seeing them. Our eyes are merely lenses; they have no knowledge, no memories, and no experience. To see well, we must open our minds as well as our eyes.

Our mind is what allows us to translate images into more than just their content. To do this, we draw on the accumulation of everything that we have ever experienced as seen by the mind's eye. This is visual perception. In 1912, Dr. Max Wertheimer founded the school of Gestalt in Germany. Through his research, we have learned how our minds organize and group visual elements so that we see them as a whole. Of course, this is only one facet of visual perception, but it is this part that photographers need to understand most. We need to know how our minds allow various picture elements to be seen as a single, whole image.

"The whole is different from the sum of the parts." — *Dr. Max Wertheimer*

There are many principles in Gestalt, but I will only touch on two: the Principle of Similarity and the Principle of Proximity. Our eyes see various parts of an image separately. It is our mind's job to organize these separate parts and group them together, enabling us to see a single image. For example, if we drew a woman's face using letters of the alphabet rather than lines, we would register the creation as a face. However, if we examined it closely, we would see that the face was made up of letters. So, indeed, "[t]he whole is different from the sum of the parts."

The Principle of Similarity

The Gestalt Principle of Similarity states that subjects that share visual characteristics (i.e., size, shape, color, texture) will be perceived as belonging together. For example, (figure 1) our minds could group the elements in this image based on the repetition of rectangular shapes. The doorway itself is rectangular, as is the lone shutter to the right of it. In the window to the left, there are four panels of rectangular-shaped shutters, rectangular boards patching the shutter, and the outline of the entire window itself, as well as each slat in the shutters, are also rectangles. The steps leading to the door add even more rectangles for our mind to process. Our eyes keep moving in the image from the steps to the door to the window, and back again. The rectangular shapes create a visual bridge between the image elements. This gives the image a sense of motion that is strongly reinforced by the similarity of color and texture that the peeling, faded blue shutters provide. The doorframe is the same color of blue, and the blue-green stairs are categorized comfortably in our minds as similar in color. The background color of the wall is a yellow-orange, which is complementary to the blue-green. This gives the image strong contrast, creating drama and dimension. When you look at a color photograph and your eye sees a primary color (in this case, blue) your mind will then look for its complement color (in this case, yellow). Seeing both the primary color and its complementary color together in the image gives this photograph the balance and harmony that our mind's eye is seeking.

figure 1

In this next example of the Gestalt Principle of Similarity, (figure 2) the house in the field has a triangular-shaped roof that resonates with the ridge of mountains behind it. In the foreground, the fence also creates triangular shapes. This repetition of triangles throughout the image keeps the eye moving in and around the photograph.

figure 2

The Principle of Proximity

Another helpful lesson from Gestalt is the Principle of Proximity. The closer two or more visual elements are, the more likely it is that they will be seen as belonging to a pattern or group. In this photo (**figure 3**), the lizard in the crack of the door was peeking out at me. All that is there is its head. However, the "worm hole" lines in the wood, because of their proximity to the head of the lizard, and because their shape resembles a lizard's leg and foot, are seen by the mind's eye as part of the lizard. As your mind organizes the information being seen, you see the lizard with his leg and foot holding onto the wood.

figure 3

So, how do we open the mind's eye? How do we become aware of how our minds work? Learning these Gestalt concepts will greatly improve the way you see and will enable you to actually create a great photograph, not just take one. Here are some suggestions for exercising your creative vision:

Work with Optical and Visual Illusions:
Check out the children's section of your local book-store. There are several great books with exercises to help you sharpen your vision and train your mind to see more clearly.

Purchase or Make a Set of Tangrams:
This ancient seven-piece Chinese puzzle game is a little bit like a jigsaw puzzle. You are given seven geometric shapes with which you must create a pre-determined picture utilizing all seven pieces. There are one or more ways to create each depicted image from the seven game pieces. This forces your mind to look at individual pieces and group them to make a whole picture. If you prefer to make your own tangrams rather than purchase them, photocopy the diagram I have included here and cut out the shapes (**figure 4**). Trace the pieces onto black mat board, then lay the pieces on white paper to create your image. (Of course, you could do just the opposite—white shapes on a black background.)

Strengthen Your Imagination:
Next time you're out in your back yard, sitting in a chair reading or relaxing, put the book down and watch the clouds as you did when you were a child. Use your imagination and find images in those clouds. Stimulate your imagination and use your creative vision.

Visit a Museum:
Don't just study the photographic exhibits; study the paintings, too. See how the masters used color, composition, and perspective. Look at sculpture and study balance and form. Store all this information in your mind. Everything you learn will enter your subconscious and be there for you to call up when you need it. By utilizing these suggestions and internalizing the lessons you learn, you will find that you will see more clearly and quickly through your mind's eye when out in the field.

figure 4
diagram for cutting tangram pieces

figure 4 (example):
picture of a duck

figure 5

Have you ever noticed that when you're preparing to make a purchase, whether it's a new car, new carpet, or a new home, you become very attuned to advertisements, billboards, radio ads, etc., that speak to your field of purchase?

You fill your mind with certain visuals as you pre-plan your purchase, and your sub-conscious mills over your inner desire unbeknownst to your conscious self.

There were no more red Hondas on the road this week than there were the week prior but, suddenly in the market for a red Honda, you see them everywhere! You have that car shape and color in your mind, so you are more attuned to their presence than you would be otherwise. If you prepare your mind to see something, it will.

The same phenomenon happens in the photographic arena. Fill your mind with images of a religious nature and this is all you will see. If you want to photograph in a certain way, fill your mind with similar images by looking at books, exhibits, etc., and your mind will travel in that direction visually when you put your eye to the camera's lens. (When I'm searching for a lost item, I visualize it in my mind. That way, I prepare my mind to see it. It works like a charm!)

Tyrannosaurus on Ice (figure 5)

I had been reading a novel on dinosaurs and happened to have a photo-shoot at a dump the following day (great stuff at dumps). I found this image as soon as I stepped out of the car. It is actually the side of an old truck covered with junk and paint. What I saw, however, was a dinosaur.

Swordfish (figure 6)

I had just spent three hours photo-graphing fish at the aquarium. I opened the door to exit and looked down at the ground to find an anchor. Some leaves had stuck to it and begun to mold and mildew. The brown leaf in the lower right gave me the impression of a fish's tail. My mind was so full of fish shapes that it took the separate elements of the anchor and the leaves and made them into a whole fish.

figure 6

figure 7

The Priest (figure 7)

It was Sunday. I was not in church. While photograph-ing, I was thinking about being in church every Sunday as a child. I came upon a huge rusting metal container about 25 feet high coated with tar. As I walked by, I stopped to examine its side and my mind's eye immediately found a priest giving out communion.

Dancing Gypsies (figure 8)

This is nothing more than paint peeling off of a wall, but it looked so much like two gypsies dancing that I snapped the shot. Three other photographers walked right past and didn't even "hear the music."

Asian Couple (figure 9)

This is just another wall with peeling paint. I was thrilled with this one. Everything about the scene worked. The pale yellows, reds, and greens gave me an Asian feel. As I approached the wall for closer inspection, I saw the couple embracing. It was just there waiting to be photographed.

Angel Over the Moon (figure 10)

I was out photographing and thinking about an image for my Christmas card. As the day went on, I happened upon an antique store with lots of junk outside. I saw an old shack in the back of the store that was all boarded up and covered with moss. When I approached it, I saw the angel on the board that was holding the door closed.

figure 8

figure 9

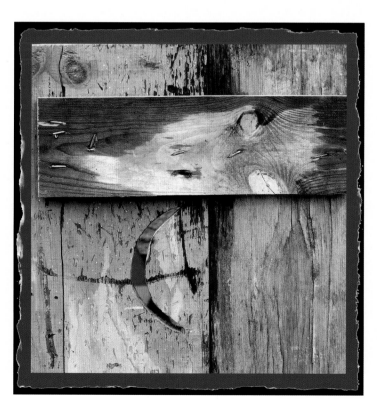

figure 10

Creating An Image

This was once an assignment that I gave out to my students. Of course, before I could ask them to do it, I had to take the challenge myself. I found out that I enjoy this, and have done it many times since, especially when I come up against a creative block that I can't seem to shake. This process stimulates my imagination and exercises the creative side of my brain. There are no wrong ways to do it and you will be surprised at how many times you will come up with an exciting new image that is so far beyond the original you will wonder where it came from. Let your imagination and resourcefulness take over, and have fun!

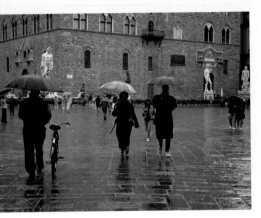

figure 11

Guidelines:

* Choose a photograph that you like.
* Create four variations of that image.

Push your limits! Be as outrageous as you wish. You can paint, draw, collage, and manipulate the image with different softwares. You can crop it any way you wish, even using only a portion of the image to create something different. Each of the four variations should be as unique as possible!

Here are four variations of one print that I came up with using this process:

Rainy Day—Version 1

Step One
This is the original digital photograph taken in Florence, Italy on a very wet day (figure 11).

Step Two
I cropped it in Photoshop and printed it out onto Hahnemühle Japan paper. This lovely, exotic fine art paper is embedded with long white fibers. It is almost like a translucent fabric. I printed the image with an Epson 2000 printer and it turned out a bit too dark.

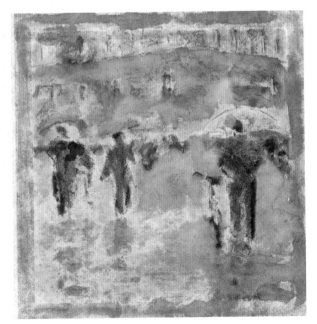

figure 12

Step Three
The paper I used was thin, and the inks were heavy, so I could easily see the image through the back. I decided to turn it over and apply watercolor crayons to the back of the print. These look just like crayons and you use them by dipping them into water or putting them on dry, then using a wetted brush or cotton swab to get a flow of color. The paper soaked up and spread the color, mixing with the ink already entrenched in the fiber. I was delighted with the result! It looked just like a watercolor and fit the image perfectly (figure 12).

Rainy Day—Version 2

Step One
The next version I created was made using watercolor crayons and collage. First, I colored the people walking in the rain with a heavy black, adding a bit of blue and red.

Step Two
Then, I colored the ground with blue and purple and outlined the windows of the building in black. I did all my coloring rather heavily, as I planned to collage the image with paper.

Step Three
Next, I used matte medium as a glue and coated the top half of the print.

Step Four
Then I took a natural-colored paper that had bark inclusions and covered the top half of the area I had coated with matte medium.

Step Five
I used a white paper with fibers running through it for the bottom half of the glued area, leaving the figures uncovered by the papers.

Step Six
Once the matte medium had dried, I painted into the collaged papers using a wash of color (i.e., diluted color, not intense). When it look good to me, I stopped. This version of the Rainy Day image has a different feel to it—more of a wintry, blustery, cold day than my first rendition (figure 13).

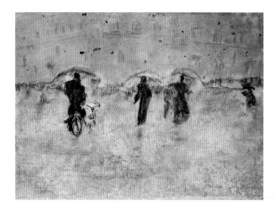

figure 13

figure 13 detail

Rainy Day—Version 3

Step One
I cropped the image quite a bit for this version, selecting a main figure and two others in the background.

Step Two
I did some collage on the image as my next step, cutting out black paper for the figures, then adding an orange paper to the building.

Step Three
Then I outlined the building and the windows with a waterproof, lightfast ink pen.

Step Four
After I was satisfied with this haphazard drawing and collaging, I still wanted to give the image more feeling and less detail. So, I used the matte medium as glue again and laid the white paper with fibers that I had used in the previous version over almost the entire print, tearing out some areas to allow detail to come through. I think this version has more of a lonely feel to it (figure 14).

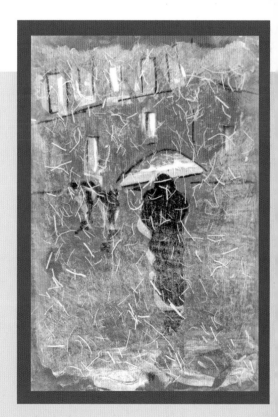

figure 14

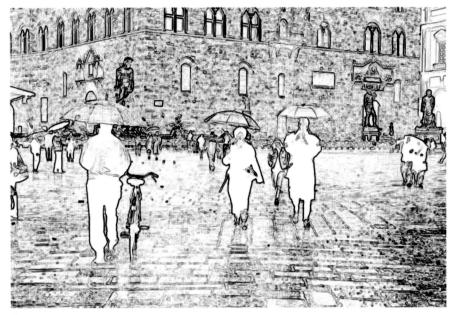

figure 15

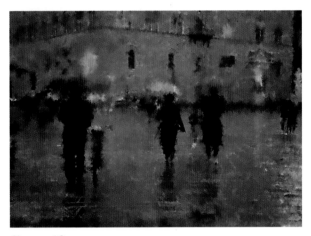

figure 16

Rainy Day—Version 4

Step One
For this final version, I actually created two renditions of the Rainy Day image in Studio Artist and combined them in Photoshop using Layers and the Darken blending mode.

Step Two
This is the sketched rendition I created (figure 15) using the Texture Invert command in Studio Artist (see pages 142-151 for more about Studio Artist).

Step Three
I created the second rendition by selecting Water from the Category drop-down menu and Canvas Diffuser1 from the Patch drop-down menu (in Studio Artist) (figure 16).

Step Four
This is the final combined image (figure 17).

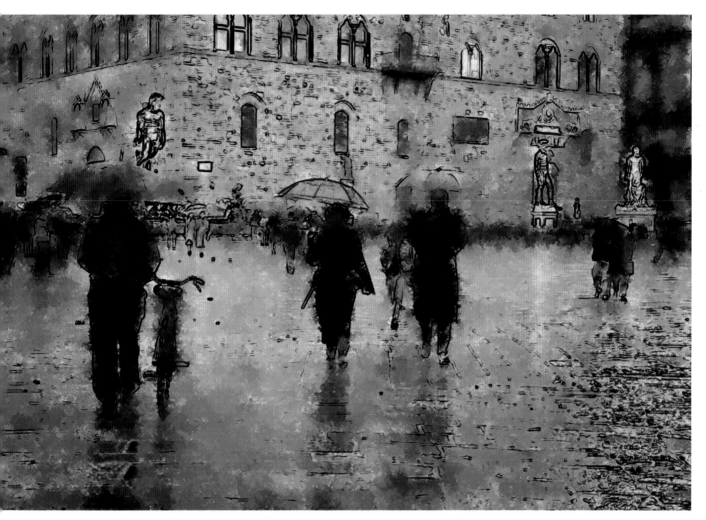

figure 17

Watercolors

Watercolors is an abstract fine art photography series that has followed my transition from film to digital. The series has been a work in progress for seventeen years. It began with photographs I took of objects reflected in the calm waters of my home environment in Bermuda, and has progressed to include photographed reflections from my global wanderings.

Awareness and vision is paramountly important with this series. Without knowing what to look for and then actively seeking it, these reflections would be elusive. The conditions have to be ideal to achieve images like those in this series—great light on the object being reflected, sheltered water, enough motion in the water to create abstract patterns, close proximity to the water, and a harmonious color palette. Water reflections are also technically challenging. The focal lengths I use are usually in excess of 250mm, and the shutter speed must be 1/250 second or faster. To achieve reasonable depth of field, the f/number has to be f/5.6 or higher—I prefer f/8.

When I first started shooting pieces for the *Watercolors* series with digital cameras, noise was a problem and, while there is still some noise in the images, the improvements in technology will soon solve this—I hope! With film, I used ISO 100 speed and pushed it 2 stops. With digital, however, I manually set the shutter speed to 1/250 second and the aperture to f/8. I shoot RAW files and play with Levels in Photoshop to achieve the desired result.

Ian Macdonald-Smith's island home of Bermuda has been a great inspiration since 1987, but he has also traveled extensively, photographing landscapes and architecture. Ian specializes in fine art photography, concentrating on color and composition. He has written several books. In addition, Ian founded three environmental Non-Governmental Organizations (NGOs) to help preservation efforts in Bermuda. He established the Global Archive Foundation in 2002 to be a comprehensive repository of our respective global environments, as well as a free resource for educational and environmental institutions interested in documenting human and environmental change. For more information about Ian and his artwork, please visit his website: www.imacsmith.com.

Ian Macdonald-Smith—*Watercolors*

2

Creative Printmaking

For some photographers their art is in the camera taking the shots; for others, it is in the darkroom or in the computer room, creating, manipulating, and printmaking. I am of the latter group. I consider myself more of an image-maker than a photographer. That is not to say that I do not enjoy photographing, as I very much do. However, my real love is in the darkroom or the computer room making images and prints.

In this chapter, I will illustrate how to use creative softwares to enhance or manipulate photographs into a more painterly or artistic interpretation of the straight shot. I will also provide examples of art pieces that I scanned and manipulated. With third party softwares—such as Photo/Graphic Edges and Mystical Lighting by Auto FX Software, nik Color Efex Pro and nik Sharpener Pro by nik multimedia, Inc., and Studio Artist by Synthetik Software, Inc.—in conjunction with Photoshop, I can create thousands of variations from just one shot.

The possibilities are virtually endless! All it takes is imagination, a willingness to allow yourself to make mistakes, and of course, the time to play.

✳✳✳✳✳✳✳✳✳✳✳✳✳✳✳✳✳✳✳✳✳✳✳✳✳✳
✳✳✳✳✳✳✳✳✳✳✳✳✳✳✳✳✳✳✳✳✳✳✳✳✳✳

Man Walking on the Beach

Step One

This is the original shot of the man walking on the beach (figure 1).

Step Two

Here, I combined the original photo with a shot of a deteriorating wall. The textured wall was layered in using Photoshop. I used the opacity slider to get it to the degree where I liked it. The texture of the wall seemed to impart a feeling that was missing from the original photo (figure 2).

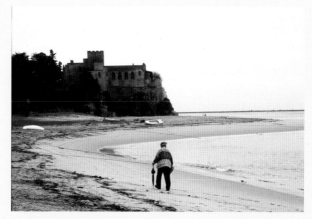

figure 1

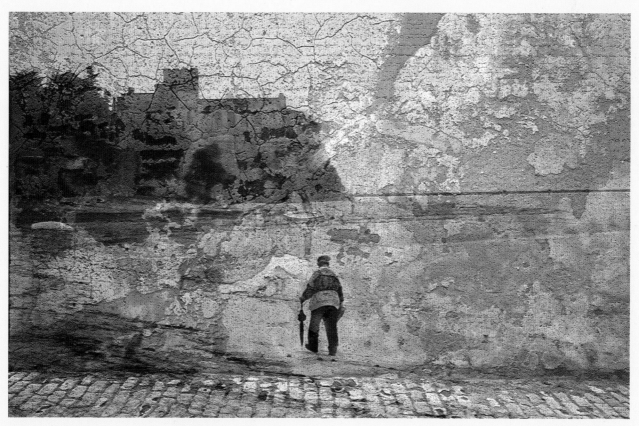

figure 2

figure 3

Step Three

I then opened the flattened, layered image from step two in the Auto FX Photo/Graphic Edges program and applied the edge found in Volume 7, #779. It automatically splits the image into three rectangles (figure 3).

Step Four

This is the final image (figure 4). I created a new file (with the same resolution) containing a background of dark blue with a light blue border using the textures found in Photo/Graphic Edges, then used the program to create the ruffled edges. I dragged the image from step three over the background I created and flattened the image again.

Note: The Auto FX Photo/Graphic Edges program contains 14 unique photo-graphic effects, including over 10,000 edges, and can function both as an independent image-processing program and as a plug-in for Photoshop, Elements, Paint Shop Pro, and Corel Draw.

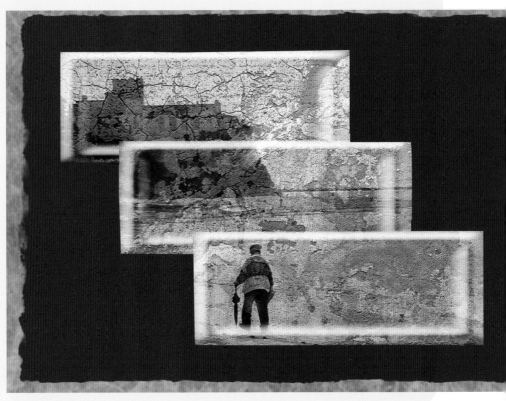

figure 4

Statues in God Beams

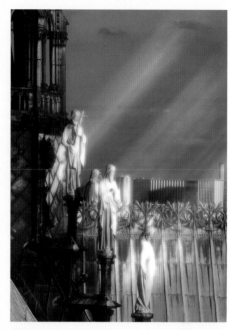

figure 5

Step One

I added the beams of light to this image using the Auto FX Mystical Lighting program. I also used the program to add a bit of light flare to the statues themselves (figure 5).

Note: Auto FX's Mystical Lighting program enables computer application of photo-realistic lighting and shading effects to digital images. It is comprised of 16 distinct visual effects, and more than 400 presets that combine these various effects for instantaneous results in a wide variety of different looks.

Step Two

In this version of the image, I used nik Color Efex Pro to transform the color image into a full-tonal black-and-white image, then added the light beams using the Auto FX Mystical Lighting program. The extra light flare I added to the statues gave the image a pseudo infrared look (figure 6).

Note: For more about digital infrared, see pages 102-115.

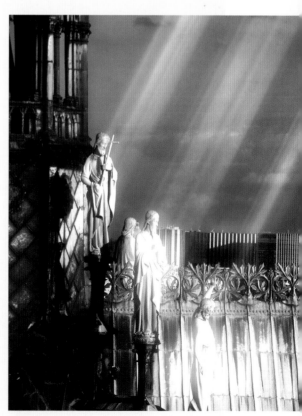

figure 6

Vincent van Gogh Café

figure 7

figure 8

Step One
This is the original image, taken with slide film (figure 7). I had always wanted to see the Vincent van Gogh Café in Arles. It was high noon when I got to Arles and the café was packed with tourists. I was so disappointed. I took one shot and left. Later, at home on the computer, I decided to create what I had so wanted to see.

Step Two
I made a starry sky by opening a deep blue background and cloning in white circles with different sized brushes, using a soft-edged brush to give the glowing star effect (figure 8).

Step Three
After selecting the sky in the original image, I layered the starry sky I had created onto that selected area.

Step Four
Then, I opened the image up in Studio Artist and manipulated the tree with the paint patch Wet Mixer. By selectively applying the Wet Mixer effect more subtly in different areas, I was able to give the image an overall painterly look.

Step Five
Lastly, I darkened the shaded area where the tourists were sitting. This is the final result (figure 9).

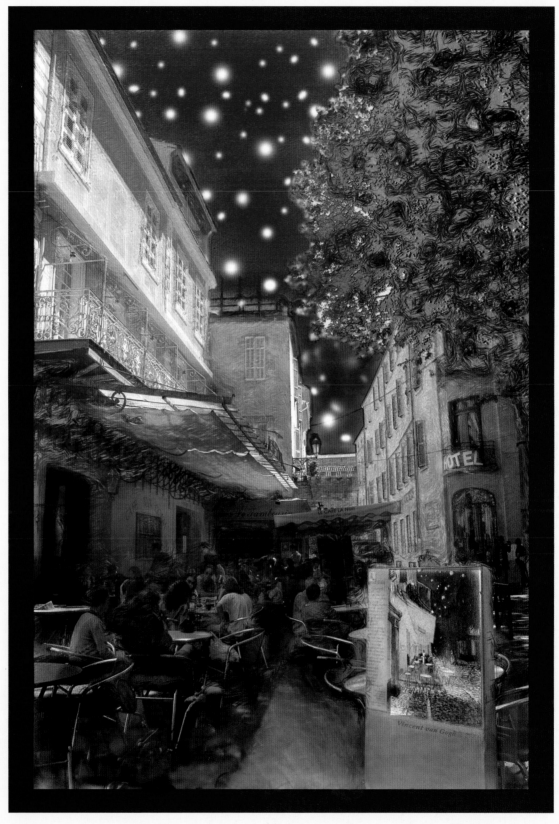

figure 9

figure 10

figure 11

Leap of Faith

Step One
This original image was a reflection of the Bermuda Cathedral in the third floor window across the street. As I walked by, the shapes became twisted and distorted and I saw a man and woman dancing in the warped reflection (figure 10).

Step Two
I printed the image out onto Fabriano Classico 5, 140 lbs., cold-pressed watercolor paper, then selectively colored it with pastel pencils. I felt it still needed something, so I collaged in the figure of a man leaping and added more color (figure 11).

The Vision

Step One
The original piece was created using collaged artifacts and heavy paint (figure 12). Even though it was very abstract, I felt it had the feeling of turbulent water crashing onto rocks.

Step Two
I scanned this piece, then layered two different shots on top of it in Photoshop, blending them with the Layer modes (figure 13). The figure in the bottom left corner was added, and the two dancing figures in the upper right. Both of these images were black and white infrared files (in the RGB mode).

figure 12

figure 13

figure 14

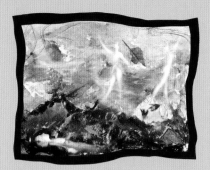

figure 15

Step Three

I then put a blue canvas border around the image and opened it in the Auto FX Photo/Graphic Edges program. In the program window there is a bar called Layer Presets. I opened it by double clicking on the Layer Presets bar, which brought up the Preset window. I then scrolled down and selected Transfers. When the Transfers window opened, I selected the effect I wished from the examples by highlighting it and clicking OK (figure 14).

Step Four

The transfer was applied immediately when I selected the preset, giving me a genuine wet Polaroid emulsion transfer look. Once the transfer preset has been applied to your image, you have controls available that allow you to add more wrinkling where you wish it, or "iron out" existing wrinkles.

Step Five

I printed out the transfer version of the piece, which I entitled, *The Vision*, but didn't like the off-white textured background that came with the transfer (figure 15).

Step Six

I selected the background around the blue border with the Magic Wand tool in Photoshop, then held down the Option key (for Macintosh; Alt key for PC) on my keyboard and hit Delete. This gave me a plain white background around the transfer that I found more pleasing (figure 16).

Note: Whatever color your foreground square is (in the toolbox) will fill in the selected area when you hit the Option/Alt and Delete keys. You can reduce the color with the Edit/Fade button.

figure 16

Printing with Unusual Substrates

The most wonderful thing about ink jet printing is the selection of substrates from which you can choose. You can print onto all types of papers, from rough to smooth, and anything in-between. You can also print on various types of fabric, some made for ink jet printing, some not. I like "marrying" an image with a paper or fabric that enriches the overall finished product. If you choose to print on a surface that is not treated for ink jet printing, you can purchase a product called inkAID and give just about any material an ink jet pre-coating that will enable you to print an image on it using your desktop printer.

Unique Papers

Sometimes all that an image needs to take it into the realm of fine art is to be printed on the right paper. This image, *Annie's Back* (figure 17), would look okay printed on glossy ink jet paper, but printing it on a rich, sensual paper takes it to another level. I chose Hiromi Peacock Buff paper to accentuate the richness of the lines and to draw attention to the subtleties of the image. I also chose this paper in order to impart a color to my black-and-white, sketch-like image. The Peacock paper comes in Rose as well as Buff. The Peacock Rose has more pink tones; both have a silky mother of pearl finish that changes in the light, adding a wonderful high-light and glow to the image. (It is similar to Inomachi, which is a very expensive Japanese paper. Inomachi actually means "mother of pearl.") Hiromi Peacock papers do not have a heavy ink jet coating and the inks tend to sink in, which causes a muting of the colors. For this reason, I use this lovely paper with brown-toned or black-and-white images only. Unfortunately, the print shown here cannot adequately show the unique qualities of this beautiful paper (figure 18).

Another paper that I like printing black-and-white nudes on is Hiromi MM-2 Kozo-Shi. This paper is very thin and translucent, imparting a delicate, sensual feel. Hiromi carries a great selection of unique and distinctive papers for the fine art printer, all of which are 100% acid free and archival. I would suggest getting the digital paper sample pack and trying them out.

figure 18
detail

Annie's Back

Step One
This is the manipulated image I created by combining a sketch and a black-and-white image in Photoshop. I then added Gaussian Blur (figure 17).

Step Two
This is the same image printed on the lovely Peacock Buff paper (figure 18).

figure 17

figure 18

Big Grouper

Step One
I painted *Big Grouper* using dry watercolor pencils and a wetted cotton swab to spread the color (figure 19).

Step Two
Once the print was dry, I went back and added highlights with Jo Sonja's Pearl White iridescent gouache paint #002 (figure 20).

Step Three
This is a close-up of the painted surface. I like the texture and the feeling that the paper and the watercolor paints added to the image (figure 21).

figure 19

figure 20

figure 21

figure 22

figure 23

Fishes

Step One

Fishes was printed on Hahnemühle Japan paper.
This is a very unusual paper that is more like a fabric.
It has a lovely texture with embedded white fibers.
I especially like the way it absorbs watercolor paint.
The piece was painted with watercolor pencils.
I colored the printed image dry and then, with a wet
cotton swab, I spread the color. Look at the backside
of the Japan paper (figure 22). You can see how the
color absorbs into the paper and spreads out. I liked
this quality, as it created a watercolor look that suited
the image perfectly.

Step Two

This close-up view of the piece shows the
unique quality of the paper and the painted surface
(figure 23).

Step Three

This is the final watercolored digital print (figure 24).

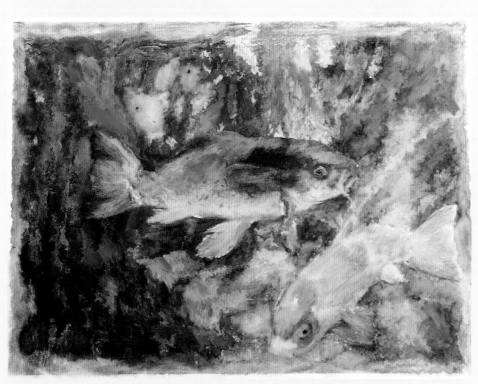

figure 24

Ink Jet Fabrics

Jacquard has come out with a great line of fabrics to use in ink jet printing. They come in silk and cotton. I've washed both the silk and cotton with my normal clothes using cold water and the dyes have held up for over four washings. The silk is especially beautiful, and is much silkier than the Pictorico brand, which actually has the feel and look of heavy polyester. Jacquard silk is soft and transparent. You can paint on both the cotton and the silk with Jacquard Green Label Silk Colors. These paints do not make the silk or cotton stiff and they have a great selection of colors.

figure 25

Flowers

This piece was printed on Jacquard silk. It looks lovely in a cradled frame or a shadow box frame with a light behind it. It just seems to glow. I used Auto FX Photo/Graphic Edges (specifically, Volume 1, AF077AFX) to create the ragged edges in the printed image (figure 25).

figure 26

Fountain in St. Remy

I used Jacquard silk for this piece, too. I slid a bright orange paper under the silk to demonstrate how translucent the fabric is. Whatever color you lay under it, the image will pick up those tones and colors, especially in the light areas (figure 26).

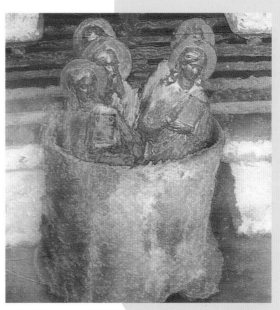

figure 27

Saints in a Pot

This image was printed on cotton ink jet paper. It is more opaque than the silk, giving the image a more solid look and feel. I imagine that quilters and seamstress would enjoy sewing with this fabric and incorporating photographs into clothing, wall hangings, and quilts (figure 27).

Heaven and Hell

I was asked to create an image for a show entitled *Heaven and Hell* at a Seattle art gallery. I had just returned from a trip to Europe, with its powerful cultural and religious imagery still fresh in my mind and in my dreams. The image I created is a toned digital collage made from four color photographs I took during that trip.

Step One
I began by doing a rudimentary sketch of some ideas to consider. Sketches help me focus on ideas and composition rather than the complexities of the digital process.

Step Two
After making a 360 ppi master file, I began by importing and cropping a portion of the sky image to use as a moody background.

Step Three
I then opened the archway photograph, masked away the background and doors, added contrast, and used the Burn and Dodge tools to selectively add modeling.

Step Four
Next, I added a layer with the photograph of the wall of skulls, selectively retouching and masking away the unwanted parts in a basic manner to be refined later.

Step Five
Finally came the cross image and a black background I used as a bottom layer that all others would fade into.

Step Six
Each layer was carefully retouched and transformed to fit cleanly with the others. Each was also given a clipped Curves layer to fine-tune it's tonalities, as well as Channel Mixer and Color Balance adjustment layers to reduce the original colors to a richly-toned brown, referencing the classic Van Dyke darkroom process. Many of the original birds were then retouched out to simplify the composition.

Step Seven
I then added a scanned rebate edge from a black-and-white darkroom print I made in the '80s, as well as a vignette layer of black using the Airbrush tool set to Multiply mode. Selective use of the Blur and Burn tools was also used for a vintage effect.

Step Eight
Above all the layers, I added a selective color adjustment layer to tweak the overall color. The resulting flattened file printed in a rich Umber brown on heavy Somerset Velvet paper, hand-deckled, with patina along the edges from pastel pigment embedded in cotton cloth. The print was floated on black in a vintage Gothic frame to emphasize the power of this theme.

David Julian holds a BFA from Pratt Institute (New York) and is a widely-published photographer, illustrator, and mixed-media artist. Over the past 23 years, he has created art for galleries and private collectors, as well as for nationwide clients. He has also been featured in various arts publications.

Using traditional and digital processes interchangeably, he is always pushing the creative and conceptual envelope in his work. David's life-long passion for science influences his artistic expression, allowing his art to blend the subtle beauty of the natural world with his vivid, dream-like imagination. He also teaches creative workshops and enjoys helping others develop the ability to reach their artistic goals. When not immersed in his studio filled with vintage devices, curiosities, and other wonderful distractions, he travels for renewed inspiration. For more information, visit www.davidjulian.com.

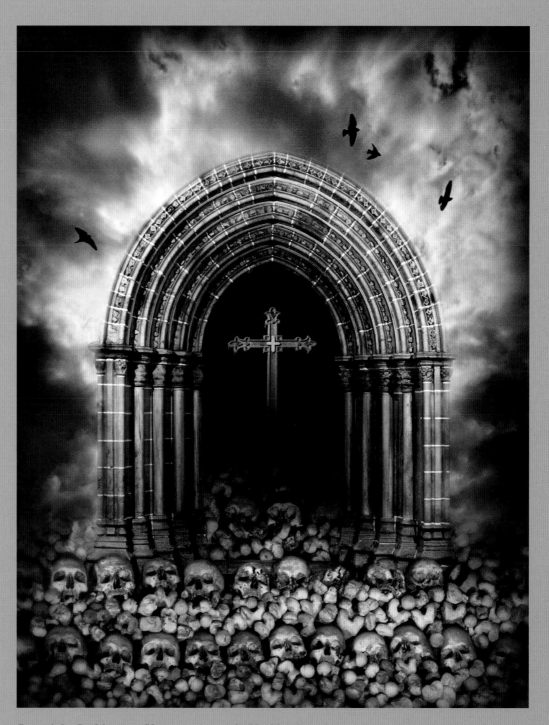

David Julian—*Heaven and Hell*

3

Digital Image
Transfers

Digital image transfer is the technique of transferring a digital image from its printed surface to another substrate such as wood, metal, glass, canvas, or paper. In this chapter, we will cover creating digital transfers from prints made on various types of Lazertran materials, as well as transfers from inkAID-coated substrates.

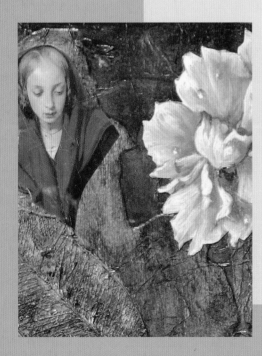

Lazertran Transfers

There are three different kinds of Lazertran available for use in creating image transfers:

❋ **Lazertran:** Regular Lazertran is only for use with a color photocopier machine. It will not work with ink jet printers. It is a waterslide transfer paper. The image is actually printed onto a clear film of acrylic. Just photocopy an image onto the Lazertran and then soak it in hot water. After a few seconds, the image slides off of the backing as a transparent decal. These decals can be applied to almost any surface—wood, stone, paper, fabric, etc. You can glue the decals to your substrate surface using craft glue. On rough surfaces, such as wood, stone, or paper, use turpentine to soak into the surface a bit before applying the decal. With glass or ceramic transfers, the transfer must be placed, then the substrate (with the transfer on it) must be heated in an oven. When transferring to fabric, place the decal and iron it on.

❋ **Lazertran Inkjet:** This is also a waterslide transfer paper, but it is made to be used with ink jet desktop printers. It will not work with color copiers. These decals can be transferred to just about any surface, including paper, stone, and wood. Like regular Lazertran, it can also be baked onto ceramics. Lazertran Inkjet is not good for transferring onto fabric.

❋ **Lazertran Silk:** This a silk surface with a paper backing that peels off. Lazertran Silk can only be printed on with color photocopier machines. Once you've printed out your image, it can be transferred to fine fabrics, such as silk or satin, with a hot iron. It fuses with the material onto which it is transferred without making the material stiff where it is applied. With metal sheets, iron the Lazertran Silk onto the surface and then soak it in water and peel away the backing. When transferring to polymer clay, all you need to do is place the image and the clay will absorb the inks. To transfer to paper, spray the paper substrate with a spray adhesive, then lay the Lazertran Silk on top of the sprayed paper. Brush the backing of the Lazertran Silk with water and leave it to soak for a few minutes, then peel away the backing.

Note: Remember to varnish the final image transfer. Lazertran recommends Plasti-kote Fast Dry Enamel. I use Krylon Crystal Clear spray and it seems to work just fine, but other brands of acrylic spray might do just as well. The important thing is not to spray too heavily. It is better to give the finished piece two or more very light coats of spray so as not to damage the decal.

Note: When placing any Lazertran transfer (regular, Inkjet, or Silk) onto your chosen substrate, be sure to lay it face down against the substrate surface. As with all transfers, the image must be printed in reverse in order for the transfer to end up correctly oriented.

When printing on regular Lazertran or Lazertran Silk, you should print your image darker than normal (i.e., with more ink). However, this is not the case with Lazertran Inkjet. Use less ink when making a print onto Lazertran Inkjet, as the inks have a tendency to spread out upon transfer-ring (use the Glossy paper setting on your printer if available).

Caution: *When printing with ink jet inks, do not over ink the Lazertran Inkjet paper. I use the Glossy paper setting on my Epson 2200 and this works fine. If too much ink is used, it tends to spread out when transferred.*

Lazertran Inkjet Waterslide Decals

Always something new! Lazertran Inkjet is an exciting new product for digital artists. This waterslide decal paper is the latest fun and easy way to make image transfers without the expensive and time consuming procedure of buying film, getting correct exposures, and needing an enlarger or slide printer to have at your disposal. The end result of this new, digital process looks the same as the original Polaroid emulsion transfer technique!

The instructions below are the five steps involved in a basic Lazertran Inkjet transfer (not for regular Lazertran or Lazertran Silk). Subsequent to these instructions, I have provided more detail with regard to transferring onto specific substrates. In addition to the substrates detailed below, Lazertran Inkjet (as well as regular Lazertran) can be transferred onto ceramic surfaces.

Step One
Select your image and prepare it in the computer.

Step Two
Once you have your image ready, print it onto the white, matte front side of the Lazertran Inkjet stock with an ink jet printer. Be sure to check the Glossy, or Film, setting in your printer's dialog box. You don't want too much ink on your decal, and these settings will lessen the ink output.

Caution: Always print on the front! The back side is a pale greenish-blue color, but it's hard to see under tungsten lights so, during daylight hours, mark the back of the Lazertran Inkjet with a "B" or an "X." Then, if you decide to print in the evening, you will easily be able to recognize which is the back side (or the wrong side) of the stock.

Note: You don't necessarily have to use the entire image for your transfer. You can choose to cut out a selected portion of the image to soak and use.

Step Three
After printing, let the print dry thoroughly (for at least one hour) to give the inks time to become waterproof.

Step Four
When the print is dry, soak it in hot water—not boiling, just hot. (It will also work in cool water, but the paper tends to curl as it dries.)

Note: Lazertran Inkjet cannot be used on cloth. (Refer to page 69 to see which type of Lazertran is appropriate for your cloth substrate of choice.)

Step Five

Upon soaking, the print will slide off of the paper backing. Gently drip the excess water off of the decal and place it onto your substrate surface. Then, you can press the transfer down gently and push out any air bubbles that may have been caught underneath. If the surface is rough, however, as with certain stone substrates, you may tear the decal if you try to smooth out air bubbles. In this case, it is better to make a pin hole and gently press the air out. For a more creative approach, you can choose to tear, fold, or break off the edges of the transfer. This causes a more distressed look, which in some cases may suit the image better than a pristine, straight edge. It all depends on the image and the artist.

Step Six

If you wish the decal to be transparent, you can now apply a coat of varnish on the decal and let it dry. Or, you can selectively coat with an acrylic matte medium to keep chosen areas white, and then coat with varnish to make the rest of the background transparent. The transfer will take about an hour to dry.

Step Seven

When it has thoroughly dried, it is a good idea to spray the transfer with either an acrylic spray, such as Krylon Crystal Clear, or give the finished work a thin coat of varnish to protect it.

Note: If you apply a coat of polyurethane clear gloss or oil-based varnish to the Lazertran Inkjet image before soaking it in hot water, the background of the image (wherever it is white) will be transparent (see page 82 for more information).

Paper Transfers

Step One

Prepare and print your image, being sure to allow proper drying time (detailed in Steps One through Three of the Lazertran Inkjet Waterslide Decals section—see page 64).

Step Two

When using watercolor papers, especially the lighter weight ones (90 lbs or 140 lbs), you should stretch your paper so that you will not get cockling (ripples or buckling) when applying or working with a wet medium. (This is necessary for some printmaking papers, as well.)

To stretch your paper:

✤ Soak your paper in a tub of water. Lighter paper should soak for 3 – 4 minutes; more heavily sized paper will take from 7 – 10 minutes, and heavy paper (300 lbs) will take around 20 minutes.

✤ Lay a thick towel on the counter and place the soaked paper down on one side of the towel. Then, take the other half of the towel and fold it over the wet paper. Blot out the excess moisture by lightly rubbing your hands over the towel, pressing down slightly.

✤ Now take the paper and lay it on a clean wooden board. Before taping it down, remove any remaining excess water with a clean sponge (not the sponge you use to wash your dishes or household surfaces) and dry out the edges of the paper where the tape will go with a paper towel.

✤ Pull out a piece of brown packaging tape (the kind with a gummed backing that you need to wet) that is longer than the longest side of your paper by at least two inches. Wet the tape with a damp sponge and place it half on the paper and half on the board, beginning with the two longer sides of the paper.

✤ Do the same for the two shorter sides, being sure that the piece of tape you use is at least two inches longer than the side to which it will be applied.

> *Note:* If the taping process is more than you feel like dealing with, you could purchase some plastic gripper rods (at your local arts and crafts store or through an artist materials catalogue). These rods are pushed into grooves in the edges of the board to hold the paper while it dries. Or, you could skip the whole stretching process altogether and buy art board that already has the paper adhered to it.

✤ Now, leave the paper to dry naturally. Do not try to dry it out with a hair dryer or lamp.

Note: Sizing is a material, such as glue, rosin, gelatin, or starch that is added to the paper to make it more resistant to liquid. A paper can be internally sized, surface sized, or tub sized. It can be lightly sized or heavily sized. When a paper has no sizing, it is called waterleaf paper. It is wise to know your paper's properties before working with it. Generally, watercolor papers are sized and print-making papers are not. However, some printmaking papers are lightly sized. Find out the details of your chosen paper substrate before using it for this transfer technique.

Step Three

When the paper is dry, brush a thin coat of acrylic matte medium onto the surface.

Step Four

Place your decal in hot water for a few seconds and, as you lift it back out, shake off the excess water.

Step Five

Position the decal and, when you are satisfied with the image placement, give it a topcoat of diluted acrylic matte medium and let it dry (the milky white matte medium will dry clear).

Note: I mix a bit of water with the acrylic matte medium—just enough to make it thinner and more like water. The mixture is probably about one part water to two parts acrylic matte medium.

Remember that, if you wish your decal to have a transparent background, you must coat the decal with varnish and allow it to dry before putting it in the hot water.

Watercolor paper (also called artist paper) is categorized in three ways: hot pressed, cold pressed, and rough. When paper pulp is formed into paper sheets, the sheets are run through rollers to press them flat. With hot pressed papers (HP), the rollers are smooth and hot; the paper comes out very smooth, with little or no texture. With cold pressed papers (CP), the paper sheets are run through cold, slightly textured rollers; the paper comes out with a slight "tooth," or texture to the surface. With rough paper (R), the sheets are run through cold, very deeply textured rollers; the paper comes out with pronounced texture and the surface is very rough.

Hint: You can buy sample packets of papers from art supply stores and catalogues.

Note: These textures are not uniform from one paper manufacturer to another, so you should examine the paper before you buy it if you can.

figure 1

I had no idea what I would ever do with this paper (figure 1) as it has such a deep, textured imprint. However, when I started to look for a paper to use with my two images, *Mermaid* and *The Grouper*, the heavily textured paper seemed like the perfect choice. Its texture has a watery feeling that corresponds with these images. Lazertran Inkjet transfers sink into paper substrates as they dry, which I also thought would work in favor of the watery feeling I was going for.

Mermaid

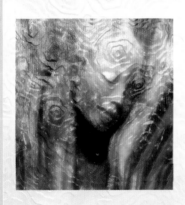

figure 2

I printed this image onto Lazertran Inkjet, then transferred it onto the heavily textured paper. I coated the decal with acrylic matte medium before the transfer to affix the image to the paper, and again after the transfer as a topcoat (figure 2).

I also created an additional digital image from the *Mermaid* transfer. I scanned the textured paper transfer into my computer, then adjusted the tones in Photoshop using Color Balance. The green and gold really added more to the watery effect. Using Photoshop, you can change the color to any hue that you desire! (figure 3)

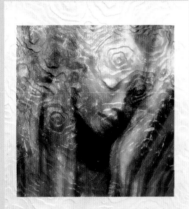

figure 3

The Grouper

After printing *The Grouper* onto Lazertran Inkjet and transferring it to the heavily textured paper (again using acrylic matte medium to coat the decal both before and after the transfer), the figure of the fish sunk into the paper and I was very pleased with this effect (figure 4).

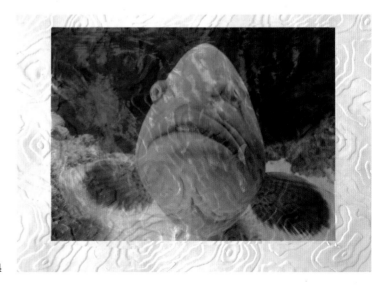

figure 4

Lazertran Quick Reference Guide

Wondering which Lazertran product works best with your chosen substrate? (Be sure to check out their website—www.lazertran.com—for more information.)

Lazertran

✳ Candle (decal is placed directly onto candle)

✳ Glass and ceramics (transfer is baked on)

✳ Heavier cloths and fabrics (transfer is ironed on)

✳ Metal (transfer is baked on)

✳ Paper (decal is placed directly onto paper)

✳ Plaster (prime first with acrylic medium or turpentine)

✳ Stone (prime first with turpentine)

✳ Wood (seal first with acrylic medium, turpentine, or varnish)

Lazertran Inkjet

✳ Candle (decal is placed directly onto candle)

✳ Ceramics (transfer is baked on)

✳ Paper (decal is placed directly onto paper)

✳ Plaster (prime first with acrylic medium or turpentine)

✳ Stone (prime first with turpentine)

✳ Tile (if porous, prime first with turpentine)

✳ Wood (seal first with acrylic medium, turpentine, or varnish)

Lazertran Silk

✳ Fine fabrics—i.e., silk and satin (transfer is ironed on)

✳ Metal (transfer is ironed on then soaked in water)

✳ Paper (use spray adhesive to mount decal onto paper, then soak backing off in water)

✳ Polymer clay (place the decal and the clay absorbs the ink)

✳ Wax (pour melted wax onto the printed side of the transfer image)

Transferring to Wood, Stone, Plaster, Marble, or Cork

Hint: To achieve a very old, deteriorated look to your wood, stone, plaster, marble, or cork transfer, follow Steps One, Three, and Four (skipping Step Two). Then, for Step Five, position your decal and apply a liberal amount of straight turpentine (instead of the 50/50 mix you would have prepared in Step Two) and let the decal soak it in for a few minutes. The decal becomes very brittle and you can pick at the edges and pull away some of the image.

If you're using a particularly rough-textured stone as your substrate, coat the stone with turpentine and place the transfer on the top as you normally would (again, skipping Step Two—you won't need the 50/50 mix). For Step Five, coat the transfer with straight turpentine and let it sit overnight. The turpentine will actually suck the transfer down into the grooves and texture of the stone, completely integrating the image with the stone's surface.

When transferring to any of these substrates:

Step One
Prepare and print your image, being sure to allow proper drying time (detailed in Steps One through Three of the Lazertran Inkjet Waterslide Decals section on page 64).

Step Two
While your print is drying, prepare a mix that is 50% oil-based varnish and 50% turpentine. Set this mix aside for use in Step Five.

Step Three
Paint the wood, stone, plaster, marble, or cork surface with real turpentine, not a turpentine substitute.

Step Four
Soak the Lazertran Inkjet decal in hot water and drip off any excess.

Step Five
Place the decal on the turpentine soaked substrate surface, blot off the excess water, then immediately apply an even coat of the mix you prepared in Step Two and allow it to dry completely. You will know the transfer is dry when it is no longer tacky to the touch. Drying times will vary, depending on how damp the weather is that day—it dries faster in drier weather. You can expect it to take about an hour.

Note: If you apply a coat of straight varnish in Step Five (not the mix), it will make the background of the image transparent (see page 82 for more information).

Caution: If you wait until the decal is partially dry before coating it with the varnish mixture, the decal will be easily brushed away from your substrate when applying the mix. You must apply it immediately, while the decal is still wet, or wait until the transfer has dried completely.

Golden Buddha

Step One
This is my original Golden Buddha image printed onto Lazertran Inkjet paper (figure 5).

Step Two
Here, you can see the Lazertran print soaking in water and the piece of grey slate to be used as a substrate (figure 6).

Step Three
This image shows the Buddha after it has been transferred onto the slate. Note how the image conformed to the stone. I picked off the edges to give the image a more time-worn look (figure 7).

Caution: Remember to wear gloves if you use your fingers to break away the transfer edges that are soaked in turpentine, and work in a well-ventilated room. You can also use a wooden pick to work at the edges instead of using your fingers.

Step Four
The last step was to spray the transferred image with Krylon Crystal Clear. This spray protects the image from chipping and fading. You can choose a glossy or matte spray, and you can also brush on a varnish if you like.

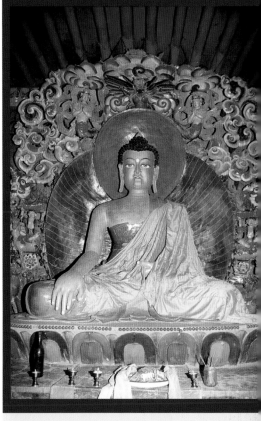

figure 5

figure 6

figure 7

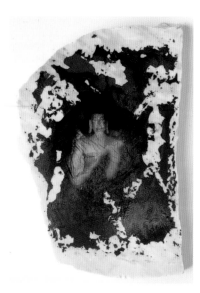

figure 8

Cosmic Buddha

Step One
For my *Cosmic Buddha* image, I took the original *Golden Buddha* shot and used Layers in Photoshop to create the feeling I desired for this version (figure 8).

Step Two
I then printed the *Cosmic Buddha* on Lazertran Inkjet paper and soaked it in water. The piece of white marble was the substrate I chose for use with this image (figure 9).

Step Three
This is the result of the transfer. Again, I picked off the edges for a more worn look (figure 10).

Step Four
Then, I used iridescent gouache paints to enhance the image, and attached a leaf using a coat of acrylic matte medium on the surface of the transfer, then another coat on top of the leaf. I sprayed the final piece with Krylon Crystal Clear final fixative (figure 11).

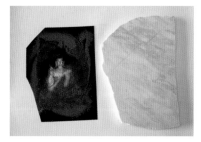

figure 9

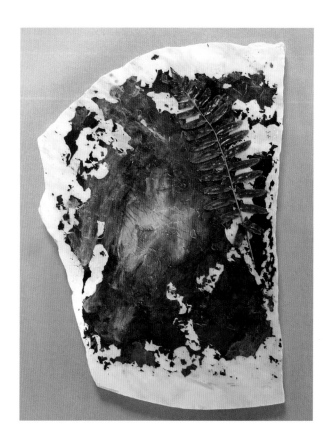

figure 11

figure 10

Time Continuum—Created from the Time Keeper Transfer

Sometimes an image is created and completed quite simply, while other times it just keeps growing and transforming the more you work with it. The following is a perfect example. I used the computer to combine digital photos into one image, printed it onto Lazertran Inkjet paper, transferred the image to marble, and then scanned the marble transfer back into the computer. Once that altered image was back in Photoshop, I was free to play with it all over again, using filters and/or combining it with other images. If you are willing to take the risk of wasting time and effort, you will more often than not come up with very unique work. Of course, there is always the chance of ending up with a disaster and hours of wasted time but, if you enjoy the process, it is worth taking the risk—even if you end up throwing the image away. I just chalk it up to a learning experience. Nothing ventured, nothing gained, right?

My piece, *Time Continuum*, grew out of the marble transfer piece called *Time Keeper* that I had previously created. These next steps and their corresponding images depict the transformation of *Time Keeper* that led to the birth of the *Time Continuum* piece.

Here is the final *Time Keeper* piece transferred onto marble (figure 12).

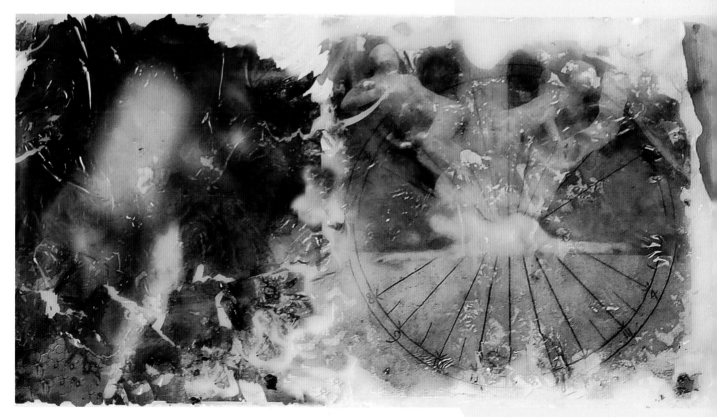

figure 12

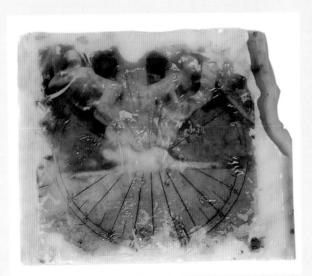

figure 13

Step One

I scanned *Time Keeper* into the computer and decided to crop out the Gargoyle image on the left side (figure 13).

Step Two

Next, I cropped the image even further and inverted it, using various filters (Curves, Find Edges, etc.) in Photoshop to create a variety of effects. As I created each new look, I saved it and pasted it onto a new document. I ended up with six versions of the same image on one page (figure 14).

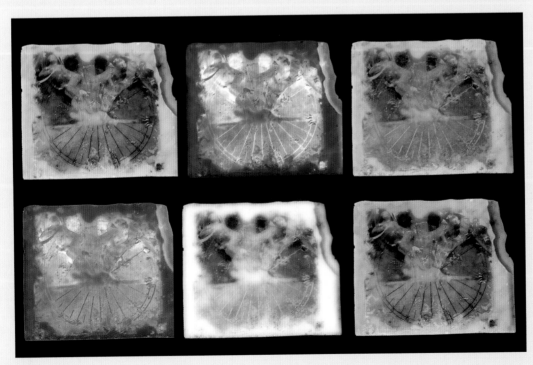

figure 14

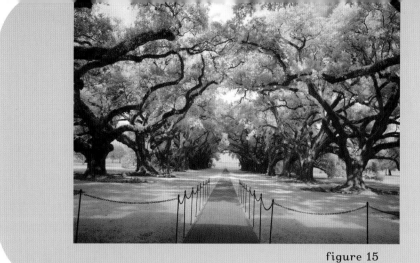

figure 15

Step Three

I didn't feel that the six images were integrated enough, so I overlaid this digital infrared image of oak trees (shot with a Minolta DiMAGE 7) on top of the file (figure 15).

Step Four

Then I used the Pin Light blending mode in the Photoshop Layers window to bring the images together (figure 16).

Step Five

Next, I went into the Auto FX Photo/Graphic Edges software and selected Burned Edge. I liked the look, but wanted to explore other options (figure 17).

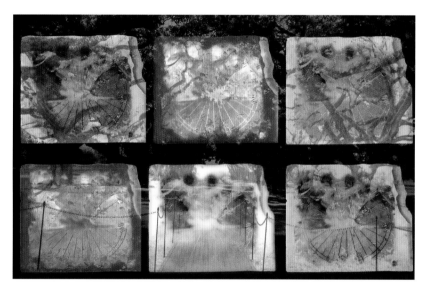

figure 16

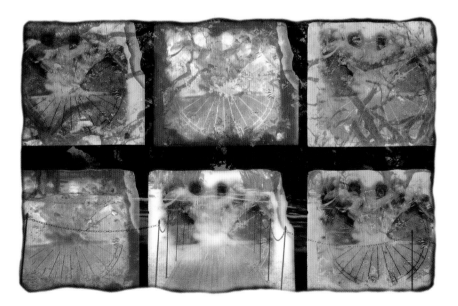

figure 17

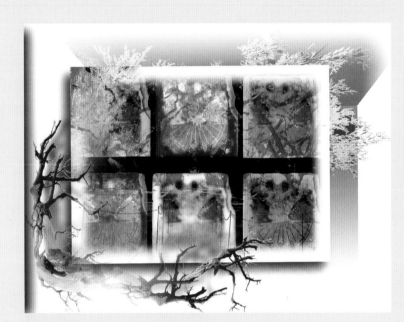

figure 18

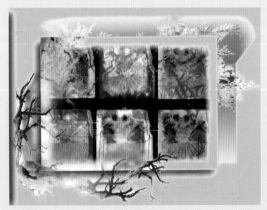

figure 19

Step Six

I went back to the saved six-image file (always save your work at each stage!), and used Photo/Graphic Edges to select a frame that suited the image. I liked the frame that I applied, and have printed this out as a final image, but I felt like all the negative space (white space) around the image could use some work so I decided to experiment even further (figure 18).

Step Seven

I clicked on the foreground icon in the toolbox and selected a turquoise color from part of my image with the Eyedropper. Next, I used the Magic Wand tool to selected the white areas that I wanted to fill with the turquoise color. Before filling, I went to Select in the Photoshop menu bar and scrolled down to Feather. I feathered the selection by 8 pixels. Holding down the Option key on my Macintosh keyboard then hitting Delete (or hold down the Alt key and hit Delete if using a PC) filled the selected space with my chosen foreground color (figure 19).

Step Eight

I still wasn't satisfied with the result and, just before giving up on the project, I hit Command/Cntrl I, which inverted the entire image. I was pleasantly surprised with the resulting color and cohesiveness and decided that this was the finished look I had been trying for (figure 20).

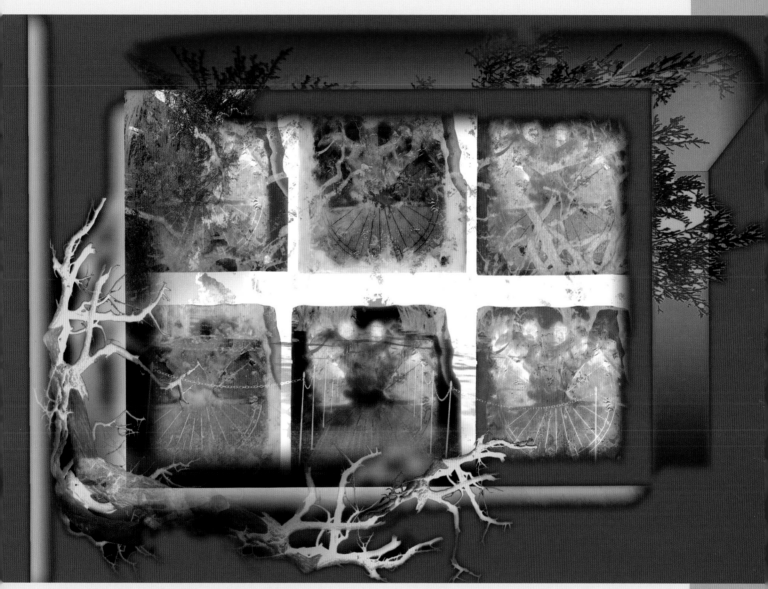

figure 20

Plaster of Paris Transfers

For a fresco-type image, try doing a Lazertran Inkjet transfer onto Plaster of Paris. In the example here, the original image I used was actually a photo I took of a fresco on an old building in Paris. I manipulated the image in Photoshop and printed it out onto the Lazertran Inkjet decal paper. Below are the steps I then took to transform it. (As with any Lazertran Inkjet transfer, be sure to allow your printed image proper drying time before beginning the transfer process—see page 64.)

figure 21

Paris Fresco

Step One
Take a piece of plywood that's about a half-inch thick and place it on top of a garbage bag (to protect your table surface from the Plaster of Paris).

Step Two
Use masking tape to wrap around the perimeter of the plywood and create a raised edge. Make sure that there is a good seal where the bottom of your taped edge attaches to the back of the plywood. I wrap the masking tape around twice and make the raised edge one to two inches high (figure 21).

figure 22

Step Three
Mix your Plaster of Paris according to the instructions that came with it, making sure that all the lumps are smoothed out of the mix (figure 22).

Step Four
When the mixture is smooth, pour it onto the board within the wall created by the raised masking tape edges (figure 23).

figure 23

Step Five
Let the Plaster of Paris dry. I wait a day or two, according to the humidity (wait two days in more humid weather) and how thickly I pour the plaster. Then, I take the tape off and smooth any rough edges with a file or a knife (figure 24).

Step Six
Once the Plaster of Paris is dry and the tape has been removed, use a sponge brush to soak the surface with a coating of turpentine.

figure 24

figure 25

Step Seven

Then, place your Lazertran Inkjet decal in hot water and peel it off of the backing.

Step Eight

Next, lay the transfer on top of the turpentine soaked plaster.

Step Nine

If you wish to give the image a distressed look, you can rub the transfer off in spots using your finger. Sweep away the loose bits with a brush (figure 25).

Caution: It is best to wear gloves or coat your hands with a silicon cream before picking at the edges of the transfer. Turpentine is not good for your skin!

Step Ten

If you want to carve into the plaster, you should do that now. You can carve into Plaster of Paris with just about anything—a knife, a nail, a wooden stick, a fork, etc. At this point, the plaster is soft, so just choose a tool based on what kind of lines you wish to achieve.

Caution: Be sure to let the transfer dry overnight before completing the remaining steps.

Step Eleven

Once the transfer has dried and sunk into the plaster, you can paint the background or collage other materials onto the image. In this photo, you can see that I have started painting a base coat around the edges of the transfer (figure 26).

Note: Be sure to trim the edges of your Lazertran Inkjet transfer before soaking it if you don't want a white border around your image.

figure 26

figure 27

Step Twelve

I painted around and into the image with acrylic and gouache paints, as well as painting over any places where the Plaster of Paris and board were showing. This gave the piece a more finished look (figure 27).

Step Thirteen

I put the finished piece away for about six weeks to let the paint finish drying and soaking into the plaster. It became paler in color as it dried, and I didn't care for the look. So, I went back and used collage to enhance the piece further. I applied some thin papers on the right and left sides of the image using inkAID adhesive as the glue. The blue parts of the collage paper I used stood out against the fresco when the paper was glued down; the white areas became transparent, letting the red tones of the painted plaster come through.

Step Fourteen

Before the papers were completely dry, I scraped off some of the straight edges to create a peeling effect.

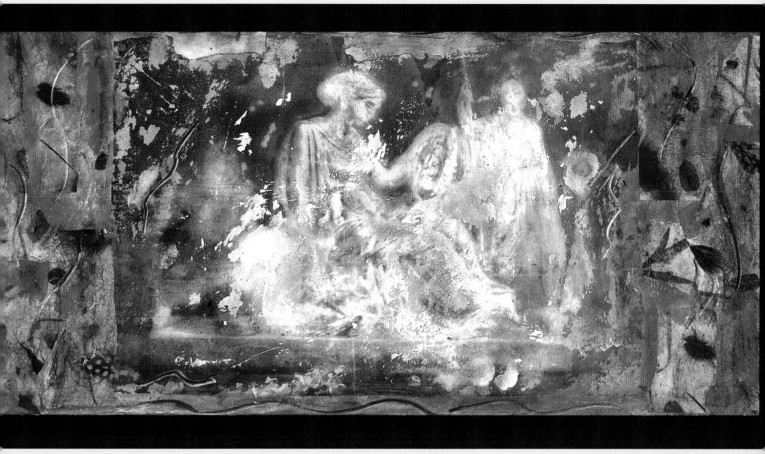

figure 28

Step Fifteen

When the collage pieces were dry (after an hour or so), I went back into the piece and added a light acrylic wash (I made a transparent wash of color by adding water to acrylic paint) (figure 28).

I took digital shots of the piece, *Paris Fresco*, both before and after I employed the collage technique. By shooting the piece at different stages, I was able to capture it with two different looks. I can now print a two-dimensional image onto ink jet coated or artist papers from these digital files. Frescos are muted in color and have a flat finish, so I choose a smooth, matte-type ink jet paper for printing to give my digital print a more authentic look.

Creating a Transparent Transfer Background

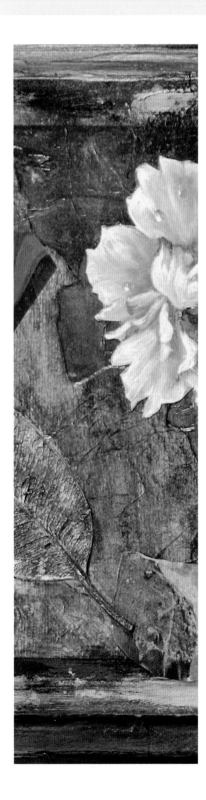

The transfer methods described above will result in a white background for the transferred image (unless otherwise specified). If you wish the image to be on a clear background, there are three ways of doing this:

❋ Apply a coat of either an exterior oil-based varnish, polyurethane clear gloss, or Plasti-kote Fast Dry Enamel to the front of the Lazertran Inkjet stock (where the image has been printed and dried) before you put it in hot water. Make sure that you have the entire image covered with the varnish. You should coat it twice to ensure even penetration. Let the varnish dry completely before submerging the decal.

> **Note:** Only the oil-based varnishes will make the white areas of the decal transparent. If you use an acrylic varnish, the white areas of the decal will remain white.
>
> **Hint:** Polyurethane clear gloss (varnish) can be found at a hardware or paint store.

❋ Applying a fine coat of Krylon Crystal Clear Spray will also achieve the transparent transfer effect. Apply one coat and let it dry, then apply another thin coat, and another, and another! You should apply at least four coats (allowing for drying time between each) to make sure that the Lazertran Inkjet stock is evenly and thoroughly coated. All coats should be applied and allowed to dry completely before you place the image in water.

❋ A third method is to use a gum or water based glue (not acrylic-based) to coat the substrate before you place your transfer upon it. After the coat of glue is dry, wet your decal in hot water, drip off the excess, and position it on the surface of the substrate. Allow it to dry completely. Then, you can selectively paint the decal with an oil-based varnish to make chosen areas transparent, or coat the whole decal and make the entire background transparent.

Caution: If you have not coated your decal with a polyurethane clear gloss (varnish), do not use an acrylic glue to coat your substrate—use a water-based glue. The acrylic glue will prevent the white areas of your transfer image from becoming transparent. However, if the decal has been coated with varnish first, you can use the acrylic matte medium (either as glue or a topcoat).

Note: Wherever you have coated your decal with acrylic matte medium, the white areas will remain permanently white.

Note: I have found that either exterior polyurethane clear gloss or the Plasti-kote Fast Dry Enamel work best for producing a transparent background, as they go on very thick and an even coat is easy to achieve. They also dry quickly while keeping the decal pliable and moveable, offering flexibility for adjusting the image transfer on the substrate surface with less chance of tearing.

Give some careful thought to the color of the substrate on which you plan to transpose your image before you decide to make the image's background transparent. If both the image and the substrate are dark, the image may need to keep its white background so that it doesn't blend in with the dark substrate and disappear. In this situation, a white background would help to bring out the details of the image and enhance it against the dark substrate. If you really prefer a transparent background, you might want to choose a lighter-colored substrate. Whatever the colors and tones in your image, try to transfer onto a substrate that will accentuate the image rather than detract from it.

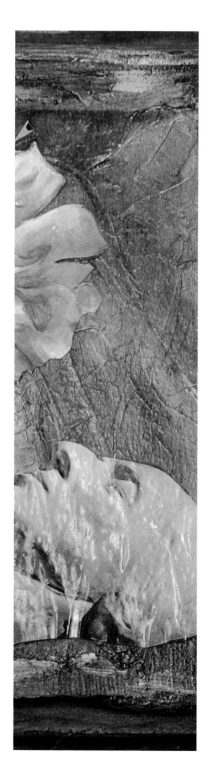

Transparent Transfers with Paper Substrates

Changing the white parts of your image to be transparent is not always the best choice. Some images need the white areas to maintain detail. Here are two versions of my piece, *Woman*. You can see that, based on the color and texture of the substrate used with each, one works and one doesn't.

The transfer below was made transparent with polyurethane clear gloss (refer back to page 82 for instructions) and affixed to paper using acrylic matte medium. (Note here that the acrylic matte medium does not disrupt the transparency of the decal as it was first coated with polyurethane clear gloss.) The white paper is clearly visible through the transparent areas, yet it does not distract from the image (**figure 28**).

figure 28

This transfer was also made transparent with polyurethane clear gloss, then transferred onto a textured paper (figure 29). This paper had embedded objects in it—bits of bark, leaves, and flowers. These objects became a part of the image and, in this case, destroyed most of the details of the print. Had the transfer not been made transparent, it would have maintained detail and the embedded objects around the outside of the image would have added to the print.

figure 29

Transparent Transfers with Wood, Stone, or Marble Substrates

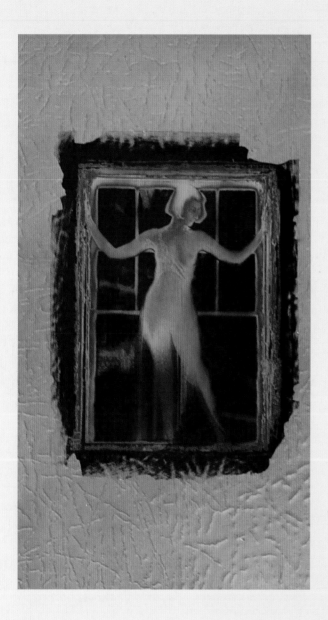

For these particular substrates, you have two options:

✳ You can coat the decal with a polyurethane clear gloss or an oil-based varnish (letting it dry completely) before immersing the decal in water, separating it from the backing, and placing it on your substrate. The white areas of the decal will become transparent, allowing the grain of the wood, stone, or marble to show through.

✳ Or, you can just soak it, remove the backing, apply it to your substrate, and then coat it with polyurethane clear gloss or oil-based varnish immediately after positioning the transfer. Remember that if the decal is allowed to dry even partially before you attempt to apply the varnish, you will brush the image away. Done quickly and correctly, this will make the white areas of the decal transparent, but it is a bit tricky to do. You must get the complete decal coated with varnish, or it will dry white in some parts.

Hint: Tiles make a good transfer substrate, as they can be lighter than stone or marble while still providing a nicely textured background. The best part is that they come in an endless array of colors.

Linda in the Window on Stone

I printed this image onto Lazertran Inkjet paper and then applied two coats of oil-based varnish before wetting and transferring it. This made the white background transparent so that, after transferring the decal to the golden yellow stone, the color of the stone could be seen through the transparent parts of the image (figure 30).

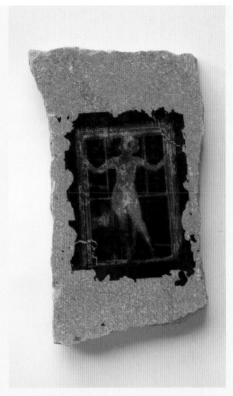

figure 30

Nude in the Window on Tile

For this transfer, I chose to keep the white background of the image, as I wanted the details to stand out against the tile. After submerging the Lazertran Inkjet decal in hot water, I removed it from the backing and placed it on the tile (figure 31).

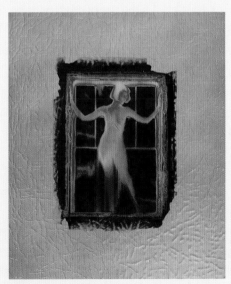

figure 31

Ink Jet Clear Film

Making digital transfers with ink jet clear film is quick, fun, and inexpensive. You'll need a clear polyester film that has an ink-receptive coating on one side. I can recommend two kinds that I know work well. One is SC4 clear film made by Kimoto Tech, Inc., and the other is FCPLS4 Universal Clear Film made by Océ. Both of these films work very well on most photo-quality printers.

inkAID

figure 32

Note: If you are working on a metal or glass surface (or any non-porous surface), it is better to first coat the surface with the adhesive, then add a coat of semi-gloss or clear gloss precoat. This will provide a better bond between the image being transferred and the non-porous substrate.

inkAID is an ink jet coating for substrates used in ink jet printers (figure 32). It is made to receive pigment-based inks (not dye-based inks) and comes in clear, semi-gloss, and gloss precoats that dry clear, as well as a matte precoat that dries to a bright white. inkAID also makes an adhesive to seal porous materials.

You can choose to use inkAID with dye-based ink prints, but you will get fugitive colors—for example, the reds might turn purple, or the greens might turn blue. This occurs within an hour of when the dye-based inks come into contact with the inkAID-coated substrate. This may not be a problem if you plan to use the transfer as a base for a painting, as you'll just paint over the fugitive colors anyway. For the following examples, I used the semi-gloss inkAID precoat. You will find that some porous surfaces will require two coats of the precoat. I usually paint it on in one direction, let it dry, then paint the second coat on in the cross direction to make sure that the surface is sealed and even. You could also use the inkAID adhesive as a first coat on a porous surface, and then give it just one layer of precoat. Coating a printed image with the clear precoat (as opposed to the matte, which dries white) allows you to preserve the color of the image underneath the coating and even apply another transferred image on top if you like.

Nude in the Arches

I transferred a black-and-white digital image onto copper sheet metal to create this piece. If I had wanted more detail in the transfer, I would have first coated the copper with adhesive, then given it a coating of semi-gloss precoat. However, I wanted to emphasize the deterioration of the arches, so I only coated the copper with one coat of inkAID semi-gloss precoat so that there would be missing information when I lifted the film from the metal. Because the image was black and white, the color of the copper showed through nicely (figure 33).

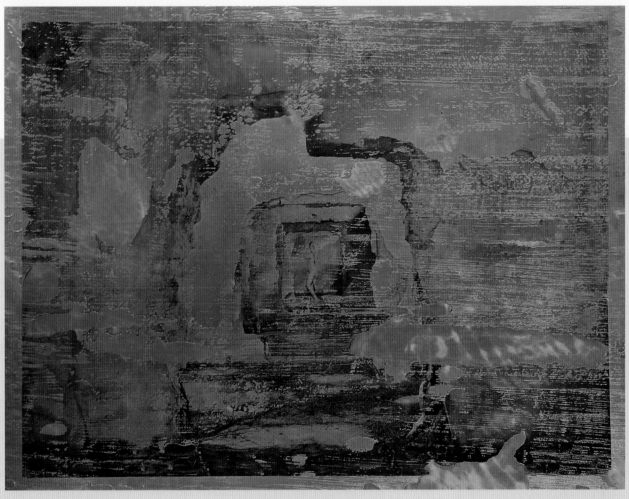

figure 33

For the following examples, I coated wooden panels with Plaster of Paris to create a very rough, aged look to the transferred image. (Refer back to page 78 for more Plaster of Paris transfer techniques.)

Asian Couple

Step One
This image was transferred onto a 16x20-inch gessoed panel. The panel came with a primed cotton surface, which I coated with a very thin layer of Plaster of Paris.

Step Two
When that dried, I coated it with inkAID semi-gloss precoat.

Step Three
Then I laid my image (which had been printed onto ink jet clear film) face down (ink side down) on the wet inkAID coating and rubbed lightly with my hand and a baron (see glossary) to make sure of good contact (figure 34).

Step Four
After I had rubbed lightly over the entire area, I gently peeled the film off, revealing the transferred image. It doesn't have much color because I was using dye-based inks (archival). This was not a problem, however, as I planned to paint and collage on top of the transfer (figure 35).

Step Five
Next, I went back into the transferred image and scraped sway at some of the Plaster of Paris to add texture.

Step Six
I painted on the transfer with gouache paints to achieve a fresco feeling— these paints tend to be muted, and dry flat. They are like opaque water-color paints (figure 36).

Note: When rubbing the film down to make contact with the substrate, you can use your hand, a baron, or the back of a large spoon.

figure 34

figure 35

figure 36

figure 37

figure 37 detail

figure 38

figure 39

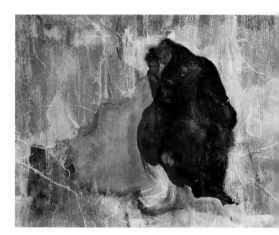

figure 40

Step Seven

Here is the painted transfer (figure 37).

Step Eight

I felt the piece needed more dimension and texture, so I decided to collage a bit of silk tissue onto the surface. I did not want the tissue to cover up the couple, just the background. Even though the silk tissue is very soft and transparent, it is made with strong fibers and cannot be torn easily. To avoid hard cut edges, I used a paintbrush dipped into water to draw a wet line where I wished to tear, and carefully pulled the outlined area away from the main piece. This left a nice pseudo deckle edge (figure 38).

Step Nine

I coated the painted transfer with one layer of matte medium, then laid the silk tissue over it.

Step Ten

When it was positioned where I wished it to be, I gave the top another coat of the matte medium (figure 39).

Step Eleven

Here is what the piece looked like once the tissue dried (figure 40).

figure 41

figure 42

figure 41 detail

Step Twelve
Next, I added extra tissue to selected areas to create more texture
(figure 41).

Step Thirteen
This close-up shot shows the delicate pseudo deckle edges and the texture
of the paint (figure 42).

Step Fourteen
When I felt the image had the texture I wanted, I added some more paint
overtop of the collaged tissue pieces to blend them in.

Step Fifteen
As a finishing touch, I rubbed in some Jacquard Pearl Ex gold and silver
pigments, after which I sprayed the image with a coat of clear fixative.
Here is the final fresco, Asian Couple (figure 43).

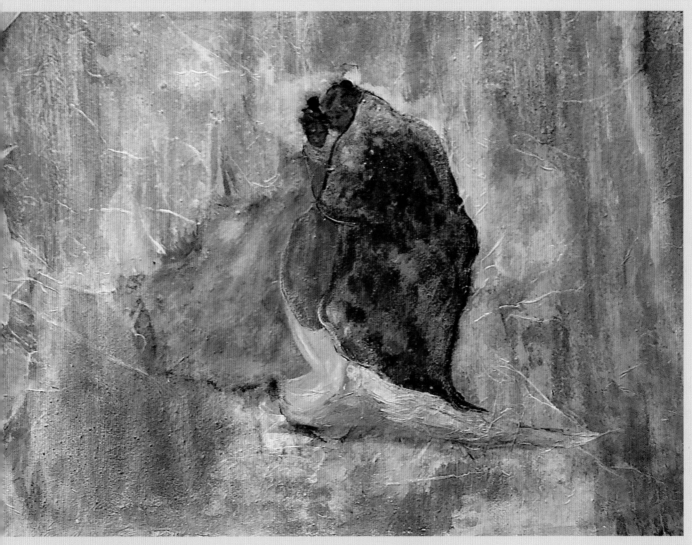

figure 43

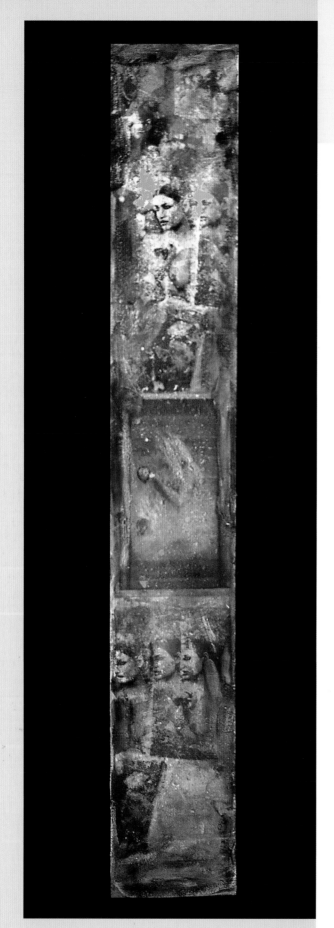

figure 44

The French Poster

Step One
I printed several images out onto clear film.

Step Two
Then, I gave the dried plywood/Plaster of Paris surface a coat of inkAID semi-gloss precoat. The Plaster of Paris is very porous, but I did not give it two coats, as I wanted to attain a peeling, aged look to the piece.

Step Three
I laid the film images down onto the inkAID-coated surface (ink side facing down) and rubbed lightly with my fingers, peeling the film off almost immediately. This gave me the peeled look that I wanted.

Step Four
After the images had set and dried, I went back into the piece with acrylic paint and tied it together with color.

Step Five
I waited until everything had dried (I generally wait at least two days, sometimes more if we're having hot, humid, or rainy weather), then I sprayed the image with a final fixative to protect it. *The French Poster* is 6 x 24 inches (15.24 x 60.96 cm) (figure 44).

Time Is Running Out

This started out as a wooden plaque upon which I poured a layer of Plaster of Paris. The image that I attempted to transfer did not work because I let the inkAID precoat get too dry. The film lifted with most of the image still stuck on it, and what did transfer was a mess. But, the textured mess that remained was interesting, so I worked with what I had.

Step One

I started by collaging various "found images" from magazines and books. I felt a theme coming through but couldn't quite grasp it, so I just continued to work it out. Sometimes you have to go with the flow and just let the piece dictate what it needs.

Step Two

When I glued the horse image in, I knew I was working with a time theme. During the period in which I created the pieces in this section, a dear friend of mine had passed away and I think I was just feeling very conscious of how little time we all have here. The skeleton leaf in this piece has always symbolized, to me, the passage of time and aging. This is the digital file of the piece, *Time Is Running Out* (figure 45).

Step Three

I opened it in Photoshop, then applied the nik Color Efex Pro filter, Midnight Blue. I thought the blue color fit the content of the piece. I also cloned some of the background material at a low opacity to blend in the glued-on cutouts and make them a little more obscure. The two-dimensional piece has a poignant mood that I did not achieve in the three dimensional version (figure 46).

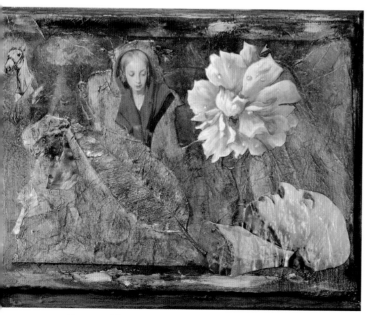

figure 45

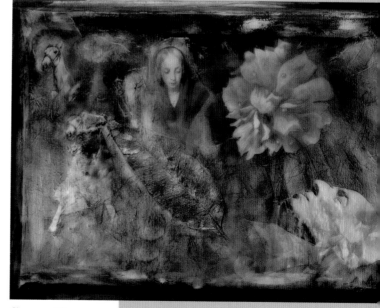

figure 46

figure 46

Hint: If you pull the clear film back very slowly and you notice that not enough information was transferred, you can lay the film back down and rub a bit longer and harder on the back of the film. Then lift it gently again.

Gargoyle Over Paris

Step One
I started out by pouring Plaster of Paris on a thick piece of plywood.

Step Two
When the Plaster of Paris was dry, I coated it with a clear inkAID semi-gloss precoat.

Step Three
While the inkAID coat was still wet, I laid two images (which had been printed out onto ink jet clear film) face down on top of my substrate; one of a gargoyle and one of a shot I call *City of the Dead*.

Step Four
After lightly rubbing the back of the film, I slowly pulled the film away, leaving the transferred image.

Step Five
When the transfer was dry, I used acrylic paint to tie the image together.

Step Six
Then, after the paint dried, I began to collage various papers and leaves onto the piece.

Step Seven
Lastly, I added some gold paint to highlight certain areas.

Step Eight
This is a close up showing the rough texture of the Plaster of Paris and the dimensional quality of the collaged leaf. The leaf was adhered onto the painted fresco using matte medium as glue. It is milky white when painted on, but dries clear (figure 46).

Step Nine
Here is the final piece, *Gargoyle Over Paris* (figure 47).

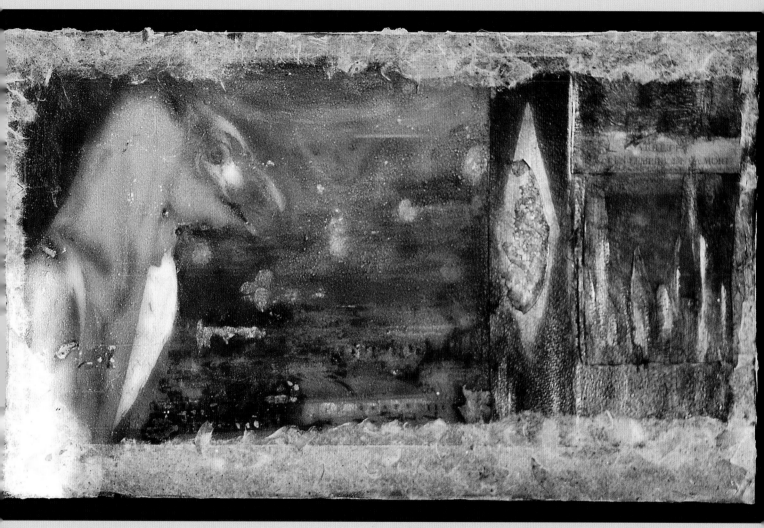

figure 47

figure 48

Mortality

Step One
This piece began with an unfinished wooden plaque that I coated with Plaster of Paris. I liked the way the Plaster of Paris was unevenly coated at the bottom, leaving the wood to show through.

Step Two
After the Plaster of Paris had dried, I coated it with inkAID semi-gloss precoat and laid my clear film print of a religious wall hanging on top while the coat was still wet.

Step Three
I rubbed in the transfer and peeled it away gently.

Step Four
After the transfer was dry, I painted over it with acrylic paints.

Step Five
Then I glued down a deteriorated "skeleton" leaf on top of the dried paints. Here is a close-up shot of the leaf and the painted plaster transfer surface (figure 48).

Step Six
When everything was dry, I gave the finishing touches with some iridescent gold paint.

Step Seven
To complete the piece, I painted the edges with a dark brown acrylic paint, then wiped the iridescent gold paint on top to highlight it. I especially like the texture and symbolism of the final result (figure 49).

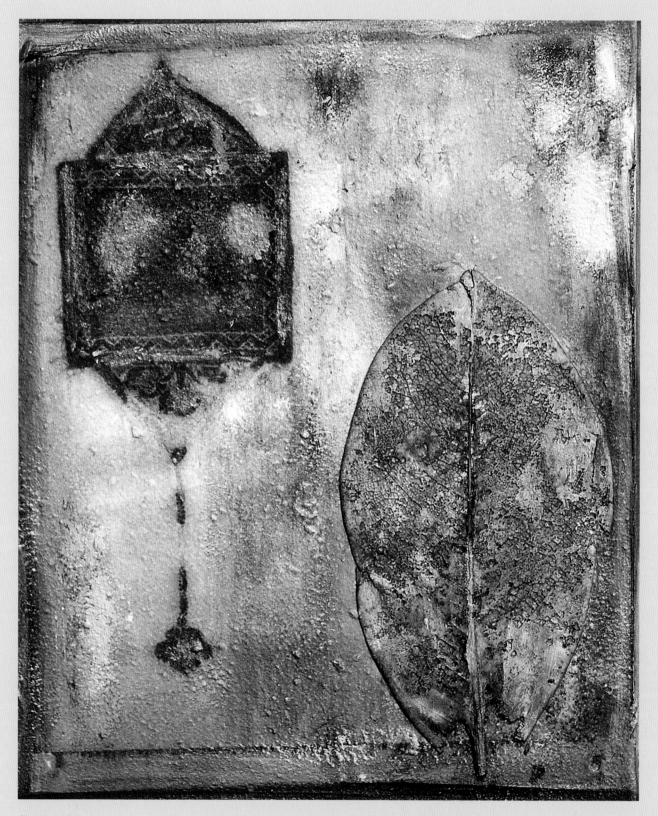

figure 49

Ladies of the Field, 2002

Ladies of the Field is part of a series called *American Perspectives* that I began in late 2001 and completed in the spring of 2002. It was my first work completed after 9/11 and, while not directly related to that event, it evoked a feeling I'd had since that awful day. The images look warmly backward with an innocent American nostalgia, yet they are inextricably woven in with an impending sense of danger and destruction. It is an uneasy balance we all live with today.

Ladies of the Field is a composite image created from an 8 x 10-inch glass plate negative and a landscape image taken with a Hasselblad. The glass plate was scanned on a Microtek Scan Maker III (an old but trusted scanner with a trans-parency adapter that can scan transparencies or negatives up to 8x10 inches). The Hasselbald image was a Kodak E100s transparency scanned on a Polaroid Sprintscan 120 scanner. The glass plate negative was scanned at 600 dpi at 100% in 16-bit grayscale. I used VueScan scanning software, which is shareware software available for many older scanners. It allows them to be used with Mac OS X, and is usually more sophisticated than the original scanning software from the manufacturer. The transparency was scanned at 4000 dpi at 100%. With both images open in Photoshop, I dragged the glass plate image onto the land-scape. Because the landscape was in RGB mode, the glass plate grayscale image also becomes RGB. To blend the two images, I relied on one of my favorite image combination tools: Layer Styles. This tool is accessed by double clicking on the image icon in the top layer (the glass plate portrait, in this case). This opens the Layer Styles dialog box, which includes two sets of sliders that allows you to alter the visibility of pixels in one layer to show the underlying information of the layer below. It allows for unusual and unexpected image blends. It can be controlled more directly by duplicating the top layer (the glass plate portrait) and moving it to the bottom of the layer stack, then using a layer mask on the landscape image to bring back information that was hidden by the Layer Styles slider. It is a very painterly technique of image combination that can be used quite simply, or in very complex ways with multiple layers. For me, it makes Photoshop technique as intuitive a tool as any I used when I painted.

John Reuter attended college in New York at SUNY Geneseo, and it was there that he began to study with photographer Michael Teres and painter and art historian Rosemary Teres. Together they inspired his early work, in which he took advantage of the photographic process to transform the camera's reality into a more "mythic" reality. He attended graduate school at the University of Iowa, where he began the SX-70 collages that still inform his work today. Following graduate school, Reuter began working for Polaroid Corporation, first as a research photographer, then later as main photographer and director in the 20x24 Studio. Here, he began collaborative relationships with artists such as William Wegman, Joyce Tenneson, Olivia Parker, Anna Tomczak, David Levinthal, Timothy Greenfield-Sanders, and others. Throughout his twenty years of working with other artists, Reuter has maintained his own vision. The SX-70 collages gave way to painted image transfers in formats ranging in size up to 5 x 6 feet. In the early '90s, Reuter moved into digital imaging. The freedom of image making provided by this new medium inspired his work in ways reminiscent of the early SX-70 pieces. This new body of work draws on John's early paintings, as well as combining imagery through digital collage. This synthesis is at the heart of his work. He has taught workshops at the International Center for Photography in New York for over ten years, and at Santa Fe Workshops and the Palm Beach Photographic Center for four years. His work has also been published in several magazines. For more information, visit www.johnreuter.com.

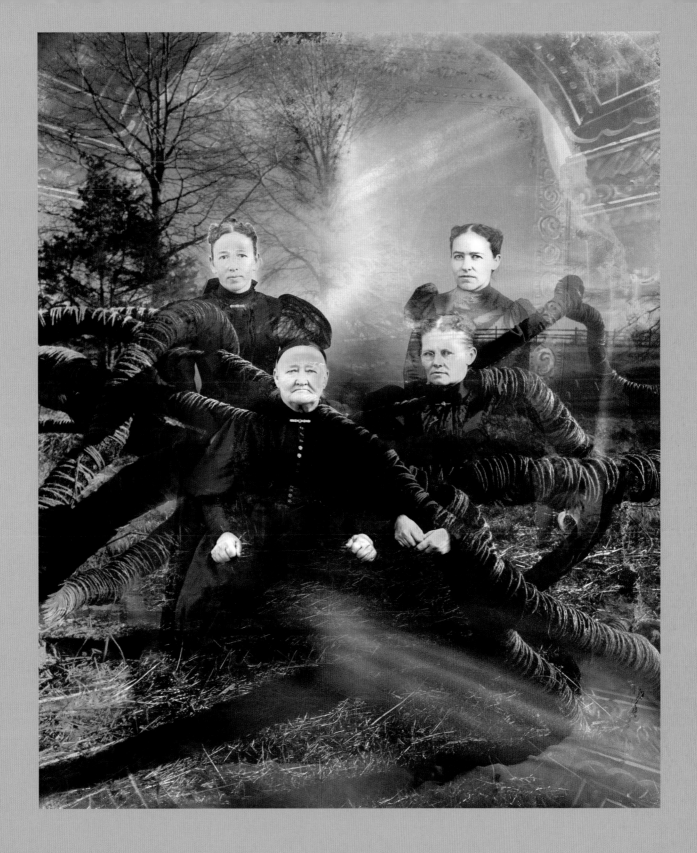

John Reuter—*Ladies of the Field*

Digital
Infrared

Right from the very first digital infrared capture I made with my Minolta DiMAGE 7, I was totally amazed and addicted. I could actually see in infrared through the viewfinder! By increasing or decreasing shutter speed, I was able to control exactly how much infrared was recorded by the camera. Magic! The longer the exposure, the more infrared you record, and the more ethereal the image will look. The shorter your exposure, the less infrared you will record, and the sharper the image will look—like a continuous-tone black-and-white photo.

Working with the landscape or the nude in digital infrared is much the same as using traditional infrared film. Foliage is recorded as white, and sky and water are black.

With the nude, if the veins are close to the surface and you can see them through the skin, infrared will record them as black lines. Also like traditional infrared, digital infrared will "see through" sunglasses and some other materials (such as dense velvet, depending on the light). Since infrared light is invisible to the human eye, we cannot entirely tell what digital infrared will record and what will be transparent to it just by looking through the viewfinder. The blue haze in the mountains that we saw with our eyes was not recorded. The dark sunglasses on our friends appear as clear as reading glasses. It is not always possible to see the finer detailed effects of the infrared capture until we pull it up on the computer. Even when using the digital camera's LCD monitor, there are still some small surprises with digital infrared.

There are many cameras that can record infrared. Believe it or not, the best ones to do this are the older versions of the various models. As digital camera manufacturing and design has improved, manufacturers have created new image sensor designs that block out infrared light in order to help the camera record better color. The down side is, obviously, that the camera's ability to record infrared is diminished or, in some cases, eliminated.

Of all the cameras I've found, none work as well for digital infrared photography as the Minolta DiMAGE 7. You look through the viewfinder and see in infrared when the camera is in black-and-white mode and there is an infrared filter on the lens. To alter how much infrared you wish to capture, simply adjust the shutter speed. The longer the shutter stays open, the more infrared will be visible. Conversely, the less time the shutter is open, the less the infrared that will be recorded. You can preview the effects in the viewfinder by turning the shutter-speed dial. With some other camera models, you have to look at the LCD monitor to see the infrared that's being recorded.

The Wishing Well

This photo was taken in Palm Gardens, Bermuda. The sky was very blue, with puffy white clouds passing by. A perfect day for infrared. The foliage was diverse in texture and variety, which added an interesting element to the image. It looked like a scene out of a fairytale, and the infrared showed it as such. I used a Tiffen 87 filter for this shot (figure 1).

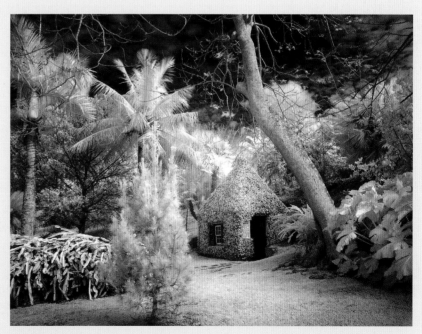

figure 1

figure 2

Aboriginal Girl Fishing

I took this photo while I was driving through Kakadu National Park in Australia on the road to Ubirr. There had been a flash flood; the road was underwater and I could not get through. I was very disappointed but, as I stopped the car, I saw an Aboriginal family fishing on the flooded road. The scene was perfect for an infrared shot. I didn't have my tripod with me on this particular journey, but I was able to handhold the camera for this photo of a young Aboriginal girl fishing. I used a Cokin 89B filter (figure 2). Later, I took my original black-and-white version and toned it brown in Photoshop (figure 3).

Are there pluses to shooting digital infrared rather than using infrared film?

There are many reasons to shoot digital rather than traditional infrared. There are no surprises! No more guessing at exposure times, no more worrying about X-ray machines at the airport, no more dark changing bags, no more refocusing, no more paying $12+ per roll of film, no more expenditure of time and money with processing films, no more worrying about heat, and no more worrying about running out of film!

Are there drawbacks to shooting digital?

There may not be any surprises, but there is the hassle of taking along a battery charger and rechargeable batteries. There is also the one-time expense of a good memory card, as well as the purchase of a portable storage device if you want to be able to download images in the field without having to drag your laptop along. A portable storage device allows you to download your card and records your images in a numbered folder. Most of the models, like FlashTrax and Nixvue Vista, for example, have nice sized LCD screens for previewing your images.

The Nixvue Vizor is a CD-ROM based storage device that burns your images from the memory card to a CD—it has no memory. Unfortunately, you cannot check to see if your images were burned to the CD until you get to your laptop or desktop computer. And, using this device means that you have another thing to carry with you—a stack of CDs. As you can see, there is a lot to consider when shooting digital in the field.

Caution: Before purchasing a portable storage device, be sure to verify that it will keep your files intact even if the batteries run down.

The biggest drawback to shooting digital is the need for battery power on long photographic trips. This is usually not a problem unless you are out for a long period of time in the wilderness, or in a country where electricity is hard to find. Be sure to contact your camera manufacturer and/or your battery charger manufacturer to ascertain whether you need a converter to use your equipment on international travels. Sometimes, an adaptor plug is all that is necessary if your camera gear has a converter built in.

So, is it worth it? Well, all I can tell you is that I have a smile on my face every time my camera bag goes through the X-ray machines at the airport, and an even bigger smile when I see the images I captured with my digital camera in print form.

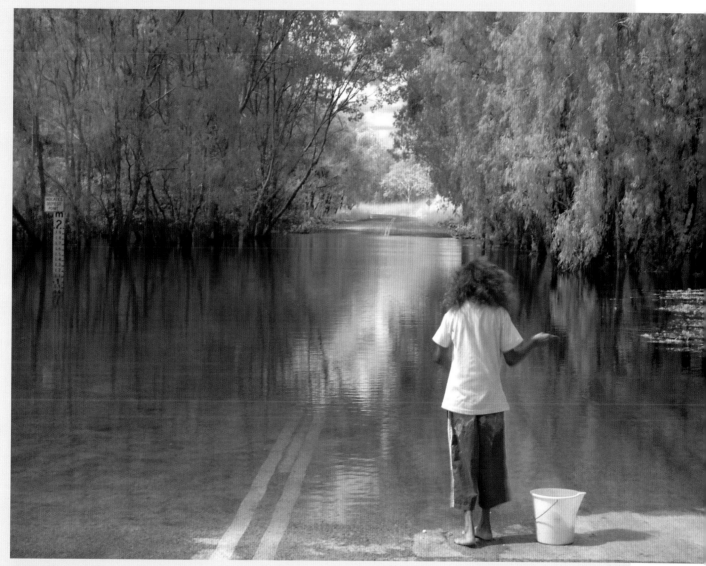

figure 3

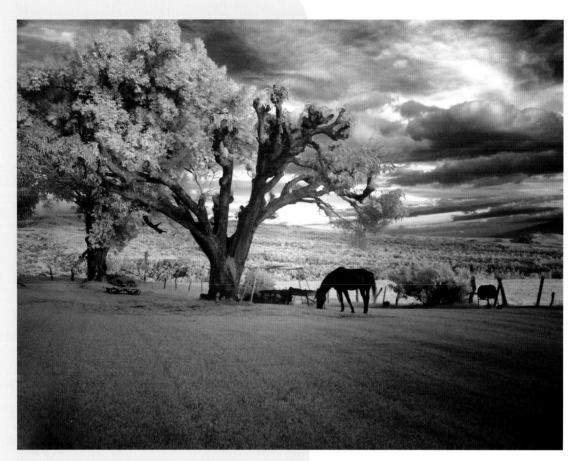

figure 4

Henry's Horse

When I captured this image, we had just had a rainstorm and the clouds were breaking up as the sun was setting. The old tree and the sky captured my attention, then the horse dipped his head and the stage was set. The grass mower's tracks were emphasized by the infrared capture. I did not notice them with my eyes until I looked through the viewfinder with a Tiffen 87 filter on the lens (figure 4).

Can Your Camera Capture Infrared?

Not all the digital cameras are capable of capturing infrared. To see if your camera has that capability, do the following simple test:

Step 1: Check to see if your camera has a black-and-white mode.

Step 2: If it does, turn your camera on and select the black-and-white mode.

Step 3: Now take a TV remote control and aim it at the camera. Push the power button on the remote; if your camera can see the beam coming from the remote, it can record infrared.

Note: If you have a digital SLR, the beam should be visible through the viewfinder. If you don't have a digital SLR, check your camera's live LCD for the beam.

Some digital cameras can record infrared but do not allow you any control over the exposure while in the black-and-white mode. The best way to find out is to try adjusting aperture or shutter speed while in this mode. If your camera does not allow you to adjust them, you can still try to optimize your shot in Photoshop later. If you are able to choose an exposure mode for shooting in black and white, the following information is what I use to get the best infrared shots that I can.

I generally shoot in Manual Exposure mode (often signified by an M) or Aperture-Priority mode (signified by A or Av). The Program mode (P), if available, will also work. As with traditional cameras, the smaller the aperture, the greater the depth of field. Using a larger aperture limits depth of field, but allows you use a faster shutter speed and freeze motion. Aperture-Priority mode comes in handy when there is a breeze stirring the foliage.

Hint: If you don't want to give up depth of field and you intend to hand color the image, the slight blur caused by longer shutter speeds and wind can be camouflaged with pastel pencils or paint.

My typical exposure, using an 89B or an 87 filter, is at f/6.7 with a 1/2 second shutter speed. If the light is low, it may take a whole second.

Note: Be sure to use a tripod at these shutter speeds! Hand-holding a shot with a shutter speed slower than 1/60 second is not recommended, as it will most likely result in motion blur. For my infrared photography, I get the best exposure with the greatest depth of field at f/stops between f/6.7 and f/8, so I think it is worth the trouble of carrying and using a tripod.

figure 5

Meditation

This is a combination image. I took the shot of the woman in a pool using a Harrison & Harrison 89B filter on the lens. The deep blue sky reflected in the pool water and recorded as black because of the deep red filter I used. Her skin was so white that, at a certain angle, her face was reflected in the water. The shot I combined with the woman in the pool was a slow shutter speed shot of the ocean rolling in on a rocky beach. I blended them in Photoshop using Layers. The dream-like quality of the ocean mist and the reflected face seemed to imbue the piece with a calm, peaceful, meditative feel, so I called it *Meditation* (figure 5).

Trees in the Front Yard

Step One

This is the original print, shot with a Canon PowerShot G3 using Sepia mode and a Tiffen 87 filter on the lens (**figure 6**).

Step Two

This is what the image looked like after I adjusted it in Photoshop using Auto Levels—a good split, but the whites were not white. They had a greenish cast, and the overall picture looked flat (**figure 7**).

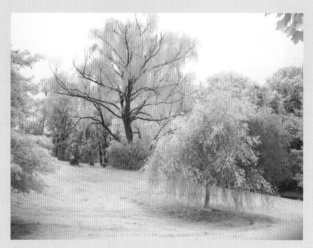

figure 6

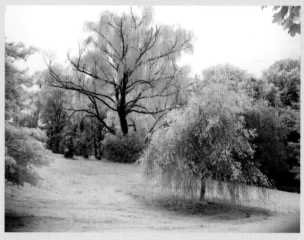

figure 7

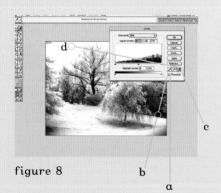

figure 8

b

a

c

Step Three

I brought up the Levels control (**figure 8**) and manually adjusted the image to bring out the whites and blacks:

a. Click on the first Eyedropper. This controls the blacks.

b. Take the Eyedropper over to the image and click on the darkest area of the print. The image will adjust to a good black.

c. Then click on the third Eyedropper, which controls the whites.

d. Click on a white area in the print (an area that is supposed to be white). The image will adjust to a clean white.

> ***Note:*** In Photoshop, you can perform manual Levels control as many times as you like, and the image will constantly change. You can also hold down the Option key (or the Alt key for PC) and the Cancel button will change to Reset. This way, you can start over with the original image at any time.

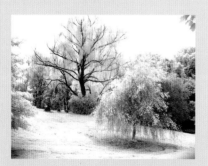

figure 9

Step Four

This is the image adjusted to a good white and black. The color is better and the image has the contrast it needed (figure 9).

Step Five

Because the image looks a bit plain with such a white sky, I decided to add some blue:

❊ Select the sky with the Magic Wand tool from the toolbox (figure 10).

❊ Feather your selection, if you wish, by going to Menu > Select > Feather. I chose to feather it by 2 pixels.

Step Six

I then selected a Graduated Light Blue filter in nik Color Efex Pro (figure 11).

> **Note:** nik Color Efex Pro, as with any other Photoshop plug-in, adds to your existing Photoshop options. You do not need to open your file in another program in order to access these additional options (providing you have previously installed the plug-in software).

Step Seven

This is the final print. I was quite pleased with the results. It has a good split-tone effect and I like the addition of the pale blue sky. This image was originally taken in mid-August on a hot, humid day, but the altered piece gives the impression of an early snowfall in late October (figure 12).

figure 10

figure 11

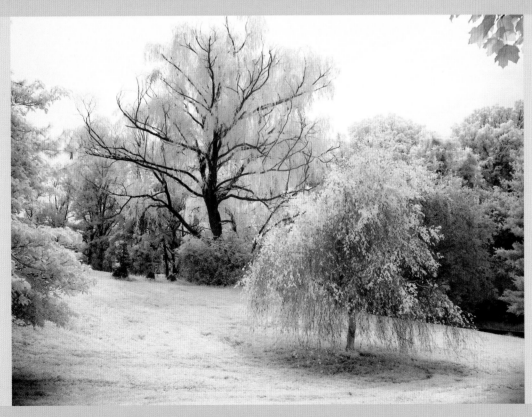

figure 12

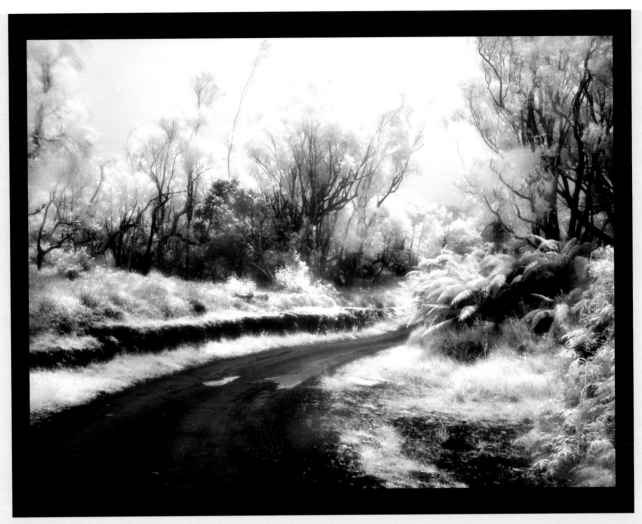

figure 13

The Bend in the Road

This was taken in a sacred forest in Molokai, Hawaii. The day was not perfect; we had a low cloud ceiling that made for a very white, blank sky. But, every once in a while, the sun would come out and shine on the tree tops and grasses. As I walked around this bend in the road, the sun came out and I recorded this image. I further enhanced it with Gaussian Blur in Photoshop to give it a dream like quality. The shot was taken with a Tiffen 87 filter (figure 13).

Digital Infrared Filters

The less dense the filter you use to capture your infrared photos, the shorter the shutter speed you can use, the less infrared you will capture, and the sharper your image will appear. Conversely, using a very dense infrared filter will capture more infrared light and require a longer shutter speed. For this reason, the denser infrared filter will produce a softer looking image (often caused by wind related motion in outdoor photos).

Another point to note when considering which filter is right for your photography is that the denser infrared filters produce much darker, more dramatic skies than the less dense filters do. If that is a look you particularly like, then a very dense infrared filter may be your best option. The filters that I recommend for infrared photography are the Tiffen 87 opaque filter, the Harrison & Harrison 89B filter, the Hoya Infrared R72 filter, and the Cokin A007 Infrared 720 (89B) filter (commonly referred to as the Cokin 89B filter).

Tiffen 87 Opaque Filter

This filter records deep, rich, black skies—very dramatic. The images recorded appear to have more contrast (see figure 13) than the Harrison & Harrison 89B filter (see figure 14), perhaps because of the deeper blacks recorded in the scene. However, I have found that the resulting image is not as sharp as the Harrison & Harrison 89B, probably because it records more infrared, making the details in the image appear softer. Using this filter means taking more time for the exposures because it is a very deep red (almost black).

Dancing Fern

I shot this image as the setting sun was highlighting the fern and the leaves around it. I knew the background, which was in deep shadow would go black and the leaves would look like stars in the sky. The fern had such a beautiful, rhythmic shape that seemed to dance in the gentle breeze. The infrared light captured perfectly what I had envisioned. The Harrison & Harrison 89B filter was used for this photo (figure 14).

figure 14

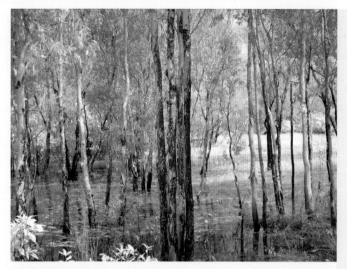

figure 15

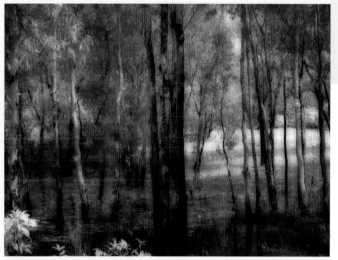

figure 16

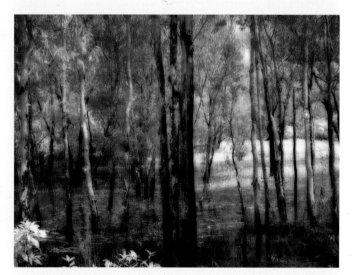

figure 17

Trees in the Wetlands

This scene was just off to the side of the flooded road where the Aboriginal family was fishing (on page 104). Again, this image was handheld and shot with the Cokin 89B filter (figure 15). I later experimented with my original black-and-white infrared image using nik Color Efex Pro software, first applying a Midnight Blue filter (figure 16), then trying out the Midnight Sepia (figure 17).

Harrison & Harrison 89B

This filter (see figure 14 on page 111) is less dense than the Tiffen 87 opaque filter, thus it takes less time to record infrared capture (usually around 1/3 or 1/2 second at f/6.7). I have found it to be sharper than the Tiffen 87 opaque filter, perhaps because it doesn't record as much infrared. The more infrared recorded, the less sharp the image will appear. With the Harrison & Harrison 89B, the skies will be lighter and less dramatic than those recorded with the Tiffen 87 opaque filter. Harrison & Harrison will make almost any size filter to fit your lens. (To contact them, refer to the Resources section in the back of the book.)

Hoya Infrared R72 Filter

This filter works well and it does not take as long to make an exposure with it as with the Tiffen 87 opaque or Harrison & Harrison 89B. It recorded at 1/4 second what took the others 7/10 and 1/2 second to record (see figure 18). It's not quite as sharp as the Harrison & Harrison 89B, but it's close. It also renders good black skies.

Cokin 89B Filter

Cokin makes a creative filter system, which consists of a filter holder that mounts onto the end of your lens and can house a variety of filters that just slide into the holder. To obtain good digital infrared results, use the Cokin 89B filter (as in figure 15). It is less dense than the Tiffen 87 opaque filter, so it takes less time to record the infrared. In most cases, the Cokin 89B filter allows you to hand hold the camera and shoot with the aperture wide open at 1/20 second. The big plus is that it also gives you dramatic dark skies—not quite as dark as those recorded with the Tiffen 87 opaque, but close.

Manon in the Banyon Tree

The form and shape of trees have always attracted me, and this one is so anthropomorphic that the small human figure blended in perfectly. Infrared light captured the feeling of spirit and life that I intended.

I used a Hoya Infrared R72 filter to shoot this image. Then, I changed the black-and-white shot to the RGB mode in Photoshop and went to Image > Adjust > Color Balance. Once the Color Balance widow was open, I added a bit of red and yellow to create a pleasing brown tone for the image (figure 18).

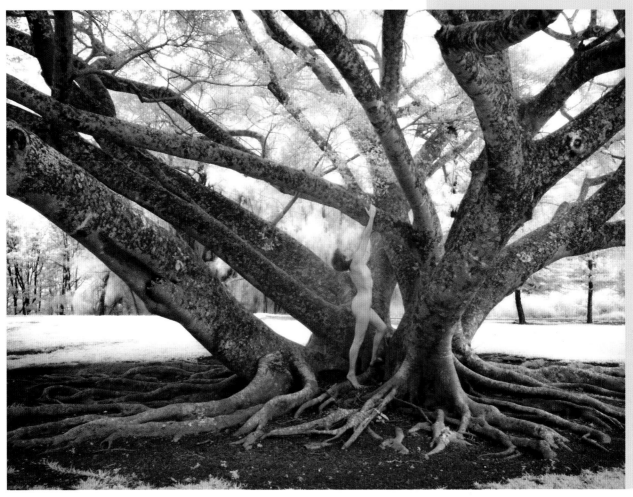

figure 18

Sepia-Toned Digital Infrared

Some digital cameras, such as the Canon PowerShot G3, actually have a Sepia mode built in to the camera. This makes it easy to take great split-toned infrared images. The captures look similar to the split-toned images made using the old Azo contact printing papers back in the 70s. If your digital camera has a Sepia mode, you can follow these simple steps to create a sepia-toned infrared image. And, of course, if your camera doesn't have such a mode you can always tone your infrared images any color you wish using computer software, as with the Palm Grove image on the following page.

Step One
Set the camera to Sepia mode and switch it to Manual focus (if available).

Step Two
If your camera allows for aperture adjustment, select an aperture that will optimize the depth of field you desire for your subject.

Step Three
Place a deep red filter on the lens. If your digital camera doesn't take filters, or you just don't have one in the size appropriate for the camera you're using, you can hold the filter over the lens during exposure.

Note: Be sure to use a tripod!

Step Four
After obtaining the sepia-toned image in the camera, open it in Photoshop.

Step Five
Use the Auto Levels tool and, like magic, the image splits, with the dark values turning to a rich, coppery brown while the highlights remain white. The midtones turn a silvery blue color.

Hint: While several filters will work, I prefer to use an opaque red filter because it will capture more infrared light, resulting in a deeper tonal split when the image is adjusted with Auto Levels.

Note: Using the Sepia mode by itself (with no filter) will, as the name suggests, give you an overall sepia print. When put into Auto Levels, a basic sepia-toned print will not split. It will look like a normal black-and-white image.

Caution: Be sure that your sepia-toned digital infrared capture is not too dark or too light by checking the LCD monitor before you leave the scene. Your image should have some white highlights. If it is too dark, the image will not split in Auto Levels, and if it is too light, the split will not have those nice, rich, dramatic shadow areas. It may take a few shots at different exposures (and perhaps even varying filter densities, if you have that option) for you to see what works and what doesn't.

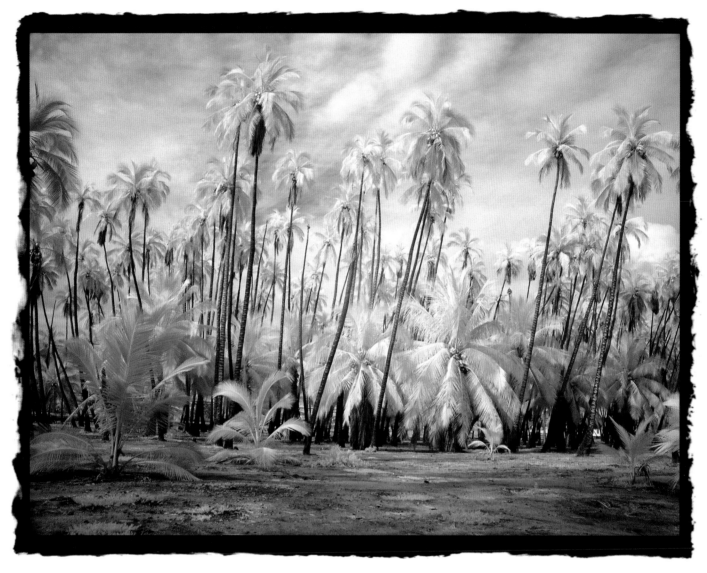

figure 19

Palm Grove

This is another image I shot in Molokai, Hawaii. The sky was very cloudy and there wasn't any definition to the clouds. The Tiffen 87 filter, however, brought out the cloud formations. I could not have gotten this shot with traditional infrared film because the sun was behind thick clouds, but with my digital camera and the nearly opaque deep red filter combined with a long exposure time (two seconds) I was able to force the infrared. I then opened the image in Photoshop and gave it an overall sepia tone to create a more gentle look (figure 19).

Ana's Hands

A Digital Iris Print of the Original Chocolate Polaroid

Ana's Hands is a figurative portrait made of a friend who was visiting the studio and readily became a model for the antique embroidered oriental robe that I had recently borrowed from another artist friend. We carefully selected the three eggs as props, being objects to which Ana related. Seemingly fragile, the eggs are made of glass, giving them a translucency with considerable weight, and bringing a strength to the locking gesture of her small hands.

The original image was photographed at the Polaroid Studio in NYC, with the large format 20 x 24 camera. Each image is unique in the original glossy format.

"Chocolate" is a cross process that came from an accidental combination of Polacolor ER negative, Polapan positive (black and white), and reagent. This combination produces a result where the silver from the color negative transfers to the black-and-white positive, and the color dyes in the negative "stain" the positive. This results in a chocolate-brown image colonization (cooler in tone than sepia) and unusual suppressed highlights similar in appearance to those of 19th century Albumen prints. The deep shadows can solarize (i.e., overexpose) at times, producing an effect like no other photographic process.

Since I prefer my images on paper, and Chocolate Polaroid is by it's nature not very stable, I scanned the original (with a digital scanner back on a Sinar 4 x 5 view camera) and made digital Iris prints on Somerset Velvet, Fabriano, and Arches watercolor paper in a limited edition series.

Iris printers create images using a continuous ink stream that is capable of producing tiny drops of ink in up to 32 different sizes. The printers can accept virtually any substrate that can be wrapped around the diameter of the 48-inch drum. This particular print was made on 40 x 29-inch Arches 300 lb. cold press paper—the actual image size is 32 x 24 inches. It was printed with Lyson Archival Inks on a drum Iris printer at Thunderbird Editions in Clearwater, Florida.

Anna Tomczak's work is widely exhibited in galleries, museums, and public art displays. She received her M.F.A. in Fine Art Photography from the University of Florida where she studied with Jerry Uelsmann, Evon Streetman, and Wallace Wilson. Tomczak holds workshops in the United States, as well as in Italy. Her Polaroid transfer technique workshops, conducted in her studio in Lake Helen, Florida, are held in April and November each year. Anna is currently compiling a book of her photographs, entitled *Blue Dresses, White Lies,* in collaboration with poet Silvia Curbelo. Please visit www.annatomczak.com to see more of Anna's work.

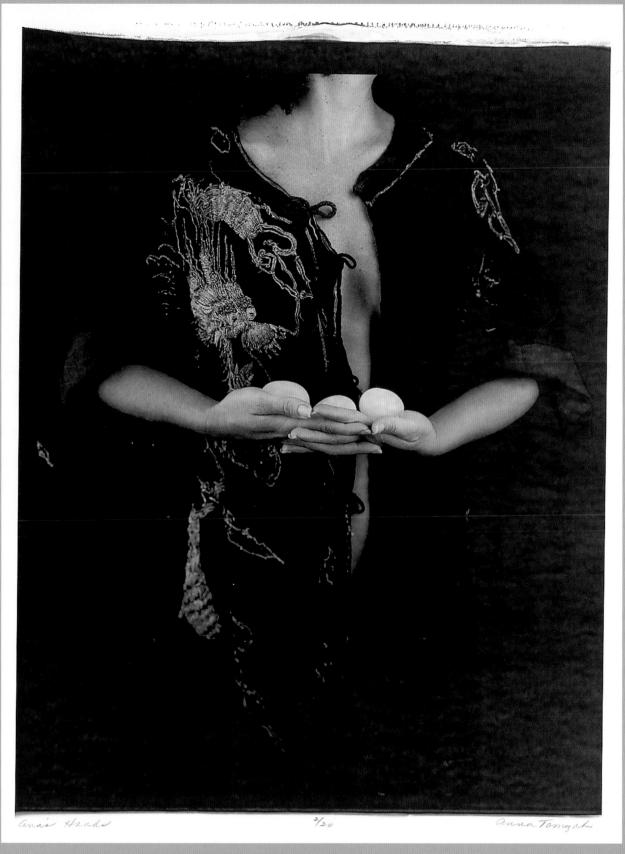

Ana's Hands 2/20 Anna Tomczak

Anna Tomczak—*Ana's Hands*

Hand
Coloring

Hand coloring gives the photographer a poetic license—the freedom to control the image and create the mood by adding a dimension of color and texture. It can give the photographer an opportunity to change what the camera actually captured into the vision seen by the mind's eye. It allows the photographer to put emotions and feelings onto paper. Hand coloring is a means to tap into the subconsciousness of artistic expression.

I have been hand coloring my photographs for years.

Now, with digital photography, I can print my images with archival inks onto artist watercolor papers and archival ink jet coated papers for hand coloring. According to what best suits the image, I will print in black and white, toned black and white, or color. In some cases, I hand color the entire print; other times I enhance it only slightly, wherever the color needs to be intensified or corrected. In still other cases, I print out a light version of the image to be used as a sketch from which to make an oil painting or a pastel rendering. For these types of prints, I am not concerned with resolution and print color, as it will be completely covered with paint or pastels.

Pastel pencils are just pastels wrapped in wood, which allows them to have a smaller point than the traditional chalk-like form. (For the large areas in a print, I frequently use the traditional chalk-like pastels, as they cover faster and easier.) Pastel pencils work on semi-matte and matte photographic papers, artist watercolor papers, and ink jet coated papers. I prefer to hand color my photographs and ink jet prints with Conté Pastel Pencils because they are not too hard or too soft. In addition, I often use Marshall Oil Pencils for detail work because they are smaller and you can achieve a sharper point than you can with the larger pastel pencils.

Blending and mixing colors can be done with your finger, a tissue (wrapped around your finger), or a cotton swab (figure 1). The color can be reduced or removed with a kneaded eraser (figure 2), leaving no telltale smudges behind on the surface. If you don't like the color you have applied, remove it try another one. Nothing could be easier or more fun!

Kneaded erasers can be found at your local arts and crafts store. They are made soft and pliable by kneading or working them in your hand. When soft, they actually pick the color right off the surface without disturbing the paper fibers or ink jet coatings. You clean these erasers by stretching them out and kneading them up again. You can mold them into small points or flat edges, whatever shape is needed to pick out the color in a selected area. When the eraser is full of pigments, it will begin to look grungy and you won't be able to get a clean surface when you try to stretch and re-knead it. Just throw it away at this point. Kneaded erasers are very inexpensive.

The main difference in working with pastels as compared to other mediums is that, with other mediums, you blend (or mix) the colors on a palette before applying them to the paper or canvas. With pastels, you blend the colors directly on the paper or canvas surface.

Note: You can use oil pencils and pastel pencils together to hand color a print but, if you over-use the waxier oil pencils, the wax base will leave a shiny surface, whereas the pastels leave a nice, flat, matte surface.

You must apply the pastel pencils before you apply the oil pencils when using both to hand color your work. If the oil pencils are applied first, the wax will resist the pastel pencil coloring. Oil pencils are great for last-minute detail work on your hand-colored piece, such as tree branches, eyebrows and eyelashes, or to draw a line to help define some edge in the image.

figure 1

figure 2

Caution: In pastel coloring, the resulting dust will sometimes cover over areas where you do not wish it, especially in the darker areas of the print that help to maintain contrast. When this happens, the print will look flat. I constantly check for unwanted coverage after blending and remove stray pigment with a kneaded eraser as needed, thus preserving the contrast and snap of the print. When doing portraits, a likely place for this to happen is in the whites of the eyes. After coloring the skin tones and the eye color, take the kneaded eraser, form a point, and remove unwanted color from the whites of the eyes. You must constantly "clean up" after pastels!

figure 3

With pastels, you should apply color from dark to light. In other words, when beginning to apply pastel to the print, I put down my dark colors first in the darker areas of the print. For example, here in the trees (figure 3), I applied a dark green in the shadow areas. Then I used a cotton swab to spread the color. Next, I went back into that area and applied a moss green on top of the dark green and, finally, a lighter green around the edges with a bit of soft yellow (see page 123 for full image). Had this been a print with fall foliage, I might've used reds and rusty oranges on top of the dark green base. The application of a variety of colors will give your print a dimension and depth that would be missing if you limited yourself to, say, only one shade of green . When only one shade of a color is applied, the area becomes flat. I call this the "coloring book syndrome." To avoid this, use the color layering technique of applying dark colors first, then mid tones, and finally highlighting with a light color. This method works well with everything from landscapes to nudes.

Note: If you have added too much color in an area, the build up of pastel will not allow any more color to be added. Use a light coat of workable fixative. Wait for the coat to dry (about five minutes), then add more color. The workable fixative gives the surface a tooth, or a rough texture, which allows more color to be added. You can layer color in this fashion, allowing the color underneath to be seen through the new top layer of color. To tone down a color, or to lighten the shade, use a white pastel pencil to color over it and blend to achieve the desired effect.

If you have never really worked with coloring before and wish to learn, take the time to study color. You might elect to take a color course at a local university, or even just go out and study the colors of nature. Look at a leaf—really look at it—and observe the many shades of green that come together to form that particular shade. Study a field and note the myriad colors that emerge in various seasons. Watch the clouds and see how they change color as they fill with water, and how they reflect the sunlight. Take notice of shadows and highlights. Pay attention to the colors in both the sky and the clouds during sunrise or sunset. Look at someone's clothing and watch, as the person moves, how the light creates dark and light values in the cloth. A blue blouse isn't just blue; where a shadow is created, the blue is darker, perhaps even a little violet. Where the sun strikes the cloth, it is a lighter shade of blue. Notice people's hair; see how the hair reflects light, and how the light hits the hair and creates highlights. Sometimes colors can even be tinted by other nearby colored surfaces from which the light is reflected.

Teach yourself to really see! When you turn to your hand coloring work, keep these observations in mind. If you go to hand color a print of that blue blouse and you use only one shade of blue, it will look flat. Add shadows and highlights! Remember the multiplicity of tonal values that exist in the colors of the world around you.

Hand Coloring with Pastels

Step One
Begin your coloring at the top of the image and work your way down to avoid smearing.

Step Two
When applying color with pastel pencils, lay the pencil slightly on its side. This will help to avoid pencil indentation marks on the image, and it will also help to avoid scratching soft surfaces, like those of some ink jet coated papers.

Step Three
Use colors sparingly. Pastels will spread when blended, filling in the area.

Step Four
If your print will not take more coloring, use a light spray of workable fixative. Wait until it is dry, then apply more color.

Step Five
To sharpen pastel pencils, use a knife or a small hand held manual pencil sharpener. Electric pencil sharpeners crack the pencil and break the medium all the way through the pencil shaft.

Note: Always apply workable fixative before you apply final fixative. Give two light coats rather than one heavy one (letting the first dry before applying the second). A heavy coat of spray will dissolve the pastels. If you apply the final fixative first, your colors will disappear and go to pastel heaven!

Caution: *Always spray outside. Fixative sprays are toxic. Spray the print at arm's length and make sure that the wind is blowing away from your face. Tape the print to a piece of cardboard and hold the cardboard when spraying to avoid spraying your hands.*

Note: An image colored with pastels (whether pastel pencils or soft pastels) should be sprayed with two light coats of workable fixative, followed by a coat of final fixative. Apply the first coat, wait five or ten minutes, then apply another. This will keep it from smearing and protect it from atmospheric pollutants.

If you apply more color after workable fixative has been applied, you must reapply a layer of workable fixative to set the color before spraying the print with a final fixative.

Caution: *When spraying, remember that pastels are water-soluble. If the spray is held too close to the print surface, or you apply too much at once, the colors will dissolve.*

figure 4

Street in St. Remy

This shot was taken early one morning in Provence, France and the light was very flat. I transformed the image into a black-and-white using nik Color Efex Pro, and toned it a warm brown (figure 4). Then, I printed it out on Flaxen Weave ink jet coated paper.

Using pastel pencils to hand color the image, I was able to capture the feeling of an early morning in Provence even though the light in the original photograph was low and the alleyways were dark. I brightened it up by giving the sky a nice midday blue. The pastels were perfect for this scene, and the D-Max (see glossary) of the paper helped to give the image a bit more snap and contrast (figure 5).

Note: If you are trying to reproduce the colors of your base image but you've decided to work from a black-and-white base, print out a small, color reference print of the same image to use as a guide for your coloring.

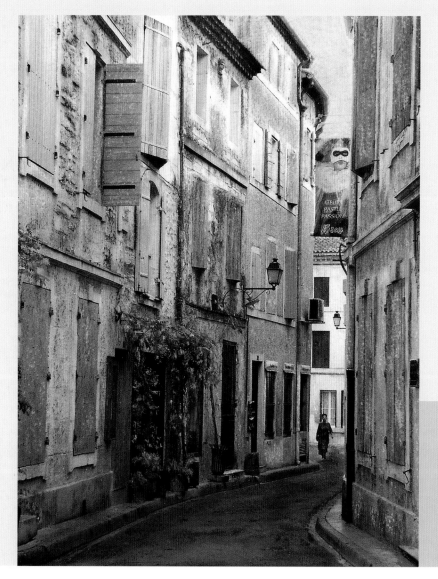

figure 5

Printing an Image for Coloring

There are several ways you can print the image you wish to color. If you start with a black-and-white image, you can print it as is or you may choose to tone it slightly to create a backdrop for the mood you intend to project through your hand coloring. If you're starting with a color image, you can convert it to black and white if you wish, again choosing to tone the black-and-white rendition if it suits you. Or, you could print out the image in color, but overly lightened, and just augment or reduce existing colors in the print when you hand color.

Shelly in the Olive Grove

This is a digital black-and-white infrared image taken in St. Remy, France that I toned sepia in Photoshop to facilitate hand coloring (figure 6).

I then chose to print the image on Charcoal R paper for its smoothness, as I wanted to show strong detail in the trees.

I placed the dark green coloring down first in the shadow areas of the trees, then added the lighter greens and finished off with yellow. (See the close-up shot of hand coloring on page 120.)

Here is the final piece, *Shelly in the Olive Grove* (figure 7).

figure 6

Hint: If you aren't quite sure which colors you should blend to achieve the look you want for your image, get a basic book on mixing colors, practice, and have fun doing it!

I keep a reference box that's full of color photographs of fields, trees, leaves, bark, clouds, seashores, sand, water, sunsets, etc., including photographs of many of these from each of the different seasons. I use these images as a reference for colors, especially on those cold, gray days of winter when I find it very difficult to recall all the wonderful colors of a spectacular sunset or a lovely fall landscape.

figure 7

Note: I shoot a lot of black-and-white infrared photography because it lends itself to hand coloring. If you take black-and-whites or infrared photos for this purpose and are not quite sure you can recapture the color correctly, take a color snapshot of the scene as well so that you'll have a reference print from which to work. (See pages 102-115 for more about digital infrared.)

figure 8

figure 9

figure 10

Pharmacie

Step One
The original photo was taken in Goudes, France. I printed it on cold-pressed watercolor paper to exaggerate the texture of the building.

Step Two
Next, I hand colored the print with pastel pencils using the techniques described above—beginning with the darkest colors and moving to the lightest, starting at the top of the print and working my way down so as not to smear the coloring.

Step Three
I used the kneaded eraser to pull out some unwanted color around the small white pipe under one of the lights (figure 8).

Step Four
The last pastel color I added was white, which I used to brighten the flaking part of the wall, add chipping and flaking to the window sills, and to soften the color in some areas (figure 9).

Step Five
Lastly, I did detail work in the sign with oil pencils (figure 10).

Here is the final piece, *Pharmacie* (figure 11).

Note: When applying the last color, or the highlight color, remember not to blend it in too much. This final color can be gently patted down or left on without blending to accentuate it.

Caution: You cannot make a bad print a good one by hand coloring it. If you color a bad print, you will just end up with a hand-colored bad print.

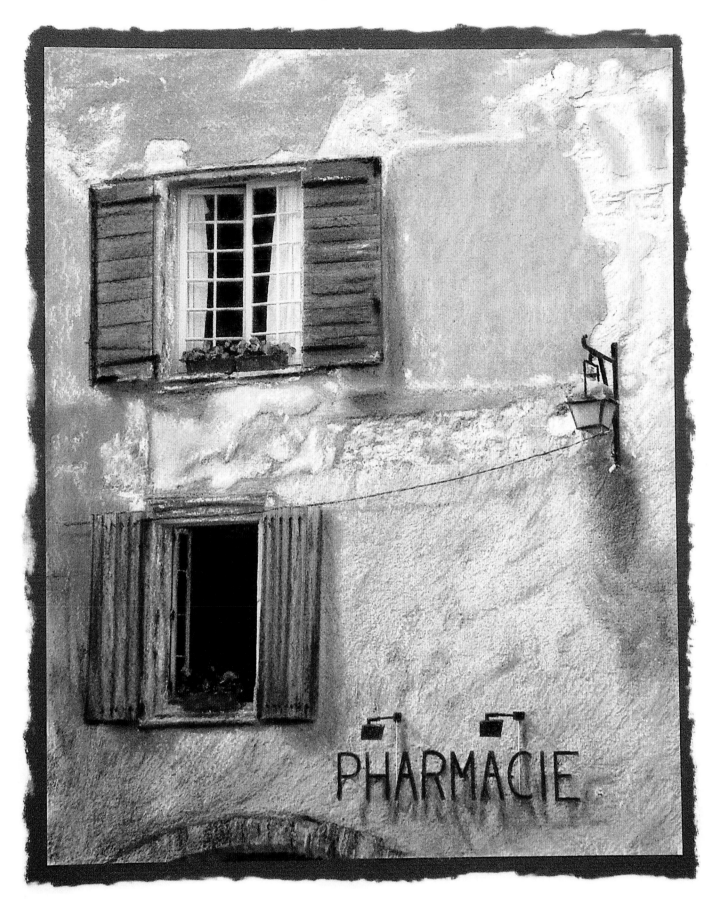

figure 11

figure 12

Heron in Tobacco Bay, Bermuda

Step One
I turned the original color image into a black-and-white using nik Color Efex Pro, then gave it a nice brown tone (figure 12).

Step Two
Then, I printed it out on Flaxen Weave ink jet coated paper and hand colored the image with pastel pencils to create a primeval look.

Step Three
Here is the final Heron in Tobacco Bay, Bermuda piece (figure 13).

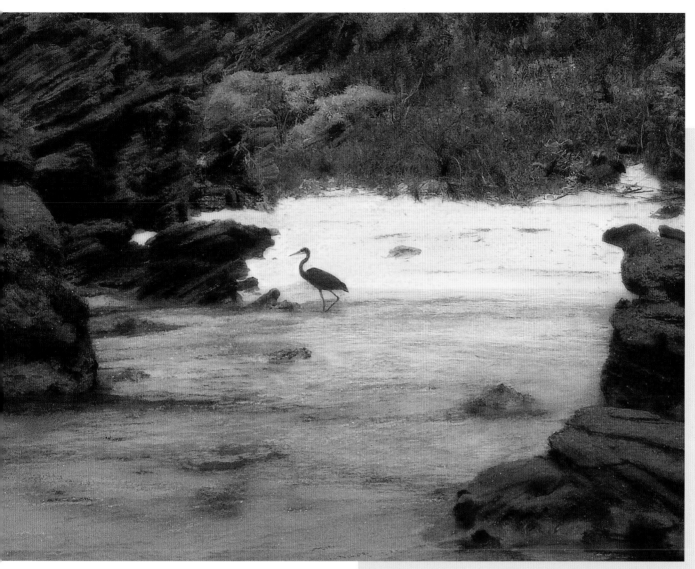

figure 13

Note: When printing your image, be aware of your final artistic goal for the piece when selecting which resolution to print at. If you'll only be adding slight color to your photographic print, you'll probably want to select a high resolution so that the image is clear and sharp. On the other hand, if you intend to use the digital print as a base sketch for a painting, as I often do, you can print at a lower resolution since you will ultimately color over the entire image with paint or pastels.

Suggested Papers for Hand Coloring with Pastel Pencils

Ink Jet Coated Papers

Lumijet

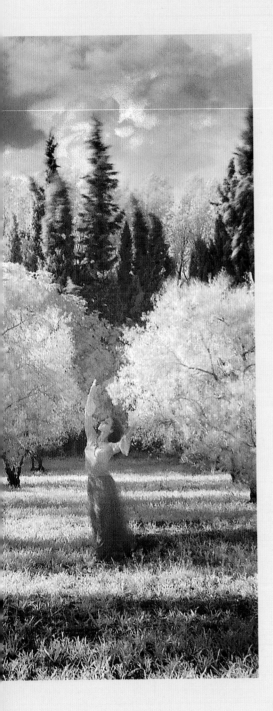

* **Flaxen Weave:** A rough textured paper that resembles a cold-pressed watercolor paper. It has great D-Max (i.e., maximum density, great color saturation—see the glossary for more details), giving the image good contrast. This paper receives pastels extremely well and allows blending of the colors beautifully. This one is my favorite.
* **Tapestry X:** Has a heavy, textured surface resembling canvas.
* **Charcoal R:** A very smooth paper. Pastels colors must be blended gently, as they are easily rubbed off. It renders a nice, subtle coloring.
* **Museum Parchment:** A lovely surface for pastels, but it tends to be fragile and the coating can be rubbed off if the applied color is worked in too hard. I usually use this paper for images that only need accentuated color, not coloring over the entire image.

Hahnemühle

* **Japan:** A translucent paper that has straw-like vegetable fibers throughout and is almost like fabric in its feel. It is great for use with watercolor pencils.
* **William Turner:** A slightly textured paper with a soft finish that is hard enough to take coloring.
* **Arkona:** Resembles a rough watercolor paper, and is great for hand coloring.
* **Structure:** Has a white finish and a softly rippled, textured surface.
* **Albrecht Dürer:** A rough textured paper with good contrast. I like this one very much.

St. Cuthberts Mill

* **Somerset Photo Enhanced, textured:** A toothy watercolor surface. Use it with pigmented inks to produce archival work.

Non-Coated Papers

Arches

* **Bright White:** A paper intended to be used with ink jet printers. It is not an ink jet coated paper, but the whiter surface gives better color to ink jet prints. Cold pressed (CP) is more textured than the hot pressed (HP, which is smooth). Both CP and HP are sized internally, so there is no "right" side. There is a smoother side to both papers and you can choose which side you prefer to work on. The piece entitled, *Pharmacie*, was printed on Arches Bright White CP paper, and I choose the rougher side to accentuate the texture of the wall (see page 125).
* **Watercolor Paper:** Arches regular watercolor paper. It comes in cold pressed (textured) and hot pressed (smooth). Both work well with pastels. This paper is warmer than the Bright White and will not produce the same range of colors from an ink jet printer. However, if you intend to color over the entire image, that is not a consideration.

Fabriano

* **Fabriano 5 Classico:** A watercolor paper with a slightly hard, bright white surface. It is 50% cotton and acid-free. Both the hot pressed and cold pressed papers are excellent choices for ink jet printing.

St. Cuthberts Mill

* **Somerset Velvet Radiant White:** A watercolor paper with a nice soft, velvet finish and enough strength to accept coloring and blending.

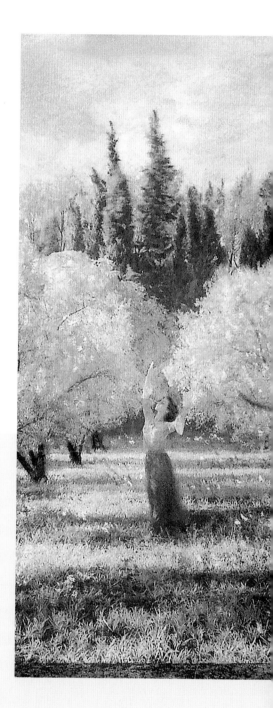

Working with Canvas

Many of the companies that produce ink jet paper also make ink jet coated canvas. The ink jet coated canvas is much more expensive than regular artist gessoed canvas, as the coating allows for better reception of ink jet inks and gives you a crisp, clean printed image. I buy and use ink jet coated canvases when I want to achieve the look of a painting on canvas. I buy the regular gessoed canvas when I wish to print out an image purely to use as a base sketch to do an oil painting or a pastel rendering (completely covering the entire image with paints or pastels). This artist gessoed canvas will not give you a great digital print, but it is good enough to use as a sketch for creating a painting. Both types of canvas (ink jet coated and artist gessoed) will take oils and pastels quite well. I tend to use the ink jet coated canvas when I want a sharp print and only intend to add a bit of color for effect (as opposed to using the print as a sketch to create an oil painting or a pastel rendering).

Rhyncostylus coelestis

When my husband and I decided to raise orchids twelve years ago, I found the perfect blend of working with plants and photography. As orchid species came into bloom, I photographed them for documentation. After collecting hundreds of slides, I felt compelled to do something a little different than a straight photo print. Pastels seemed to offer the opportunity to combine traditional artwork with photography, the end result being an old fashioned look that blended well with these spectacular flowers.

Photographing the flower is just the beginning of the process of creating this image. I scanned the color slide and converted the image to black and white using nik Color Efex Pro software. Printed on Arches hot press watercolor paper, the flowers were then colored with Conté pastel pencils.

I love to work with small images, blending and layering colors using blending stumps. Often, it requires several layers of blended color (with a very light touch to avoid tearing into the paper) to produce the desired result. Upon completion, I sprayed the image with a fixative to keep the pastels from smearing. The name of this orchid is Rhyncostylus coelestis.

Barbara Ellison has photographed and painted since she was a child. An avid gardener, she began photographing flowers when her husband, Michael Kovach, opened an orchid nursery. She has been surrounded by photography in her position as a pro-market representative for Canon USA for the past fifteen years. Her love of flowers and photography has enabled her to teach photography workshops, specializing in floral studio setups. Barbara has shown her hand-colored images and won several awards in various orchid shows around the country. She currently resides with her husband, two dogs, and a cat in Goldvein, Virginia.

Barbara Ellison—*Rhyncostylus coelestis*

6

Creative Imaging
Techniques

nik Color Efex Pro

nik Color Efex Pro is a very creative software that is used in conjunction with Photoshop. There are seventy-four amazing filters with which you can correct, enhance, or alter your image. These filters allow you to change the lighting of your image, add atmospheric conditions such as fog or sunlight, add drama to your sky—from steely grays to raspberry pinks, produce cross-processing effects (i.e., simulate the effects of using the "wrong" chemistry on slide film or C41 daylight film to produce unusual tones and colors), convert color to full-tonal black and white, and the list goes on and on. You can apply these filters globally or selectively.

The Wacom tablet, by Wacom Technology Corporation, is a very easy and smooth tool to use in conjunction with nik Color Efex Pro, especially if you like to paint and add effects selectively. The Wacom tablet has a program called Pen Palette that allows you to choose a filter and paint it on wherever you wish. If you do not own a Wacom tablet, you can use the History Brush in Photoshop to paint in an effect where you want it.

Note: Remember that, if you apply an effect, you can go immediately to the Menu tab and, under Edit, choose to reduce the effect a bit or try one of the blending modes to produce a different look. You can also lighten areas a bit with Photoshop's Dodge tool after you've applied an effect. I find this a good way to "snap" the highlights, as they tend to get dulled with some of the global filter effects.

figure 1

figure 2

Cows In the Meadow

This image was taken in Molokai, Hawaii on a very overcast day. I will use this shot to illustrate how you can take a plain image and create something quite extraordinary with the nik Color Efex Pro filters.

Step One
This is the original image (figure 1).

Step Two
I cropped and sharpened the image before applying any filters (figure 2). Once I had my base image looking the way I wanted it to, I began to experiment with the various filter options:

Old Photo: Color filter (figure 3).

Brilliance/Warmth filter (figure 4).

figure 3

figure 4

figure 5

figure 6

- **Midnight Blue filter** (figure 5).

- **Graduated Fog filter:** This was applied only to the top of the image (figure 6).

- **Graduated Fog filter:** Here, I applied the filter to the entire image (figure 7).

- **Midnight Sepia filter** (figure 8).

- **Midnight Sepia and Graduated Orange filters:**
 Before applying the filters, I selected the sky area with the Magic Wand and then hit the Option and Delete keys (or Alt and Delete for PC) to turn my selected area into white space to fill with a color of my choice. Remember to feather the selection by at least two or three pixels before hitting the key sequence. To feather your selection, go to Select in the menu bar, then scroll down to Feather. Also, make sure that the color white is in the foreground square in the toolbox. I applied the Graduated Orange filter twice, as just once looked too pale (figure 9).

figure 7

figure 8

figure 9

figure 10

figure 11

figure 12

figure 13

* **Midnight Sepia and Graduated (User Defined) Gray filters** (figure 10).

* **Indian Summer and Graduated Orange filters:** I applied the Indian Summer filter globally, then selectively added a Graduated Orange sky, again by selecting the sky area with the Magic Wand (figure 11).

* **Indian Summer filter:** Without changing the sky, I painted the effect onto the image using my Wacom tablet (figure 12).

* **Monday Morning Sepia filter:** I applied it selectively to the bottom of the image using my Wacom tablet. I left the sky alone, as it suited the colors (figure 13).

* **Foliage filter:** This one turned out a bit bright so, after applying the filter, I went to the Menu tab under Edit and faded the effect a bit (figure 14).

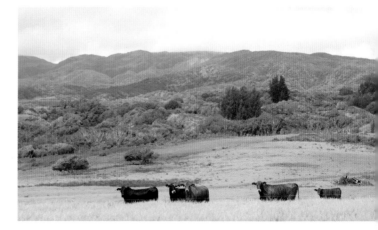

figure 14

Nude in the Arches

I took the shot of the arches in a deserted, deteriorating navy barrack in Bermuda. Looking at the image later, it seemed a bit empty to me, so I decided to snap up the colors and add a figure in the end of the tunnel created by the multiple arches.

Step One
First, I used the Brilliance/Warmth filter to brighten the colors (figure 15).

Step Two
Then, I selected a nude from another image and dragged it over into the image of the arches. I moved it to where I wanted it to be, then blended the figure into the stone with the Soft Light blending mode at an opacity of 75% in the Layers palette.

Step Three
The image still looked a little dark, so I selected the space around the figure with the Lasso tool, feathered the edges by 2 pixels, and used the Reflector: Gold filter in that space. The filter lighted the figure, as well as the dark part of the back wall, and that was all it needed (figure 16).

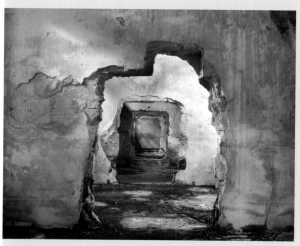

figure 15

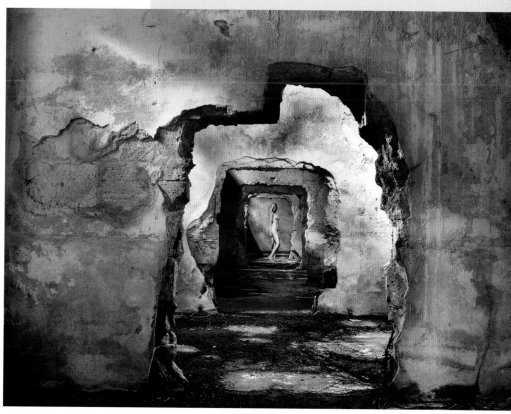

figure 16

Jerusalema Hui

I took this shot in the early morning, which gave the image its cool coloration (figure 17). Here are some of the filters that I applied to the original image:

❋ **Brilliance/Warmth:** I used this filter to see how the image would look with a warmer feel (figure 18).

❋ **Infrared: Color filter:** I tried this one just for fun! (figure 19)

❋ **Colorize filter:** I chose a yellow-brown color to give an antique look. You can choose any color that you wish (figure 20).

figure 17

figure 18

figure 19

figure 20

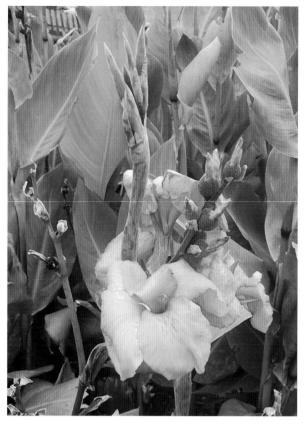

figure 21

Orange Flower

Step One
This is the original image, *Orange Flower* (figure 21).

Step Two
I opened the nik Color Efex Pro filters and chose Midnight Sepia to darken the background and give the flower a richer tone. For this version of the image, I chose not to use the blur slider (figure 22).

This is the completed initial version of this image (figure 23).

figure 22

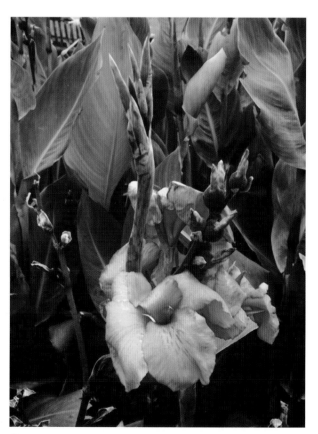

figure 23

Step Three

Then, I went back to the original shot and applied the Midnight Sepia filter again, but this time chose to use the blur slider (figure 24).

Step Four

This is the completed second version of the *Orange Flower* image using Midnight Sepia and blur (figure 25).

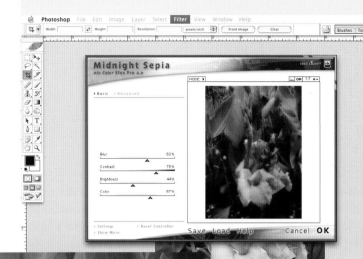

figure 24

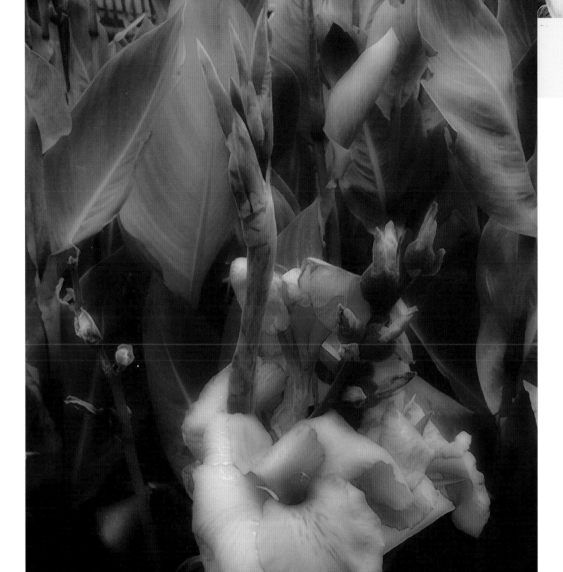

figure 25

Studio Artist
by Synthetik Software

Note: The Studio Artist program works in low resolution for speed, allowing you to work faster. It converts to a higher resolution later, providing clarity, sharpness, and great details (refer to the Studio Artist Quick Reference Guide below for more details).

Studio Artist is a painting, drawing, and video-processing program. It has hundreds of controls and effects that allow the artist to produce literally thousands of artistic variations from one image. It can turn a straight photograph into a lovely painting or sketch-like rendering, and it is easy and fun to use. The program also comes with three great tutorial CDs. You can elect to use the Studio Artist effects selectively in an area that you have designated, or you can allow the program to apply them globally across the entire image. I find the results are far better when I do it manually, applying the effects exactly where I wish them and to the degree that I feel suits the image. By applying the effects yourself, the results are more personal and look far more artistic and not as mechanical as letting the program automatically apply them.

When you first get the Studio Artist program, play around with it! That is the only way to learn. Just try out the various Patches and see what you like. You will eventually develop a unique style of your own, as well as a list of your favorite Patches.

Studio Artist Quick Reference Guide

✳ When the Studio Artist program first opens, it will show a dialog box of measurements and resolution. Just say OK to the 72 ppi. You can work more efficiently in a lower resolution and covert to a higher resolution when you're done.

✳ Once the program is open, and before you begin working, go to the menu bar and select Action. Scroll down to History Sequence Window.

✳ When it appears on the screen, move it over to the side, out of the way of the image area and check the box next to Record. Now, everything you do to the image will be recorded.

✳ To open your image file in the image area, go to the White drop-down menu in the upper right-hand corner of the screen. Scroll down and select Source Image.

✳ When you are finished working on the image, go to Canvas > ReRender Canvas.

✳ A dialog box will come up and ask if you wish to save the image as it is. Click Don't Save. (Yes, that's right—Don't Save!) The ReRender Canvas Settings box will appear as it did when you opened your image initially. This is where you adjust the final resolution to be what you wish (figure 26).

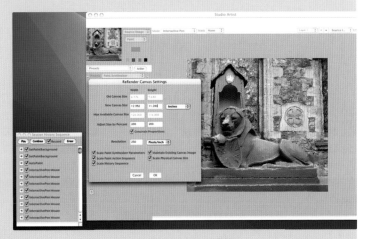

figure 26

✳ Select either Pixels/Inch or Pixels/Cm from the Resolution drop-down menu (I use Pixels/Inch), and Inches or Cent from the New Canvas Size drop-down menu.

✳ Set your desired resolution, 250 ppi, for example. Then look at the New Canvas Size entries. Here in the example (figure 26), the New Canvas Size is 12.352 x 11.280 inches. That size was fine with me, so I clicked OK. If you need it smaller or larger, lower or raise the resolution and watch the New Canvas Size change.

✳ Once you click OK, it will take a few seconds to resize and the screen will go gray.

✳ It will interpolate the image rather quickly, but it actually doesn't apply it for each step. After the gray box disappears, go to the History Sequence Window and uncheck the box next to Record, then check the box next to Play.

✳ You will now see each action that you applied to the image being resized. This takes a bit of time. The curser moves down the list and, when it reaches the end, it is interpolated to the new size and higher resolution.

✳ Next, go to the menu bar and click on File. Scroll down to Save Canvas Images As. I save my images in File Format: Photoshop after naming them. Also, I always put "SA" after the image name, so that I know that the image was manipulated in Studio Artist.

> *Note:* I work with a 9 x 12-inch Wacom Tablet. I love working with it because I can sit back with the tablet in my lap, use the pen as a drawing or painting tool, watch the screen, and manipulate the image. It is very enjoyable and easy to do. The pen gives you a lot of control, as it is pressure sensitive, so I can apply the effect exactly how I wish—lightly or heavily. By taking control with the pen, you can selectively choose where you wish to affect the image. The tablet is the same canvas area as the monitor after you set it up. It is so much easier than trying to do this with a mouse. It's just like drawing or painting directly onto the image. I highly recommend getting one if you enjoy creating painterly images.

Café with Blue Chairs

Step One
Here is my source image, *Café with Blue Chairs*
(figure 27).

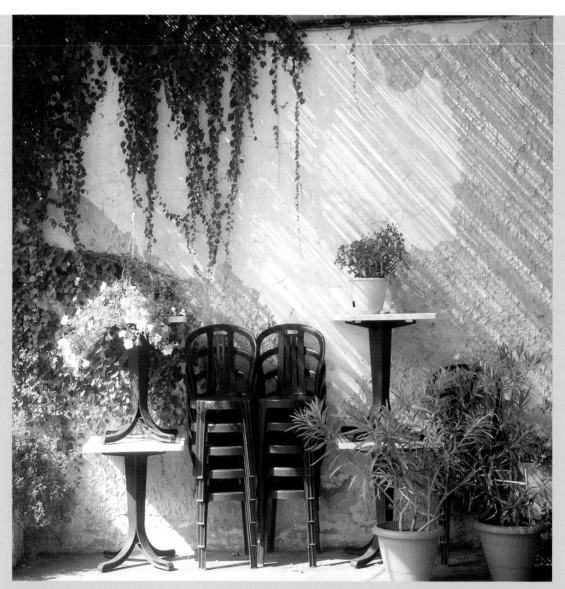

figure 27

Step Two

At the top right of white portion of the screen, there are two drop-down menus separated by two squares with circular icons inside. Go to the second drop-down menu (which should have the word "White" written in it) and use the scroll arrows to select "Source Image" (figure 28). The source image that is on the left side of the Studio Artist window will appear in the large white box.

Step Three

If you can't see the entire image (figure 29), use the "–" button in the top right corner to decrease the size of the image until it fits in the screen.

Step Four

Now, go to the very top of the screen (outside of the Studio Artist window) and access the Action tab. Go to Action > Session History Sequence. The Session History Sequence palette will appear. Move the box to the left side of the window, out of the way of your image (figure 30).

Step Five

Next, go to the Category drop-down menu on the left side of the Studio Artist window. Select the category you wish to work with (i.e., Spread Canvas, Auto Sketch, etc.). In this case, I used Spread Canvas (figure 30 detail), as I wanted to create a painting from the image, *Café with Blue Chairs*.

Step Six

Before you begin to affect your image, go to the Session History Sequence window and place a check in the box next to Record (at the top of the Session History Sequence window). With this box checked, every alteration you make to your image will be recorded in the Session History Sequence palette.

figure 28

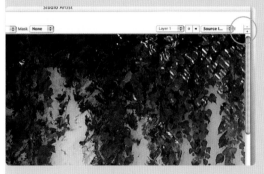

figure 29

figure 30 (detail)

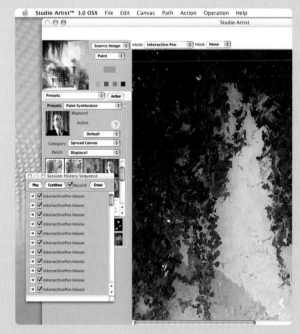

figure 30

figure 31

Hint: To create a pseudo-watercolor image, go to Category > Spread Canvas. Then go to Patch > Wet Mixer 1. At this point, you can click on Action and let the program apply the patch automatically, but sometimes the program overdoes it. The other patches to try with Spread Canvas are Displace 1 and Pixel Vacuum.

You can also try Category > Watercolor 2, then go under Patch and select Wet 1, Watercolor 1, or Ragged Tacky Lip 1. These are harder to control but, for certain images, they create just the right look. There are many, many more combinations to try, as well. I would suggest just playing with the various Patches to find the exact look you are trying to create. Sometimes I use only one effect, other times I use many, combining them as necessary to achieve the effect that I want. It is so much fun!

Step Seven

At the top of the Studio Artist screen, access the Mode drop-down menu. For this image, I selected the Interactive Pen mode (figure 31), as I use a Wacom Tablet when working with Studio Artist. This is a wonderful tool for painting at the computer. The pen is like using a paintbrush. It is pressure sensitive; the harder I press, the stronger the effect. Conversely, if I use a light touch, the effect is lessened. If you do not have a Wacom Tablet, you can use your mouse, though it is a bit more difficult to "paint" with ease. Refer to these tips, whichever method you choose:

✴ You can erase by going to the top right of the Studio Artist window and clicking on the small square with the empty circle icon (just to the right of the Layer drop-down menu). This will, however, erase everything and return you to your base image.

✴ You also have the Undo option, which will erase only the latest change you made to the image. You can either go to the Edit tab and scroll down to Undo, or use the keyboard by pressing Command/Cntrl Z, the same as in Photoshop.

✴ You can change the size of the brush by holding down the B key on your keyboard and dragging the mouse or Wacom pen until you get a dotted line that lets you resize the brush.

✴ To change the maximum size of the brush, go to Operation > Paint Synthesizer > Brush Source. A Parameters window will open and you can adjust the size and shape of the brush. When you are finished adjusting your brush, go to the Paint Synthesizer drop-down menu (just above the Parameters window) and scroll back up to Presets. This will bring you back to the Category and Patch drop-down menus.

Step Eight

Under the Patch drop-down menu (on the left side of the Studio Artist window just below Category), select the effect you want to start with. I began with Displace 1 (figure 32).

Step Nine

To create the watery effect I achieved here, I went to Category > Spread Canvas, then I began with Patch > Displace 1, alternating that with Wet Mixer.

figure 32

Step Ten

When I finished altering the image to my satisfaction, I went to the top of the screen (outside of the Studio Artist window) and clicked on the Canvas tab. Then, I scrolled down to ReRender Canvas.

The next dialogue box is Save Canvas Before Process. Be sure to check Don't Save! You want to rerender it at a larger resolution, not save it as its present low resolution.

The following dialogue box is ReRender Canvas Settings. I changed the pixel dimensions to inches and, after selecting a high resolution of 300 ppi, I selected a print size of 8 x 8 inches.

Once you have selected your pixel dimensions and adjusted your resolution, click OK. This first re-rendering takes very little time.

Step Eleven

When it is finished, go to the Session History Sequence palette, uncheck the box next to Record, then click on the Play button. The program will now re-render each of the actions applied to your the image, step by step, to a high resolution and clarity. This is a more thorough re-rendering and takes a longer time. You can actually watch it happening as it re-renders every action you applied to a higher resolution. As the steps are re-rendered, the slider bar will descend with each one until it hits the bottom. And voila—it's done!

Step Twelve

Now, go to the File tab at the top of the screen (outside of the Studio Artist window) and scroll down to Save Canvas As. Name your image and save it to your desktop as a PSD file. When you open your image again, it will be a high-resolution image.

I opened the manipulated image in Photoshop and decided to put a blue border around it.

To finish up, I selected an edge from Auto FX Photo/Graphic Edges (Volume 1, #77).

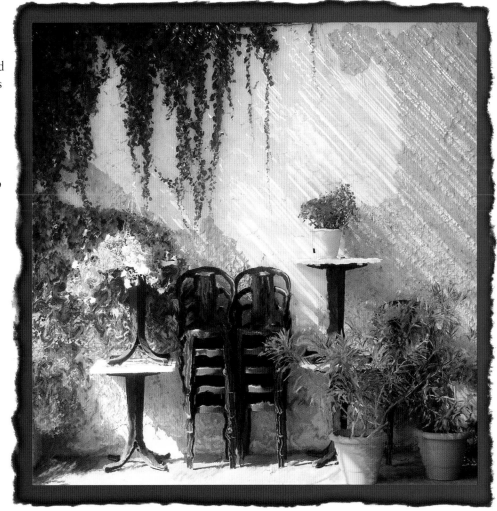

figure 33

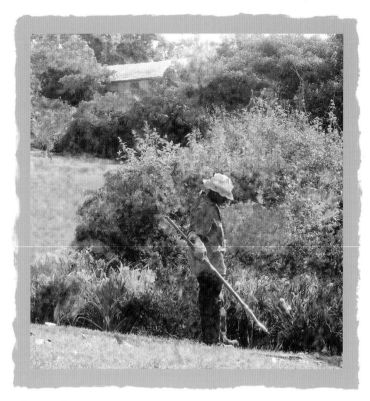

figure 34

The Gardener

I used the same Studio Artist technique to alter *The Gardener* (figure 34) as I did for *Café with Blue Chairs*.

Then, I decided to print it out onto canvas at a low resolution and use the digital print as a "sketch" from which to make the oil pastel painting. I like to use my fingers to paint, so when I wish to do an oil pastel painting, I use Sennelier Oil Pastels. They are so rich and creamy that they just glide onto the canvas. This is the resulting oil pastel version of *The Gardener* (figure 35).

Below is a close-up of the textured oil pastel painting (figure 36).

figure 36

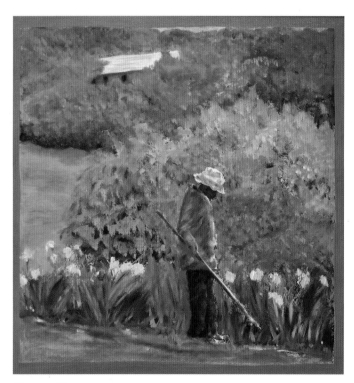

figure 35

Hint: If you intend to paint over an image printed out onto canvas, do not buy expensive ink jet coated canvas; get the standard gessoed canvas. It is far less expensive and, even though the details and clarity aren't as good as with the ink jet coated canvas, it doesn't matter if you only need it to act as a base sketch to paint over.

South Shore Moongate

After manipulating this image in Studio Artist (accomplished using the same technique as I used for *Café with Blue Chairs*), I applied the nik Color Efex Pro Midnight Sepia filter, then opened it in Auto FX Photo/Graphic Edges and selected an edge to compliment the image (Volume 1, #77) (figure 37).

Green Jugs

This image was also manipulated in Studio Artist using the process outlined for *Café with Blue Chairs*. As with that image, I created a border for my *Green Jugs* piece in Photoshop, then opened the bordered file in Auto FX Photo/Graphic Edges and applied the edge found in Volume 1, #280 (figure 38).

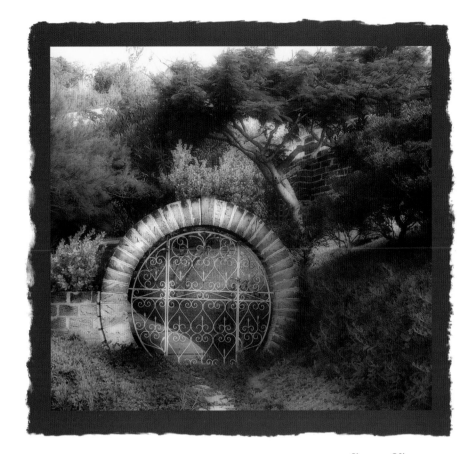

figure 37

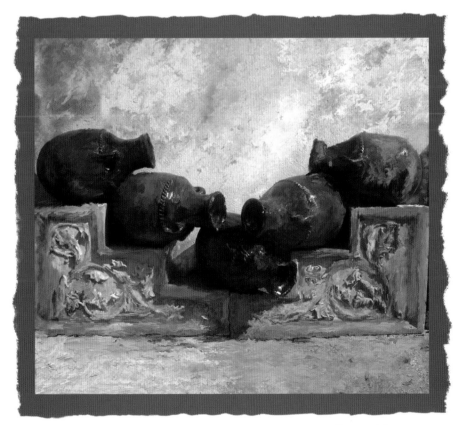

figure 38

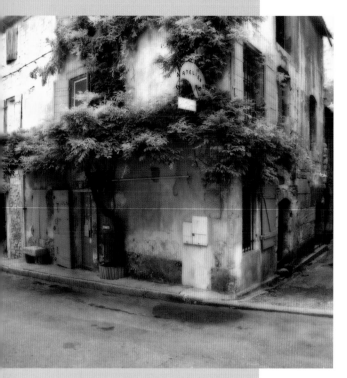

figure 39

The Atelier

Step One
This is the original shot before I manipulated it in Studio Artist. I used a Nikon #1 Soft filter when I captured the image (figure 39).

Step Two
This is the image after being manipulated in Studio Artist using the same technique described in *Café with Blue Chairs*. I opened the manipulated image in Photoshop and created a border by clicking on the background square and using the eyedropper to select a color from inside the image (figure 40).

Step Three
Then, I went to the menu bar (in Photoshop) and under the Image tab, I scrolled down to Canvas size. I changed the size by adding an inch to both the width and the height of the canvas and clicked OK. This gave me a one-inch border that was the color of the background square I had pre-selected before I went into the Canvas size dialogue box. I liked the plain border without any additional edges, so I kept it as it is.

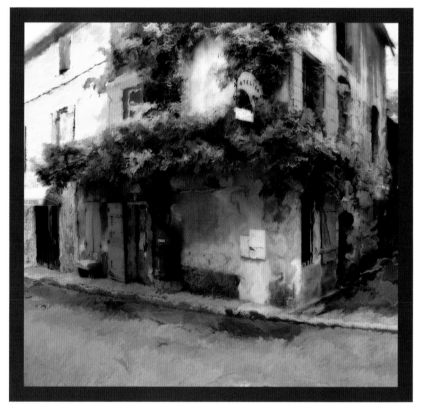

figure 40

You can, of course, also apply an edge without adding the border if that's an effect you'd prefer. The border just keeps the edge from intruding on the image. In some images, however, the edge looks great applied to the image itself; in other cases, I like to keep the image pure and apply the edge to the border.

Caution: If you try to open a Studio Artist manipulated image in Auto FX Photo/Graphic Edges and the image comes up with a strange "mask" over it, then you have an Alpha 1 Channel saved with the image (figure 41). You must open Channels in Photoshop and delete the Alpha 1 channel. Go to Windows > Channels, then click on the Alpha 1 Channel and drag it into the trash. Now you can go to Photo/Graphic Edges to add your selected edge and the program will see the image as flattened.

To Avoid This Problem:

Turn off the use of the Alpha Channel for display in Studio Artist. Make sure that the Alpha popup in the Layers window is set to Off right when you start up the program.

Be sure not to draw into the Alpha layer when painting. Go to File > Preferences > Layer Preferences. When the popup window appears, make sure that Paint Alpha Fill Status is set to Off.

I also go to File > Preferences > Layer Preferences (in Studio Artist) and set the Default Save Output Alpha option to Full On.

figure 41

Reflection

After *La Pia* by Dante Gabriel Rossetti (1868–1880)

This piece is from my Pre-Raphaelite transcription series, which consisted of a panel of fifteen works that I submitted as a successful application for an Associateship of the Royal Photographic Society in 2001. *Reflection* is comprised of 16 photographs—of body parts, leaves, ivy, honeysuckle, and a dead butterfly—and wax crayon rubbings of leaves, as well as actual leaves. The image was built using 22 different layers in Photoshop combined with layers of digital painting using Corel Painter software.

Step One
The 16 photographs were positioned onto the background of a new file in Photoshop, in Layers, using Normal blending mode.

Step Two
The leaves and wax rubbings were scanned (using a flatbed scanner), selected, and moved (as new layers) onto the 16-photograph background, then saved in Normal blending mode.

Step Three
Duplicate layers were made of each component and varied blending modes were applied. (I find that the unexpected results achieved through experimenting with the effects of different blending modes are worth the time spent.)

Step Four
The image was flattened and saved (with the layers intact) as a JPEG file, then opened in Corel Painter.

Step Five
Using a Wacom Intuos 2 Tablet and one of the many Corel Painter "real media" brushes, I used digital painting to blend the image components and add illustrative features. The painted file was saved and added as a new layer to the original image in Photoshop.

Step Six
New layers of painting and further duplicate photo layers were built up until the desired result was achieved. As the picture unfolded, my method of making extremely rough selections and using varied blending modes created a false impression of "good selection." Layers can be deceptive. However, the point of this deception, for me, was to exploit the use of the blending modes.

Step Seven
Having made the figure from several photographic components, it was completely out of proportion. (Even so, this did not appear to distract other viewers of the piece, as the picture went on to win a gold medal in a European photographic art salon!) So, my decision was to heavily crop the image, thus losing much of my extensive digital painting but leaving, for me, a more satisfying result (figure 2).

Carol Tipping is an Associate of the Royal Photographic Society. She has been awarded medals from the London Salon of Photography, the Austrian Super-Circuit, and the Photographic Association of Great Britain. After obtaining a degree in Fine Arts, Carol was an art lecturer at John Moore's University of Liverpool and Metropolitan College, Wirral, U.K. For access to her fine art limited edition prints, galleries, tutorials, and interviews, please visit her website: www. caroltipping.com. She is also a practicing astrologer.

An original photo layer.

figure 1

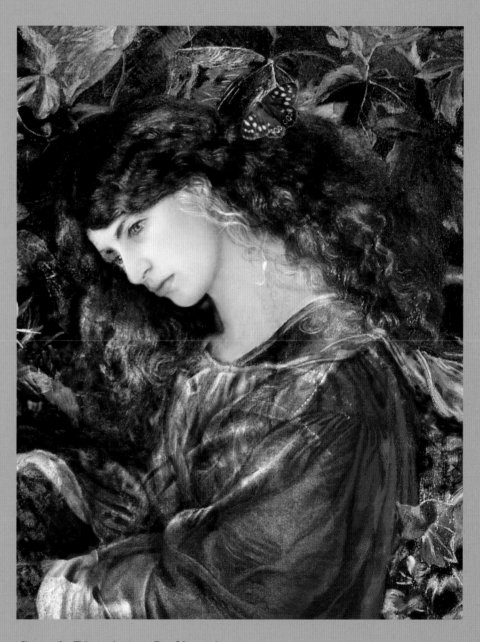

Carol Tipping—*Reflection* figure 2

Creating
Sketches and
Pseudo Watercolors

Sketches

Not all images will make good sketches, but you will never know unless you try it. The process is really quick and easy! The sketched versions will be black and white, but you can choose to tone them with any color you wish.

Hint: Photoshop does a great job creating a sketched version of images with prominent architectural structures (like *Rousillion*—see page 158) or ones that have a lot of sharp lines (like *Palm Leaves* on page 164). However, for portraits or less graphic images, I use Studio Artist to create the sketch. It gives a more detailed line drawing and works with just about any type of imagery.

My Daddy

Step One
This photograph, entitled *My Daddy,* is the original color photo base that I used to create a sketch (figure 1).

Step Two
I cropped the original shot and used this square version to work with in Studio Artist (figure 2).

Step Three
When you first open the Studio Artist program, the initial dialog box that pops up asks you to select a source image. Once you've clicked on the image you wish to alter, a second dialog box appears: Set Canvas Size. Instead of just clicking OK and starting to work on your image at the default low resolution of 72 ppi, change the resolution to a higher number, such as 200 or 300 ppi, and use the Canvas Size dimension boxes to select the size of the image (always select a size no larger than the Maximum Available Canvas Size, listed just below the Canvas Size dimensions). The drop-down menu beside the Canvas Size dimension boxes has pixels as the size measurement default. I like to switch it to inches instead of pixels, then I click OK to finalize my selections.

Note: Since this technique only involves one application step, it is okay to work at a higher resolution from the start (in contrast to the pseudo watercolor/colored drawing techniques detailed on pages 158-165).

Step Four
The program will open with the source image in the upper left corner of the Studio Artist window and there will be a blank white screen to the right. Go to the top right corner of the Studio Artist window and locate the drop-down menu that says "White." Scroll down and select Texture Invert. This will immediately render a sketched version of the source image (figure 3).

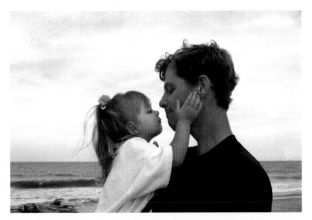

figure 1

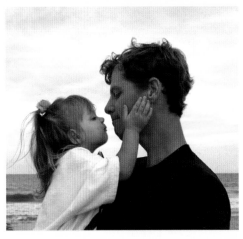

figure 2

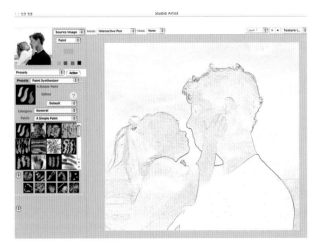

figure 3

Note: When using Studio Artist to create a sketch-like rendering, there is no need to convert your source image to black and white first, as is necessary when using Find Edges in Photoshop. In fact, the Texture Invert sketch conversion in Studio Artist gives a more detailed sketch than Photoshop's Find Edges.

Step Five

Now go to the menu bar and under File > Save Canvas Image As, title your "sketch" and save it to your desktop (or another pre-determined location).

Step Six

After you've saved your image to the desktop as a Photoshop file (PSD), you can tone the image if you wish. I opened the image in Photoshop and made sure that the file was in RGB mode. If it is in Grayscale, you will not be able to tone it.

Note: To change from Grayscale to RGB, go to the menu bar, access the Image tab, and drag down to Image > Mode > RGB.

Step Seven

To add the tone, go to Image > Adjust > Color Balance. I used +13 Red and -13 Yellow to achieve a warm brown tone (**figure 4**).

figure 4

figure 5

My Dad

This image is of my son, Scott, and his son, Liam. It was made exactly the same way that *My Daddy* was made. I love both of these shots. To me, the sketches impart more feeling than the original color photographs and create a mood not felt or seen in the color versions (figure 5).

Pseudo Watercolors

This technique involves overlaying a black-and-white or brown-toned sketch version of a color photograph on top of the original image. This will produce beautiful pseudo watercolor or colored drawing effects. I use this technique quite a bit. It can be as subtle or as emphatic as you wish, according to the blending modes you choose.

Rousillion

Step One
I selected my base image and opened it in Photoshop (figure 6).

Step Two
Then I made a duplicate of the image file to work with and set the original aside.

Note: This process works best with images that have graphic or architectural elements.

Hint: It is always wise to save your original image, perhaps even in a separate folder. You may want to add an additional character to the file name of your copy so that you don't accidentally overwrite the original (i.e., *Image.tif* and *Image2.tif*).

figure 6

Step Three

If you're starting with a color image (recommended), convert it to black and white. I accomplish this using the nik Color Efex Pro conversion filter (figure 7). The nik filter does a great job with the conversion, providing excellent tonal range, contrast, and sharpness (figure 8). If you do not have nik Color Efex Pro, go to the Menu tab and select Mode > Grayscale.

Step Four

After the color image is converted to black and white, you will need to sharpen it and add a bit of contrast.

Step Five

Next, in the Photoshop menu bar, go to Filters > Stylize > Find Edges. This will create a good black and white sketch of the image (figure 9).

Note: If you apply this filter without converting your color image to black and white, the result is less effective and there will be a lot of color noise in the final print.

If you used Mode > Grayscale to convert to black and white, you will have to change the image to RGB by going back to the Menu tab and selecting Mode > RGB. This will increase the size of the file and change the file type from Grayscale to RGB, but you will not see a difference in the appearance of the sketch onscreen.

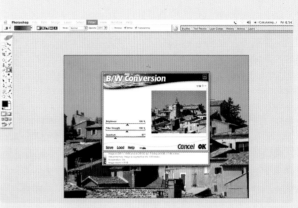

figure 7

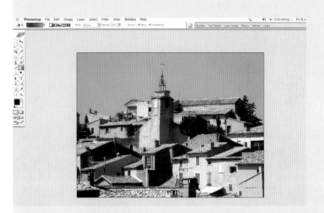

figure 8

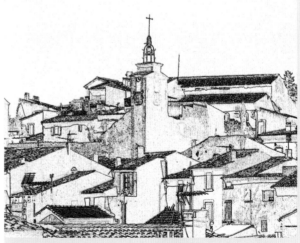

figure 9

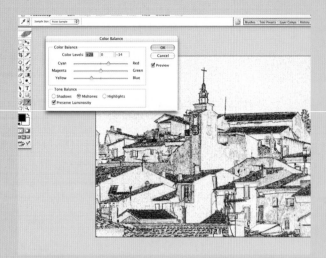

figure 10

figure 11

Step Six

Sometimes the sketch will blend better with the original image if you tone it a rich brown, but this all depends on the colors of the original shot. Sometimes the black sketch will work better. You just have to try both. To tone your sketch, go to the Menu tab, then Image > Adjust > Color Balance and move the red and yellow sliders until you have a brown tone that you like (figure 10 and figure 11).

Step Seven

Take the sketched version of your image and drag it on top of the color image base. As soon as you drag one image on top of the other in Photoshop, it automatically becomes another layer. Go to Window > Layers to see the two files on top of each other.

Hint: When dragging one layer on top of another and they are both the same size and resolution, hold down the Shift key and they will register perfectly.

Hint: If you are using Layers and Channels a lot, I would suggest that you click on the arrow icon in the upper right-hand corner of the window and select Dock in Palette Well. They will now be docked on the far right side of the Photoshop menu bar. Just click on the appropriate tab to access the window you wish to use.

Step Eight

Now, by using the various blending modes (top box in the upper left corner) in the Layers Palette and the Opacity slider (on the right side), you can create some very beautiful and interesting images. Here you can see the result of my combination of the brown toned sketch and the color image using the Overlay mode at 100% opacity (figure 13) With this particular piece, the brown-toned sketch overlay did not look much different than that of the black-and-white sketch.

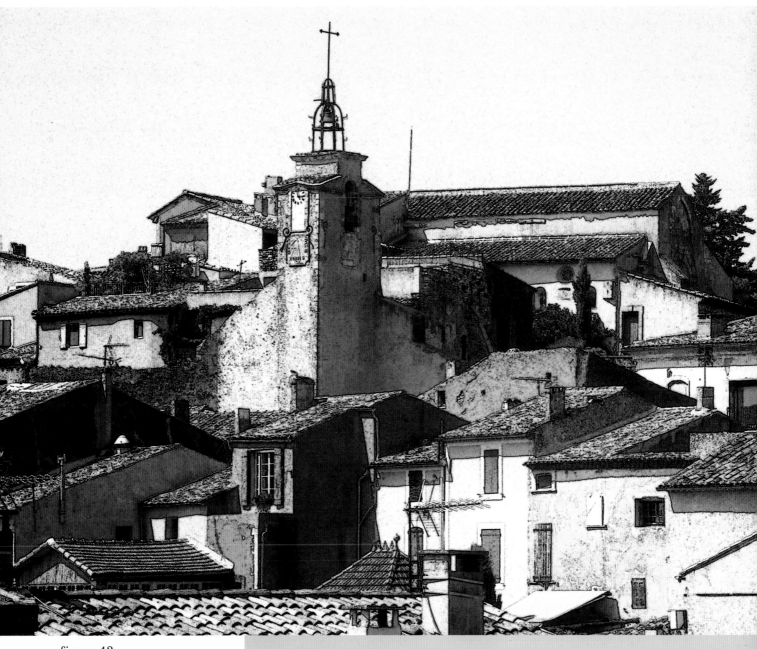

figure 12

Note: Be sure to flatten your layers before printing. You may also want to save a layered copy of the image under a new file name in case you need to make further adjustments.

Tuffy In the Snow/
I Hate the Snow

Step One
Here is the original shot, *Tuffy in the Snow* (figure 13).

Step Two
Using the same method I did for the *My Daddy* image, I created a sketched version of this image in Studio Artist. I saved this version under its own file name (figure 14).

Step Three
Then, I played with the image in Studio Artist, applying Watercolor 2 from the drop-down Category menu and Watercolor 1 from the drop-down Patch menu. I saved this version of the image with a different file name (figure 15).

figure 13

figure 14

figure 15

Step Four

Then, in Photoshop, I dragged the watercolor version of *Tuffy in the Snow* on top of the sketched version of the image, blended them in the Layers palette using Hard Light mode, and flattened the image (figure 16).

Step Five

Because the cat's face and whiskers were not as clear as I wished them to be, I dragged the blended Hard Light version over top of the original shot, adding a mask to the layer by clicking on the camera icon in the Layers palette (figure 17).

Step Six

Working in the layer mask (by clicking on the mask and highlighting it), I selected the Eraser tool from the toolbox and began to erase (at an opacity of 58%) some information from the face area, especially the whiskers, eyes, and a bit of the ears (figure 18). Remember, you can erase information from the top image if the foreground box color is white, and paint information back in if the foreground color is black. You can switch back and forth by clicking on the different foreground colors, or by pressing the X key on your keyboard.

Step Seven

Here is the final shot. I decided to title it, *I Hate the Snow.* You can see that I have brought out enough of the cat's face to see the eyes, ears, and whiskers clearly, while still maintaining a very painterly look to the piece (figure 19).

figure 16

figure 17

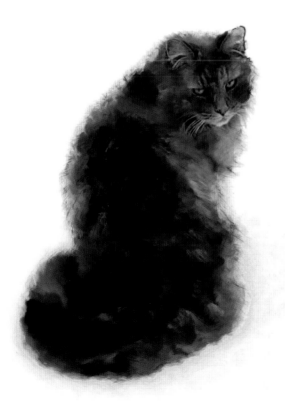

figure 18

Hint: You can erase in degrees by using the Opacity slider. Sometimes, just a light touch of detail is needed to create the perfect image.

figure 19

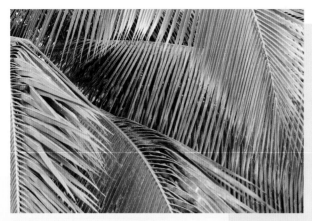

figure 20

figure 21

figure 22

Palm Leaves

In an image with lighter tones, such as *Palm Leaves*, there can be a big difference between the look of the brown-toned sketch overlay and that of the black-and-white sketch. The brown-toned sketch is more pleasing in this case, as it blends nicely with the greens. This, of course, is a subjective opinion but, as the photographer and printer, that is my prerogative. Create your art to be pleasing to your eye!

For *Palm Leaves*, I used the same process of converting a color image to black and white, making both a brown-toned and a black-and-white sketch, then overlaying the sketches on top of the original color image to see which worked best. I used a variety of blending modes in Layers to create different looks for the image.

Step One
Here is the original *Palm Leaves* image (figure 20).

Step Two
I converted it to black and white using nik Color Efex Pro (figure 21).

Step Three
Then, I created black-and-white and brown-toned sketch versions. This is the brown-toned sketch (figure 22).

figure 23

figure 24

figure 25

Step Four

Here are the various blending modes I experimented with in Layers. To my eye, the brown-toned sketch looked best overlaid on top of the original:

figure 26

- Color mode at 66% opacity (figure 23).

- Hard Light mode (figure 24).

- Lighten mode (figure 25).

- Luminosity mode at 55% opacity (figure 26).

- Pin Light mode (figure 27).

- Screen mode (figure 28).

- Difference mode (figure 29).

figure 27

figure 29

figure 28

Pines and Palace, Versailles

A recurring theme in my photography is that "reality is rarely good enough."
The Pines and Palace, Versailles image is a good example of how I take a
perfectly good scene and mess with it—both in Photoshop and in the darkroom.

I exposed the original scene (figure 1) with an Olympus E-10 digital camera.
To alter the tonality of the image, I used a series of Selection Masks in Photoshop
(figures 2, 3, and 4). These masks provided lots of control when I changed the
contrast and saturation, and blurred parts of the image.

The camera produced an image aspect ratio of 3:4, a bit "chunky" (too square)
compared to the wider 2:3 aspect ratio of 35mm cameras and full-framed digital
SLRs. With this subject, I didn't have to honor any literal rendering so I
"squished" the image by *not* checking the Constrain Proportions option in
the Image Size dialog box.

I printed this image as a Pigment-Over-Platinum print. This is a process I
pioneered in 2001 in which I combine digitally applied archival pigments with
hand-coated platinum/palladium. Because I want most of the depth and detail to
come from the platinum part of the process, I create a Photoshop Adjustment
Layer that removes all the black. This results in a very light, desaturated color
image on the watercolor paper. Figure 5 shows how little pigment is applied to
the watercolor paper during printing.

After printing the pigment onto the watercolor paper, I apply the light-sensitive
platinum sensitizer to the image. That's right, I paint the sensitizer right over the
pigments. Happily, the Epson pigments are waterproof! When this coating is dry,
I'm ready to expose it to UV light. But first, I have to make a digital negative the
same size as the print itself (figure 6). This is a cinch using the Epson 2200
printer and Pictorico OHP (overhead projector) film. I carefully line up the digital
negative to be in perfect registration with the pigment image, then clamp them
together in a vacuum frame. Next, I expose this print just like I would any tradi-
tional platinum/palladium print.

After developing and clearing the print, I wash it for one hour (just like a silver
gelatin print) to remove any chemical traces that could reduce the print's
archival properties. The final Pigment-Over-Platinum image combines the
intrigue and precision offered by digital control with the warmth and charm of a
handmade print.

Dan Burkholder is recognized as a pioneer of contemporary photography. First
exploiting digital technology in 1992 to make enlarged negatives for platinum/palladium printing,
his award-winning book, *Making Digital Negatives for Contact Printing,* is now a standard
reference in the fine-art printmaking community. Dan has taught classes at the International Center
of Photography (New York), The Museum of Photographic Arts (San Diego), The School of
the Art Institute of Chicago, and The Royal Photographic Society (Madrid, Spain), to name a few.
Burkholder's prints can be found internationally in both private and museum collections. To see
Dan's images and learn about his workshops, visit his website: www.danburkholder.com.

figure 1

figure 2

figure 3

figure 4

figure 5

figure 6

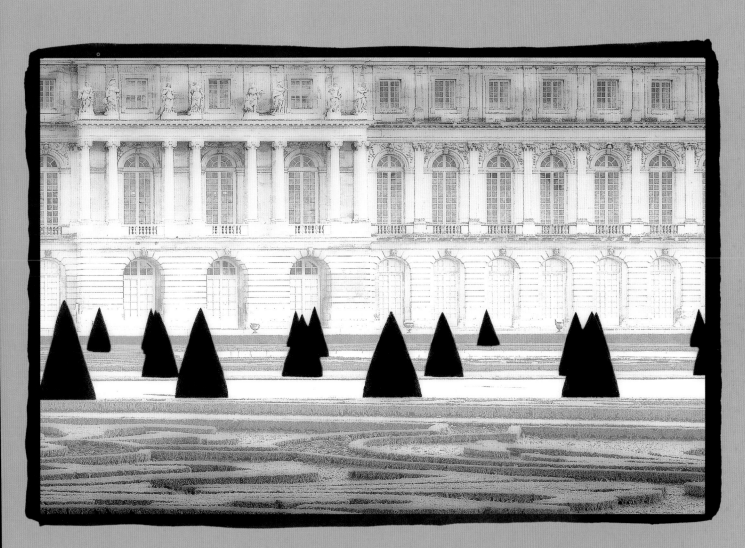

Dan Burkholder—*Pines and Palace, Versailles*

8

Creating Vintage
Photographs

Envision the Perfect Scene

Many times when traveling, you arrive at
a perfect scene only to find that it has less than perfect lighting, or
visual distractions such as fellow tourists. I have learned to take the shot
anyway. Then later, when I am at the computer, I use my imagination (with
the help of some great software) to recreate the scene that I wanted to
see—the one I visualized in my mind's eye.

Old House and Waterwheel

Step One
Here is the original shot, with tourists and a white sky (figure 1).

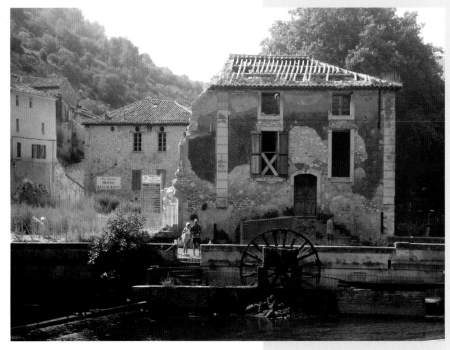

figure 1

Step Two
My next step was to remove the tourists, dog, and hotel signs with the Cloning tool and the Healing Brush in Photoshop (figure 2).

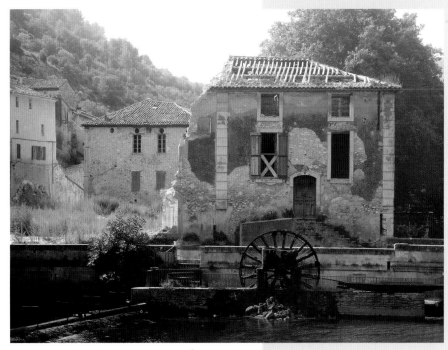

figure 2

figure 3

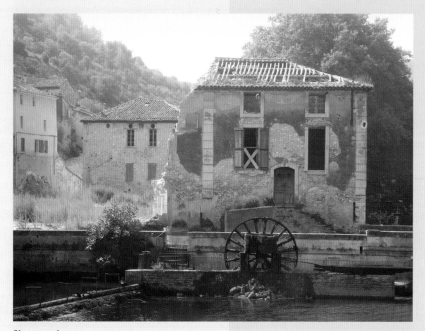

figure 4

figure 5

figure 6

Step Three
Then I selected the sky area with the Magic Wand tool and feathered the selection with a radius of two pixels.

Step Four
I then filled in my selection with the nik Color Efex Pro Graduated Coffee filter (figure 3).

Step Five
Here is the image with the Graduated Coffee filter applied to the sky area (figure 4).

Step Six
I then elected to use the nik Color Efex Pro Midnight Sepia filter globally across the image (figure 5).

Step Seven
The Midnight Sepia filter imparted the image with the "old world look" I was aiming for (figure 6).

Step Eight

I decided that a nice rolling fog would enhance the image even further, so I went into the Auto FX Photo/Graphic Edges program, selected an edge (Volume 8, #689), and moved the fog edge around until I liked it. I also played with the opacity slider (figure 7).

Step Nine

Next, I created a border around the image in Photoshop:

- I selected a suitable color by clicking on the background square in the toolbox and using the Eyedropper to pick out a nice warm brown from the image.

- To select a border in Photoshop, go to Image > Canvas Size, then decide what size border you want around the image. Add the size of the border (for example, one inch) to each of the existing canvas dimensions and click OK. If you do not like the color, simply go to Edit > Undo, and try another one!

Step Ten

Once I had applied the colored border, I went back to Auto FX Photo/Graphic Edges and gave it a finishing touch by selecting an edge that suited the image (figure 8).

Step Eleven

I printed *Old House and Waterwheel* onto Lumijet Flaxen Weave paper, giving it yet another dimension of texture.

figure 7

figure 8

figure 9

River Vaucluse

This is the original River Vaucluse image (figure 9).

I altered it (figure 10) using the same filters and software I used to create the *Old House and Waterwheel* piece.

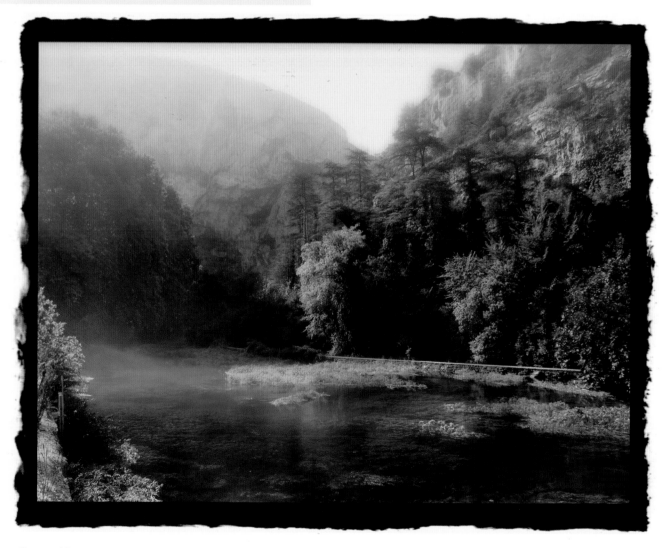

figure 10

Sam on the Pier

The shot was taken at sunset (figure 11), but the light was not as golden as I wanted it so, after I opened the file, I applied the nik Color Efex Pro Midnight Sepia filter. This increased the gold tones and darkened the background, focusing the attention on the figure standing on the pier. Now the image has the romantic and mysterious quality that I saw in my mind's eye (figure 12).

figure 11

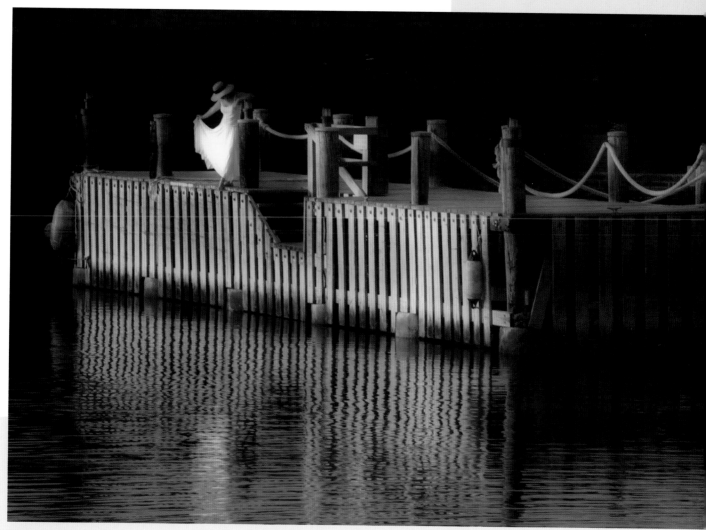

figure 12

Pseudo Bromoils

An Englishman named C. Wellbourne Piper invented the bromoil process in 1907. Bromoil prints are silver bromide or chlorobromide prints from which the silver is removed and an oil-based pigment is substituted. After making a silver print, it is then placed into a chemical bath that washes away the silver image and converts the gelatin coating that holds the silver into varying degrees of insolubility. At this point, the print is called a matrix. You place the matrix into warm water, which swells the gelatin in direct proportion to the amount of silver that was contained in the print. The dark areas (shadow areas) swell very little, the highlights swell a great deal, and the mid-tones in varying degrees.

An oil-based ink is applied to the moist matrix with a "stag's foot" brush (one in which the bristles of the brush have a convex shape) using a technique called stippling that produces a speckled look. The highlights, which are swollen with gelatin, will reject the ink, whereas the dark areas will receive the ink heavily and the mid tones in proportion to the amount of silver originally contained in that area of the print. The end result is a beautiful pigment-processed print that is perhaps the most archival of any type of photographic print. Bromoil prints have a grainy look to them and can be any color, according to the color of the oil-based ink used in the inking portion of the process.

I have taken several bromoil printing courses and have enjoyed the process very much. However, I do not have the patience or the time to do this on a regular basis. That being said, I do love the look of bromoils, so I began to experiment with Photoshop in an attempt to achieve a pseudo bromoil look.

You can use either color or black-and-white images for this technique. If you're starting with a color image, you'll first need to convert it into black and white using Channel Mixer in Photoshop, or through nik Color Efex Pro filters. Once you're working with a black-and-white image, whether original or converted, open it up in Photoshop and follow this simple checklist:

* Go to Filters > Noise > Add Noise.

* Make sure that Monochromatic is checked.

* Add around 30% noise. (This is a visual preference, I like to keep some of the details in the print, so I usually choose somewhere in the 25% to 35% range.)

* Select Uniform as your distribution mode. (I prefer Uniform to Gaussian, as Gaussian is a more pronounced grain.)

That's it! Follow those four steps and you can transform any black-and-white image into a Pseudo Bromoil. I have found that the drama and contrast of infrared images works especially well for creating pseudo bromoils. Here are some examples of infrared images I transformed using this easy software technique.

Grandfather Tree

Step One

This is the original digital infrared image, taken with a Minolta DiMAGE 7 camera and a Tiffen 87 opaque filter. I chose this filter because I wanted the sky to be very black to bring out the cloud formations (figure 13).

Step Two

I then used the steps I've outlined here to transform *Grandfather Tree* into a pseudo bromoil, adding 33% noise, and being sure to have Monochromatic checked, and selecting Uniform as my distribution mode (figure 14).

Step Three

Here is the final image, transformed by the pseudo bromoil effect (figure 15).

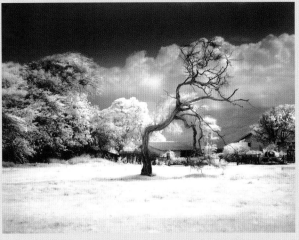

figure 13

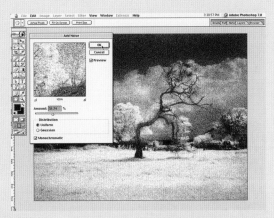

figure 14

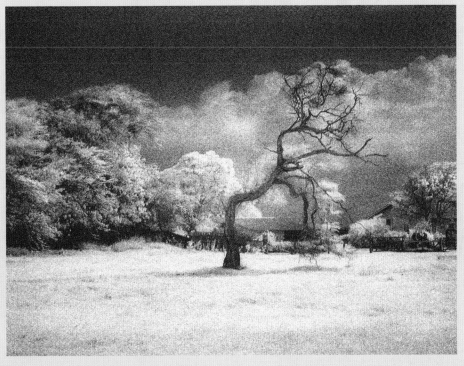

figure 15

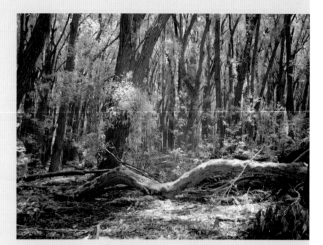

figure 16

figure 17

Log in the Sacred Forest

This original was another digital infrared image I shot with the DiMAGE 7 using a Harrison & Harrison 89B infrared (IR) filter (**figure 16**).

Here is the pseudo bromoil effect I created for this shot. I added 32% noise to my original image (**figure 17**).

Fontaine de Vaucluse

This infrared shot of Fontaine de Vaucluse was taken in France with the DiMAGE 7 and a Tiffen 87 opaque filter (**figure 18**).

I added 32.85% noise to create the pseudo bromoil effect (**figure 19**).

figure 18

figure 19

Coco

Step One

This image was taken with the DiMAGE 7 in its regular color mode. It was shot at night without a flash, hence its golden tone (figure 20).

Step Two

I converted it into black and white using nik Color Efex Pro (figure 21).

Step Three

I then added 28% noise and toned the black-and-white image a nice warm brown (figure 22).

Keep in mind that selecting the right paper for your pseudo bromoil image is also very important. The paper's texture, or lack thereof, can enhance or detract from your print. I prefer either a textured ink jet coated paper, such as Lumijet Flaxen Weave, or a textured non-coated paper, such as Fabriano Classico 5 or Arches watercolor papers. These textured papers seem to work well with the grainy prints, giving them a softer look. On the other hand, the smoother papers will emphasize the grain.

figure 20

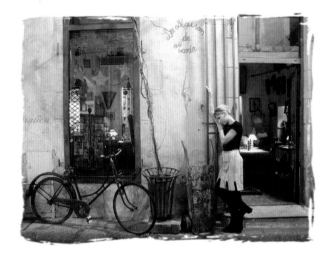

figure 21

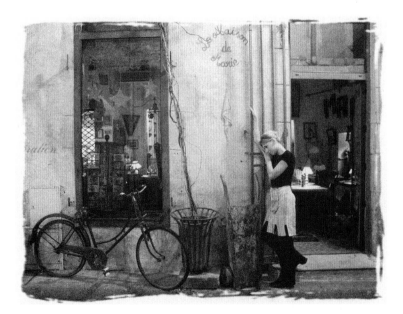

figure 22

Bamboo Temple

from the Sanctuaries of the Mind series

Over years of travel, I have attempted to make a photographic record of the speeding changes that I have witnessed in our world. For example, a Tibetan monk walking around in his traditional red robes and wearing brilliant white running shoes represented to me a clashing of cultures.

From within the computer I am able to commingle different elements into one, unlike our world today. My work reflects both my desire to touch and feel the world, and my desire for us all to understand one another—not so much as one great globalized unit, but in reverence and celebration of our coexistence.

The pieces in the *Sanctuaries of the Mind* series represent places, both real and imagined, to take the mind for a contemplative retreat. Many of the works are montages and collages of photographs taken in the East—China, Tibet, Nepal, India, Burma, and Bali. *Bamboo Temple* is comprised of three different slides taken in different parts of China.

The basic background image is a horizontal slide taken in Shanghai. I scanned it into the computer then, in Photoshop, I stretched it into a vertical, cleaned it up (removed dust and scratches), enhanced the colors using Levels, and dodged and burned (using the Dodge tool and the Burn tool, respectively).

The lotus slide was taken at the Summer Palace in Beijing. After scanning it, I selected the flower from its background and moved it to the bottom of the Shanghai image I had chosen as my base. I photographed the Buddha head in a cave in southern China. This slide was scanned and cropped; then, I selected the head, applied color correction in Photoshop, and placed it in the door of the temple.

To make the scroll, I painted with acrylic onto fabric—two coats of white and one of a pearl-like metallic acrylic paint. Next, I gave the painted fabric a coat of inkAID. After I finished putting my images together in Photoshop, I printed them onto the dried substrate using pigment inks and my Epson 7600 printer. When the print was thoroughly dry, I sprayed it with a UV protective coat. Next, I split bamboo poles (that were about 1 – 2 inches longer than my image) so that the top and bottom of my piece fit into the splits. I glued the print into the bamboo, then wrapped the ends (both top and bottom) with cotton thread, weaving in a piece of thread at the top for hanging.

Danny Conant's work is represented at the Fraser Gallery in Bethesda, Maryland, the Multiple Exposures Gallery in Alexandria, Virginia, Fitzgerald Fine Arts in Alexandria, Virginia, the Light Street Gallery in Baltimore, Maryland, and at the John Stevenson Gallery in New York City. Her work has also been included in various publications. She has held solo exhibitions in the U.S. in over ten states. For more information and to see more of Danny's work, visit her website: www.dannyconant.com.

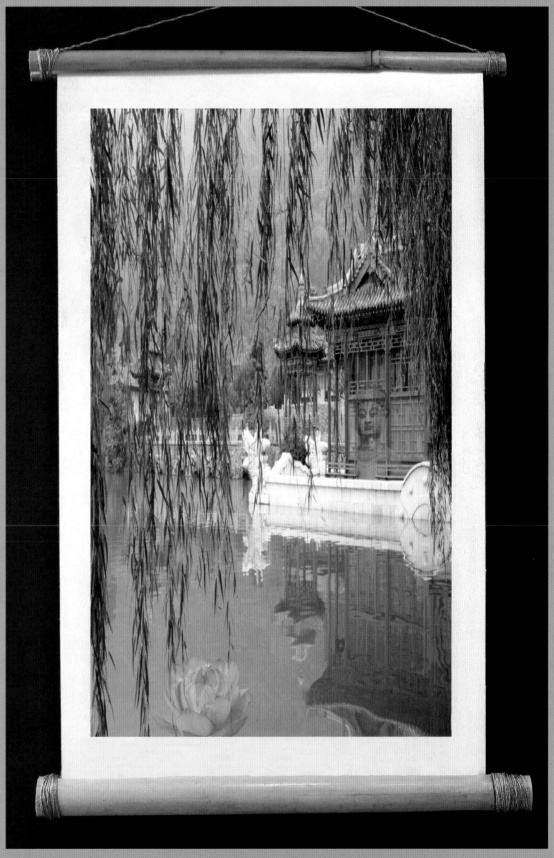

Danny Conant—*Bamboo Temple*

9

Encaustic Painting

The Encaustic Revival

Encaustic comes from the Greek word **enkaustikos,** meaning "to burn in." Encaustic painting is the process of fusing paint pigments with wax, which is kept molten on a heated palette. When applied to a surface, it is reheated (I use a hairdryer to accomplish this) in order to fuse the paint and wax into a uniform enamel-like finish. This combination of materials is among the most permanent of all painting media (as long as quality permanent paint pigments are used and you do not subject the painting to high temperatures).

Painting with wax dates back to ancient Greece. Our earliest examples of encaustic paintings are from the Romano-Egyptian mummy portraits that were painted on wood dating back to the end of the 2nd century A.D. Recently, there has been a revival of encaustic painting, which can be as simple as brushing melted wax on top of your print and adding color, or the slightly more elaborate method of actually painting with pigmented waxes. You can also incase prints in wax, colored or clear. You can paint encaustic waxes directly onto panels, or if you wish, you can first transfer an image and use that transferred picture as a sketch for your encaustic painting. There are many, many venues for creating unique and unusual images using wax.

Materials Needed for Encaustic Painting

❋ **Wax:** Natural, unbleached beeswax is the best type of wax to use. However, if you want a harder surface than that produced by using beeswax, add about 10% carnauba wax. This wax is more resistant to getting marked up and produces a harder finish.

figure 1

❋ **Powdered Pigments or Premixed Colored Wax:** You'll need pigments that can be mixed with the molten wax to produce a colored wax with which to paint. You can also buy the premixed wax with color/pigment already added.

❋ **Mixing Trays or Small Metal Pots:** You can purchase small tin paint pots at most arts and crafts stores (they may even carry containers specifically made for encaustic painting). Otherwise, a simple muffin tin will work just as well. Place the powdered pigments here until the hot wax is ready to be mixed in.

❋ **Two Pots (One Larger than the Other):** To melt unpigmented wax, place two pots on your stovetop. One pot should be larger than the other; the larger one will be on the bottom, filled with water, and the smaller one will sit inside of it and hold the wax. As the water boils, the wax will melt without burning. Once the wax is melted, pour the molten wax into the small, heat-resistant containers you've prepared to hold the powdered pigment. Stir the mixture until it is well blended.

Note: There is a wide assortment of wax, color pigments, ready-made encaustic paints, and various other encaustic supplies that can be found on the web— just type the word "encaustic" into your favorite search engine.

❋ **A Hot Plate:** To melt wax that already has pigment in it, or to keep the wax heated after you've melted it, use a hot plate. You can purchase a hot plate—a heated, flat cooking surface used to keep food hot (figure 2)—or you can make your own. To create a makeshift hot plate, buy a 1/4-inch thick steel plate that's long enough to cover two of your electric stove burners. If you don't have an electric stovetop, you can purchase a large electric frying pan (you won't need the steel plate with this method—just keep the electric skillet on Low). Try to keep the temperature of whatever type of heating palette you use at around 200°F.

> *Caution:* If the hot plate temperature is too high for an extended period of time, the wax will decompose and certain pigments can become toxic.

figure 2

❋ **Inexpensive Brushes:** Pick up a couple of inexpensive bristle brushes. I tend to stay away from the cheap nylon brushes, however, as they melt in the wax if left in the pot too long.

❋ **A Hair Dryer:** To maintain molten consistency as you apply the hot wax (with or without pigments), hold the hair dryer with one hand to keep hot air blowing on your wax-laden brush during painting (figure 3).

figure 3

> **Hint:** I find it easier to rig up a hanging hair dryer using wire or rope and position my painting underneath it, thus freeing up my hands.

Tibetan Horse

The fresco paintings on this Tibetan monastery's walls were covered with a residue from years of burning yak butter candles for interior lighting. Even today, the monastery does not have electricity. The actual frescoed images have a dark, smoky, somber look to them. The photographs that I took lacked this ancient feel; they were too bright in color, too new looking. This was partly due to the fact that I had to use a flash in those dark interiors, and partly because the wax on the walls was not noticeable in the photographs. I wanted to make my photographs more like what I had seen and felt standing in those ancient halls of spiritual solitude. To that end, I tried some encaustic techniques in an attempt to recreate that sacred dimension that my photographs lacked.

Step One
This is the original shot, taken with slide film and scanned into my computer. I then made an ink jet print of the image onto hot-pressed, l40 lb. watercolor paper (figure 4).

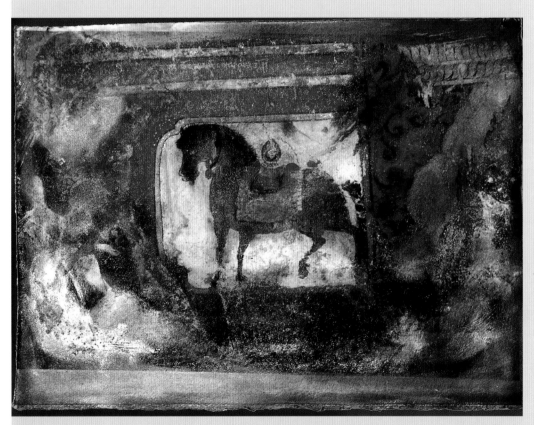

figure 4

Step Two

Next, I selectively brushed molten beeswax (without color) onto the print, using a hairdryer to keep it molten as I worked.

Step Three

After the wax hardened up a bit, I took acrylic paints and rubbed the color into the wax. I also added a bit of powdered silver pigment. This created a time-worn look to the print, giving it a glow and depth that was missing from the photograph (figure 5).

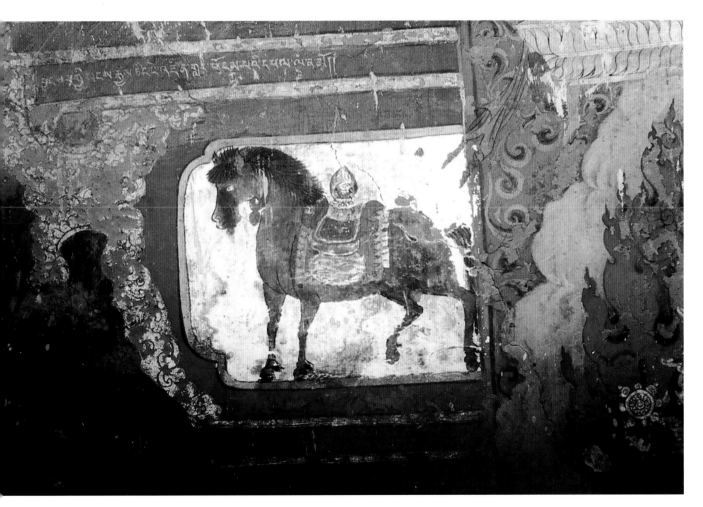

figure 5

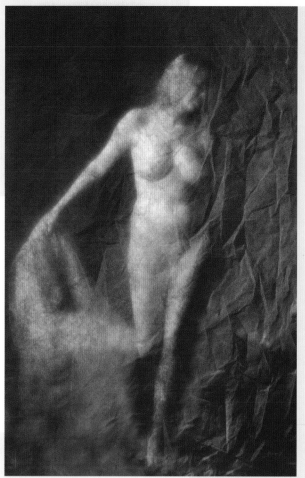

figure 6

Rubenesque Nude

Step One
This image was originally shot with slide film. I scanned the slide, made a digital file, and printed it out onto Rexam transparency film using my Epson 2200 desktop printer. I then transferred it to handmade Indian paper (figure 6).

Step Two
To do the transfer, I first coated the handmade paper with inkAID, then laid the transparency film on top of the image (emulsion to emulsion) and rubbed on the back of the film to transfer the image (see page 88 for more about inkAID). Because the paper was so textured and rough, the transfer was rather spotty. But, there was something nice about the print, regardless of its flaws.

Step Three
When the transfer dried, I decided to paint on it with melted wax (no added pigment).

Step Four
After the wax was applied, I rubbed a reddish-brown shoe polish into the waxed areas. I also applied a bit of black and brown acrylic paint to fill in some of the patchy areas of the print.

Step Five
To finish it off, I applied the reddish-brown shoe polish to the edges to add definition. The wax-embedded paper began to look like an old sheepskin scroll! I was very pleased with the final result (figure 7).

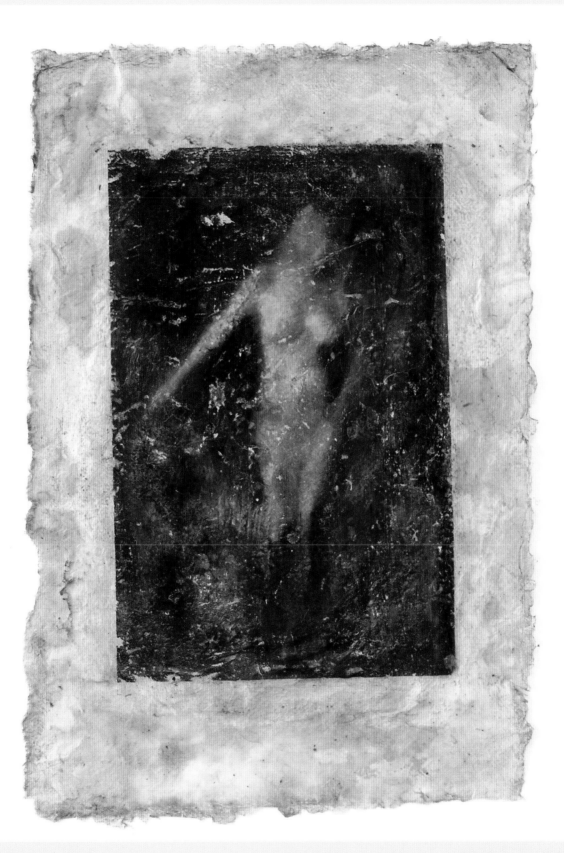

figure 7

figure 8

Deteriorated Wall

This image is a portion of a wall in a Tibetan monastery that was so old and had deteriorated so much that all that was left were bits and pieces of color and the faint image of a horse. However, these remains were so beautiful in color and form that I couldn't help but photograph it. Again, I was disappointed in the photograph, as it lacked the glow and dimension that the fresco itself had displayed (figure 8).

figure 8 detail

Step One
I printed the image onto Lumijet's Flaxen Weave ink jet coated paper using Lumijet's Preservation Inks.

Step Two
I then selectively brushed on molten wax (without color).

Step Three
When the wax hardened a bit, I rubbed in some silver pigment to add glow and warmth to the wax.

Step Four
Later, I took some oil pencils and augmented the form of the horse (figure 9).

figure 9

figure 9 detail

Hint: If you use oil pencils, you can dip the pencil in water and/or add the color dry and take a wetted cotton swab and make a flow of color (much like watercolor pencils).

figure 10

figure 11

Tree in Ireland

Step One
I shot the original image with slide film and scanned it onto my computer (figure 10).

Step Two
Then, I printed the image onto Rexam transparency film and transferred it to a wooden board using inkAID. This gave me a "sketch" to work with.

Step Three
Next, I painted over the image with pigmented wax, using the transferred photo as a guide. This close-up shot of the paint and wax build-up shows something called a wax bloom. Wax bloom occurs when the wax rises to the surface of the wax/pigment mixture. It appears as a whitish fog or haze over the color and is especially noticeable in darker colors. It is easy to eliminate by polishing the area with a piece of silk or soft cotton. In this piece, however, the wax bloom actually helped with the look of the foliage, especially in the tree, so I did not polish it out (figure 11).

Note: In encaustic painted pieces where wax bloom is undesirable, polish it away with silk or soft cotton, then (when you have finished painting) give the piece a light coat of acrylic spray to prevent the wax bloom from recurring (or occurring elsewhere).

Step Four

Here is a digital print of the finished encaustic painting. I photographed the piece and downloaded the image into my computer (figure 12).

Step Five

Lastly, in Photoshop, I went to Filter > Texture > Craquelure. Because the image already had so much texture, this filter just enhanced it and made it more pronounced. I printed it out onto Lumijet's Flaxen Weave, a textured ink jet coated paper. This is the final image (figure 13).

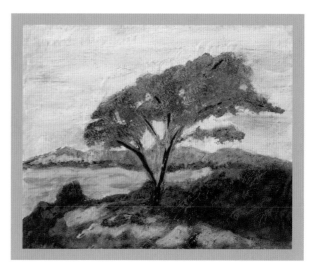

figure 12

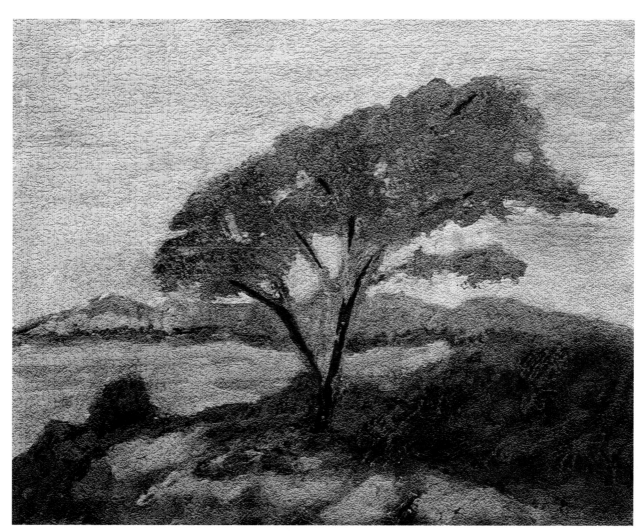

figure 13

Spring Thaw: Preserving the Spontaneous

Brushes don't make paintings, and computers don't make art.
Computers are easy. Art is hard.

Accidents happen—sometimes for the better! I usually start with a digital image and use the computer to analyze the work. I "whack" it with gross filters and adjustments to find ideas. When I actually process the image, I simplify and strengthen the idea/feeling I've identified through my image experiments. I value experimentation and spontaneity, so I try to pay close attention to each subtle change so as not to obliterate (undo) "happy accidents."

I like to print small proofs as I work. Once the image is resolved, I make mock-ups to decide what size I want the final piece to be (sometimes up to five feet in height). I divide each mock-up into sections and make an 8 x 10-inch print of each section. When I have printed them all out, I trim and assemble by hand.

Up until about ten years ago, that was my stopping point. Now, I modify the print via more traditional tools and processes. I like involving all my senses, and the works truly are one-of-a-kind. Sometimes I photograph the work and merge the good parts back into the computer file. I can always use the computer to collage-over painted areas that I don't like. It's no-risk art!

Spring Thaw is a good example of a "happy accident." My digital photo's shapes, shadows, and negative spaces attracted me (figure 1). So, I repeated, inverted, and reflected them in layers with Photoshop. After some small test prints, I decided to scale up the 8 x 10-inch proof to be about 24 x 30 inches. I divided the image into twelve 8 x 10-inch sections and made an encaustic wax print with my Tektronix thermal wax printer. The pigmented wax colors are vibrant and waterproof, and the background whites are from the unwaxed paper substrate. I used acrylic medium to join the enlarged sections of the image, then put the composite face down on a plastic bag and applied another coat of acrylic medium to the back. I should have waited a day for it to dry, but I was impatient. I removed it from the plastic too soon, and large hunks of the wax color layer stuck to the plastic bag rather than the substrate. The next day, I realized that the accident freed me to elaborate on the print. That day, I was thinking about ice falling from branches. I tore, folded, and reshaped my piece, then placed it on a heavier paper. Almost immediately, I began peeling and replacing/repositioning the now dry hunks that were still stuck to the plastic bag. Then, I collaged over some areas with translucent crystal paper (tissue paper saturated with acrylic medium and dye pigment) to further enhance the emerging design.

Leslye Bloom holds a BS, an MS, and a Ph.D. in Art Education from Penn State, and she is a certified art therapist. Leslye has taught all ages, from pre-school to the elderly. She is a jack-of-all-trades when it comes to art media, and has used computers as a teaching tool as well as an art medium. Her one-of-a-kind works integrate digital art with materials like collage, encaustics, and acrylics, and she believes such fusions will soon be commonplace. When she began working with computers in 1967, just making a simple image was enormously difficult. Today, creating quality work is the challenge. For more information, visit www.leslyebloom.com.

figure 1

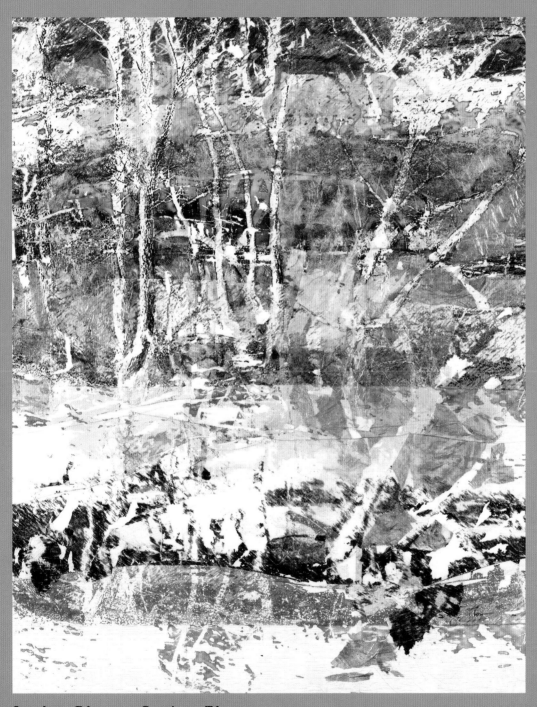

Leslye Bloom—*Spring Thaw*

Maros

Pushing boundaries. Rebellion. Invention. Experimentation. These are the concepts that spur me on. For me, the whole process of creating a photographic image starts with a point of departure. This moment of motivation can derive from a dream, an observation, a beam of light, a marvelous shadow, or even something that appears in the darkroom or computer. Mistakes are often terrific springboards. From there, I find a new itinerary... a deviation in the road... a flight from the expected. How far I go, where I go—this is the excitement and challenge of photography.

The *Maros* project is part collaboration, part "light bulb exploding," and part curiosity. I chose this image because it has so many possible interpretations, which inspired me to plunge into all kinds of experimentation to see how different approaches, moods, and techniques would affect the image.

I took one large negative and started to play with it. Soon I had three different prints from the same negative. Someone then commissioned me to install a whole wall using variations on this theme. I have now accumulated 20 16 x 20-inch images for installment in the Museum of Photography in Paris, known as MEP.

The original negative is from black-and-white 35mm film. The final prints were made through a labor-intensive development that involved the creation of both positive and negative versions of the piece in conjunction with the use of the gum dichromate process—an involved process in which watercolor paper is shrunk in hot water, soaked in gelatin, and hardened in formaldehyde. When dry, the first layer of photosensitive emulsion is applied. Diluted watercolor paint is mixed with gum arabic, then combined with ammonium dichromate. This mixture is brushed onto the surface of the prepared watercolor paper and allowed to dry. The large negative (or positive) is then placed on top of the layer of colored emulsion, and this "sandwich" is placed in a vacuum box and exposed to UV light. It is then developed in water and allowed to dry. This process is often repeated 15 (or more) times!

What I love about the process is the excitement generated from my ability to control versus my sudden inability to control unforeseen circumstances. Often a whole layer will wash away, or will not be able to be manipulated. I love to scratch, rub, draw on, sculpt, and make wild gestures with the emulsions. I try to make the images less graphic and more sculptural. The possibilities are endless.

Currently residing in Princeton and New York, **Ernestine Ruben** grew up surrounded by art and artists, and studied the history of art, painting, and sculpture. She is internationally known, and has devoted the past 20 years to the study of the human body in photography and how it relates to other media and subjects. Her experimentation and variety have been extensive, and she has specialized most recently in platinum, gum dichromate, and encaustics. Her work is in many private and public collections including the Philadelphia, Houston, and Detroit museums of art, the Museum of Modern Art in New York, and the Maison Européenne de la Photographie and Bibliothèque Nationale in Paris. She has also had recent solo shows at the John Stevenson Gallery in New York and the Baudoin Lebon Gallery in Paris. Her work can be found in many publications, and she is an active teacher. For more information, please visit her website: www.ernestineruben.com.

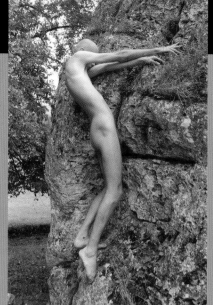

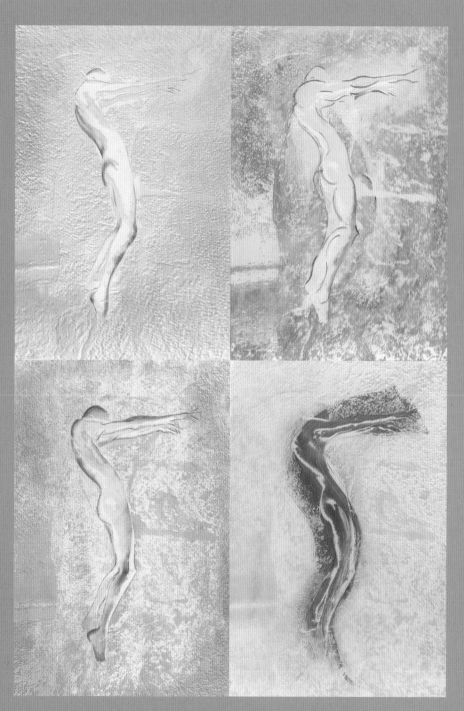

Ernestine Ruben—*Maros*

Flight

from the Sacred Spaces series

I am a painter by training and collage-maker by nature who began experimental printmaking with reprographic machines. Since being introduced to computers in the late 1960's when working on my doctorate at Penn State, I have combined traditional and digital media in multiple layers of texture and meaning. I combine the humblest of materials with the latest in technology to evoke the past and herald the future.

By focusing on timeless personal and universal issues—hopes, fears, wishes, lies, dreams, immortality, transience—I challenge myself and the viewer to look beyond the surface to see what depths are hidden. I celebrate the fragile beauty of the land and the strength of the spirit.

Flight, from the *Sacred Spaces* series, was created by digitally combining a pastel painting with a photograph taken on the Dingle Peninsula in Ireland. The painting and photograph were scanned on the 12 x 20-inch Mictotek 9800XL scanner and altered in Photoshop. Layer properties, including Hard Light and Overlay, were used to enhance the color and texture of the composite image. I printed my image on a sheet of aluminum using inkAID and an Epson 9600 printer. (This process is suitable only for printers that do not have "pizza wheels"—the tabs or feed rollers that come in contact with an image immediately after it is printed and drag or "track" through the surface of the ink, damaging the print.)

The aluminum was wiped with vinegar then washed with soap and water and dried. I applied the inkAID with a foam brush and allowed it to dry overnight. When that was thoroughly dry, a second coat was applied perpendicular to the first coat and left to dry. I fed the precoated aluminum sheet into the Epson 9600 and printed. When the print was dry, I sprayed it with Krylon Crystal Clear to protect the surface from fingerprints, moisture and abrasion. Although the preparation of the metal is time consuming, the results are unique. The final print, *Flight*, has both a physical and visual glow. It is one of a variant edition of four 24 x 24-inch prints.

Dot Krause is a painter, collage artist, and printmaker who incorporates digital mixed media. Her work is exhibited regularly in galleries and museums and featured in numerous current periodicals and books. She is Professor Emeritus at the Massachusetts College of Art, where she founded the Computer Arts Center, and she is also a member of Digital Atelier, an artist collaborative. She is a frequent speaker at conferences and symposia, as well as a consultant for manufacturers and distributors of products used by fine artists.

In 1997, Krause organized "Digital Atelier: A printmaking studio for the 21st century" at the Smithsonian American Art Museum. For that work, she received a Computerworld/ Smithsonian Technology in the Arts Award. That same year, she worked with a group of curators to help them envision the potential of digital printmaking in "Media for a New Millennium," a work-tank/think-shop organized by the Vinalhaven Graphic Arts Foundation. In June 2001, with Digital Atelier, Krause demonstrated digital printmaking techniques at the opening of the Brooklyn Museum of Art 27th Print National, *Digital: Printmaking Now* exhibit. For more information, visit her website: www.DotKrause.com.

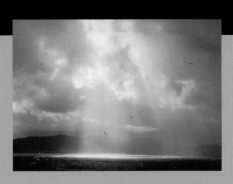

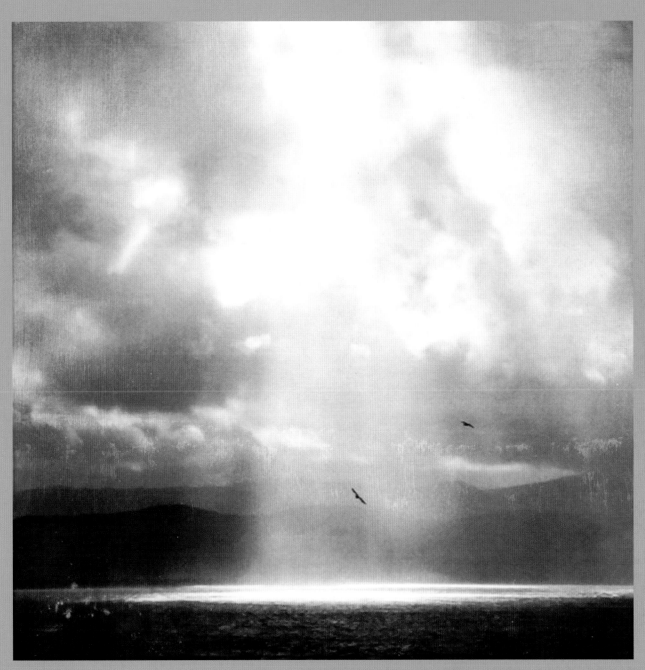

Dot Krause—*Flight*

Bermuda Cottage

I am a Bermudian, an islander in the most visceral sense, and I hope to capture in my collage works the soul of this place so dominated by nature. Here, nature reclaims all things humans try to leave behind. Our buildings and walls, scarred by the erosion of wind and water, are infested, consumed, and teeming with the plants and animals that repossess them. The results are our multicolored, mossy, fern-encrusted surfaces, damp and ready to receive any life that settles there. These natural tableaux are art works unto themselves.

Using antique island postcards as a centerpiece, I try to revive the nostalgia of the scene by employing paint chips from these old walls, local foliage, fabrics, seeds, seaweeds, pods, papers, and inks to recreate a three dimensional sense of the scene. The hope is that the piece will evoke the damp, steamy, verdant nature of Bermuda.

I begin with a scan of the postcard, which is a more malleable piece to work with than the thicker original. *Bermuda Cottage* was worked on a triangular shaped board because I find that this shape lends itself to creating an unusual perspective. For instance, if a postcard with a road or path in the foreground is placed in an upper corner of the board, then the artist can extend that road further into the foreground and instantly invite the observer into the scene. The idea is to create a window to look into the past. This can also be done by encircling the scene with embedded ferns or grasses, or painting in a swirling scene of clouds—something that literally suggests the mysterious connection between what's happening in the postcard and the elements that the artist has used.

The postcard is adhered to the board with acrylic matte medium and I begin the process of filling out the scene by painting in the general color blocks as the scene is extended. From here, I gather together the dried foliage, papers (these can be toilet paper, used tea bags, wrapping tissue), fabrics (all types of linen, cheesecloth, burlap), paint chips, etc., and plan the composition. Flat pieces can be glued on with craft glue but large, chunkier pieces get embedded into the piece, or built up, with a fibrous, paper mixture, much like a textured fiber gel, that I make from scratch with paper and glue.

When the work is dry you can apply paints and inks to finish. In places where you're not filling in small details with brushes, the paints and inks can be rubbed on as opposed to painted on. Often the texture of the foliage, papers, fabrics, or paint chips can be highlighted with this technique, which suggests an impressionistic feeling to the solution of the work. After the original piece is finished, a digital file of the three-dimensional piece can be created so cards and prints can be reproduced. These two dimensional prints can also re-worked with paints and inks.

Fayelle Wharton Bush resides on Patton's Point in Bermuda. Her work has been shown at the Art of the Northeast Show in New Canaan, Connecticut, Masterworks in Hamilton, Bermuda, the Bermuda National Gallery's Biennial Exhibit of Bermudian Artists in Hamilton, Bermuda, as well in her solo exhibit, entitled, "Bermudian: Textures & Senses."

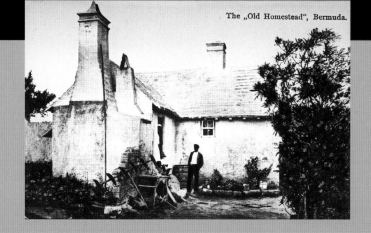

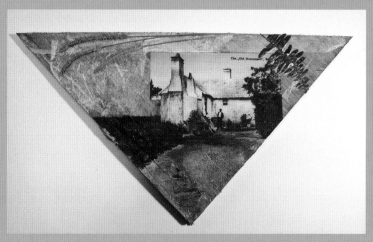

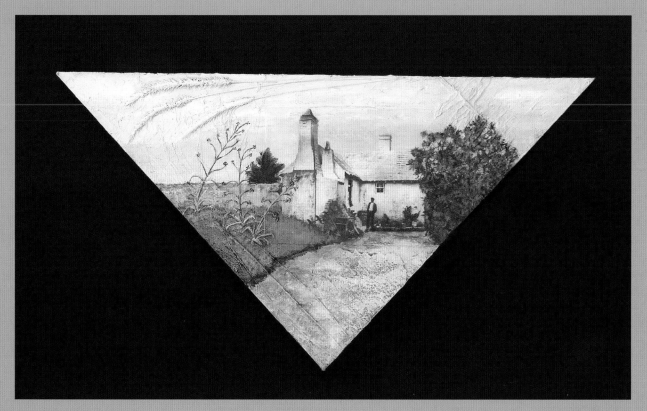

Fayelle Wharton Bush—*Bermuda Cottage*

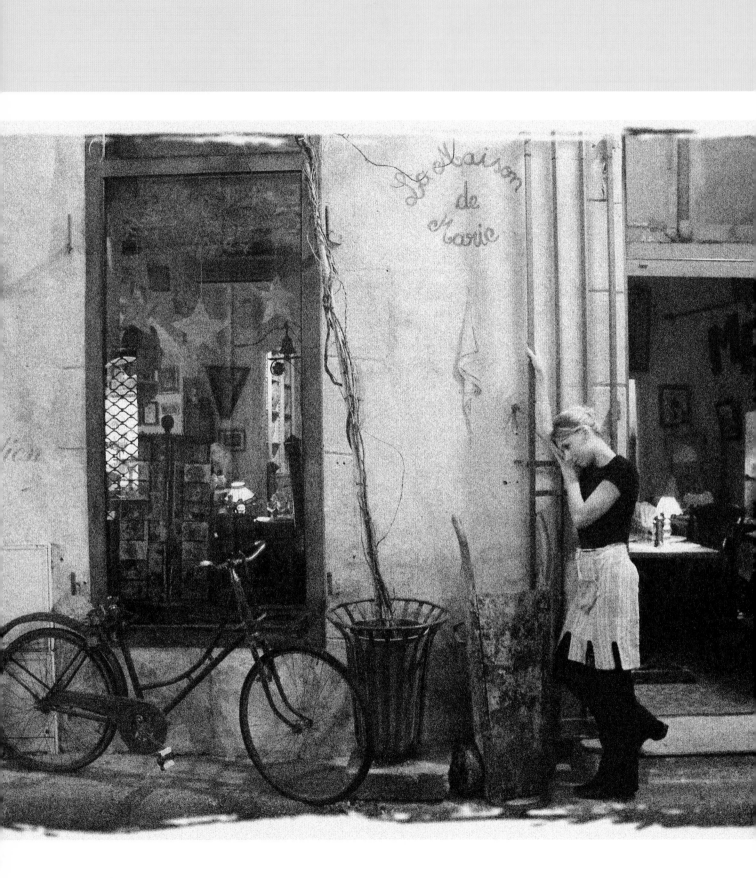

Glossary

✦ a ✦

art board
A generic name for several different types of art panels; usually, wooden panels with or without a ready-made painting surface. See also *art panel.*

artist bridge
A piece of supported wood or clear acrylic sheeting that lies over top of your artwork without touching it. It allows you to steady your hand and prevents you from smearing the mediums or materials underneath your hand and wrist while you work.

art panel
A high-grade, seamless wooden panel that is glued onto a support panel. It will accept oils, acrylics, drawing mediums, collage, and assemblage work. The surface should be sealed or primed before it is worked on if you are doing archival work. These panels range in size from 7.75 x 9.75 inches (19.7 x 24,8 cm) to 15.75 x 19.75 inches (40 x 50.2 cm).

assemblage
The layering or gluing together of found objects. Assemblages typically have a more three-dimensional quality than collages. Pieces created using this medium are usually referred to as "mixed media." See also *collage.*

✦ b ✦

barren
A Japanese tool for rubbing or applying even pressure. Traditionally, they were made from bamboo; today they are made from fiberglass. They are used for making hand transfers (as opposed to using a printing press).

bloom
A whitish film that appears if waxy pencils are used heavily—the wax comes to the surface of the print. It can be removed by buffing with a soft cloth.

blotter paper
A heavy, absorbent paper used to dry prints or to help spread out the moisture in dampened papers before printing.

brayer
A rubber or polyurethane cylinder with a handle. They look a little like rolling pins and are used to hand-transfer inks, dyes, etc., by applying even pressure.

broken color
A coloring technique in which pastel pigments are not blended so that the color layers remain separated, allowing the undercolor to show through when a second color is laid on top. See also *pigment.*

✦ c ✦

burnisher
A tool used for smoothing a surface or transferring information through rubbing. There are burnishers that smooth metal surfaces (these have a hard metal shaft, and bone burnishers (made from bone) that smooth out jagged edges on mat board and paper prints by gently running over the tattered or frayed surface.

burr
The thin, raised ridge on either side of an incision.

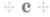

Chine Collé
In the traditional sense of the term, it is the technique of gluing thin papers then printing upon and adhering them to a heavier printmaking paper under the pressure of a printing press. Today, it is a term used loosely for gluing papers to an image or a collage, not necessarily during the printmaking process.

collage
The layering of materials (such as papers, fabric, or photographs) on top of an image. Also, the layering of materials to create an image. Pieces created using this medium are usually referred to as "mixed media."

complementary colors

Colors that are opposite each other on the color wheel.

✤ d ✤

D-Max

Maximum density. This term refers to how saturated the color black will appear on a particular paper stock.

✤ e ✤

earth colors

Refers to ochres, siennas, and umbers— the most stable of natural pigments. See also *pigment*.

✤ f ✤

ferrule

The part of the paintbrush that attaches the hair to the handle. Ferrules are most commonly made of metal.

fugitive color

Refers to a paint's lack of light fastness (i.e., the colors have faded). The original color is not permanent and has changed over time. See also *light fastness*.

✤ g ✤

gesso

A painting ground traditionally made from rabbit skin glue and white pigment (titanium or zinc) or Plaster of Paris. It is used to coat the surface of canvas, linen, cotton, paper, or other fabrics in order to prevent the acids in oil paint from deteriorating the substrate on which an oil painting is made. See also *ground; pigment; substrate*.

glazing

Painting a transparent color over top of another color. The transparent color is usually a lighter shade of the base color.

glue size

One of the substances used as a ground. It is applied to porous substrates in order to prevent over-absorption of the intended mediums. See also *ground; substrate*.

ground

A barrier painted onto the surface upon which an oil painting will be made. The barrier prevents the acids in oil paints from deteriorating the fibers of the receptor substrate. See also *substrate*.

✤ h-i ✤

hue

A particular shade of color. Paint that has the word "hue" in the color name (i.e., Naples Yellow Hue) indicates that a substitution has been made to mimic a pigment that is poisonous in its natural form. See also *pigment*.

intensity

The degree of brilliance in a color.

✤ k ✤

kneaded eraser

Erases by lifting the pigment out of the fiber of the paper with little or no abrasiveness. They must be kneaded in your hand to make them pliable, and they can be shaped into points or flat edges.

✤ l ✤

light fastness

Refers to the degree of permanence a pigment has with regard to fading from light.

Glossary

✤ m ✤

mahlstick
A stick with padded ends used by painters to steady the hand and keep the hand and wrist away from the painting surface.

masking fluid
A latex liquid used to block out or mask a particular area from additional toning, painting, or coloring applied elsewhere. It is easily removed to reveal the original color of the protected area.

monochromatic
Composed of a single color or various shades of a single color.

✤ n ✤

North light
The best light in which to paint or color because it has the least amount of shadow change due to the movement of the sun.

✤ p ✤

palette knife
A flat, knife-like tool that comes in a variety of shapes and sizes. It is used in painting to blend pigments, scrape pigment off, press pigment in, mix paints, and to apply paint in place of a brush.

pigment
The component or ingredient that makes color. Pigments can be organic, inorganic, and/or synthetic. They are insoluble powders that mix with oil, water, wax, or another base to create a colored medium (i.e., paint, pastels, etc.).

plasticizer
An additive that makes the medium in which it is used more flexible.

primary colors
The colors from which all other colors are created. The primary colors of light are red, green, and blue. These are the additive primaries, meaning they actually transmit or emit color. The primary colors of pigments are cyan, magenta, and yellow. These are subtractive primaries, which means that they reflect color. Primary colors cannot be produced by combining any of the secondary colors. See also *pigment; secondary colors.*

✤ s ✤

secondary colors
Colors produced by mixing the primary colors together. See also *primary colors.*

shade
A color mixed with black.

siccative
Usually a metallic composition, available in solid or liquid form, that is added to oil paint to speed up the drying time. Also called a drier.

size
A substance (i.e., glue or gelatin) that is used to reduce the absorbency of paper or canvas.

stippling
A method of applying small, controlled dots of color to a surface.

substrate
In the art world, an underlying layer upon which mediums are applied (i.e., paper, wood, metal, etc.).

✤ t ✤

tempera
Paint in which pigment is mixed with a water and egg yolk emulsion. This kind of paint was widely used in 14th and 15th century Italian panel and fresco art. See also *pigment.*

tint
A color mixed with white.

tone
Refers to the lightness or darkness of a color. Also called value.

tooth
The roughness of a paper or other painting surface.

tortillion
A tightly wound cylinder of paper with a pointed tip used for blending pastel pigments. Also called a stump.

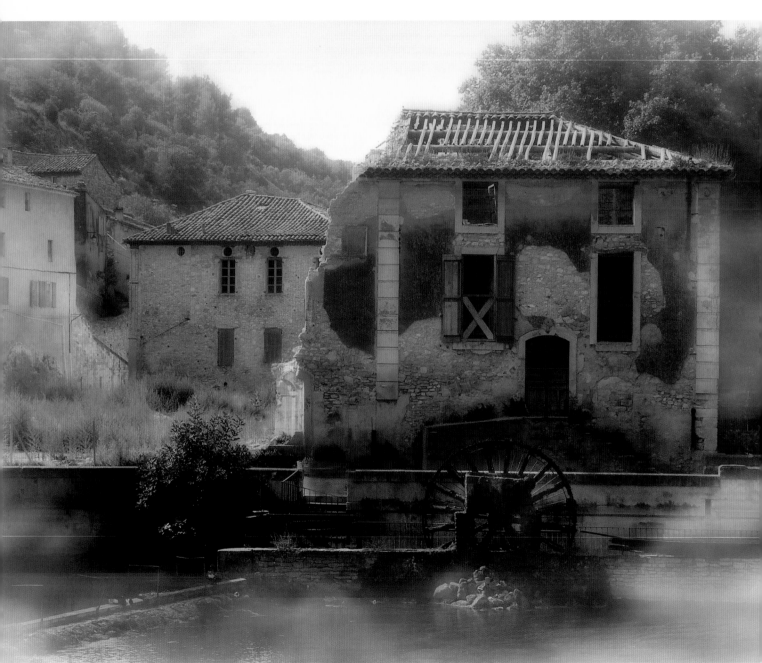

Resources

Adobe Systems Incorporated
345 Park Avenue
San Jose, CA 95110-2704
(408) 536-6000
Fax: (408) 537-6000
www.adobe.com
Creative Imaging Software

Auto FX Software
141 Village Street
Suite 2
Birmingham, AL 35242
(205) 980-0056
Fax: (205) 980-1121
www.autofx.com
Creative Imaging Software

BullDog Products
8050 Crystal Drive
Anaheim, CA 92807
(800) 579-8964
www.bulldogproducts.com
sales@bulldogproducts.com
Papers and Inks

Canto Software, Inc.
221 Main Street
Suite 460
San Francisco, CA 94105
(415) 495-6545
Fax: 415 543-1595
www.canto.com
Digital Asset Management Software

Cokin S.A.
50/52, rue des Solets
Silic 458
F-94593
Rungis, France
01.41.73.45.50
Fax: 01.41.73.45.51
www.cokin.com
Creative Filter System

Daylab Industries
41136 Sandalwood Circle
Murrietta, CA 92562
(800) 235-3233
Fax: (909) 304-3389
www.daylab.com
sales@daylab.com
Imaging Products for Artists

Grumbacher
c/o Sanford Corporation
2711 Washington Boulevard
Bellwood, IL 60104
(800) 323-0749
Fax: (708) 547-6719
www.grumbacherart.com
www.sanfordcorp.com
Art Supplies

Hahnemühle FineArt
41 Twosome Drive
Unit 6
Moorestown, NJ 08057
info@hahnemuhle.com
www.hahnemuhle.com
www.lumijet.com
Art, Photo, and Printing Supplies,
Including Lumijet Ink Jet Products

Harrison & Harrison
1835 Thunderbolt Drive, Unit E
Porterville, CA 93257
(559) 782-0121
HarrisonOP@aol.com
Photographic Supplies

Krylon Inc.
101 Prospect Avenue NW
Cleveland, OH 44115
(800) 457-9566
Fax: (800) 434-7076
www.krylon.com
askquestions@krylon.com
Crafting Products

Lazertran LLC USA
650 8th Avenue
New Hyde Park, NY 11040
(800) 245-7547
Fax: (516) 488-7898
www.lazertran.com
lazertran@msn.com
Transfer Papers for Artists

Liquitex Artist Materials
c/o ColArt International
Holdings Ltd.
11 Constitution Avenue
Piscataway, NJ 08854
(732) 562-0770
Fax: (732) 562-0941
www.liquitex.com
www.colart.com
Art Supplies

LizardTech
The National Building
Suite 200
1008 Western Avenue
Seattle, WA 98104
(204) 652-5211
Fax: (206) 652-0880
www.lizardtech.com
info@lizardtech.com
Creative Imaging Software

Marshall's
701 Corporate Woods Parkway
Vernon Hills, IL 60061
(800) 621-5488 or (847) 821-0450
Fax: (847) 821-5410
www.bkaphoto.com
bkaservice@bkaphoto.com
Marshall's Photo Coloring System, and
Other Photographic Supplies

Martin/F. Weber Co.
2727 Southampton Road
Philadelphia, PA 19154-1293
(215) 677-5600
Fax: (215) 677-3336
info@weberart.com
www.weberart.com
Art Supplies

nik multimedia, Inc.
7580 Metropolitan Drive
Suite 208
San Diego, CA 92108
(619) 725-3150
Fax: (619) 725-3151
infous@nikmultimedia.com
www.nikmultimedia.com
Creative Imaging Software

Nixvue Systems Pte Ltd.
7626 176th Street SE
Snohomish, WA 98296-5359
(360) 668-9047
Fax: (360) 668-7520
www.nixvue.com
support@nixvue.com
Digital Storage Solutions

**Prismacolor
c/o Sanford Corporation**
2711 Washington Boulevard
Bellwood, IL 60104
(800) 323-0749
Fax: (708) 547-6719
www.prismacolor.com
www.sanfordcorp.com
Art Supplies

R&F Handmade Paints, Inc.
506 Broadway
Kingston, New York 12401
(800) 206-8088 or (845) 331-3112
Fax: (845) 331-3242
www.rfpaints.com
info@rfpaints.com
Paint and Supplies

Simple Star, Inc.
2325 3rd Street Suite 424
San Francisco, CA 94107
(415) 861-7529
david@simplestar.com
www.simplestar.com
Software Products and Services

SimpleTech Inc.
3001 Daimler Street
Santa Ana, CA 92705
(800) 367-7330 or (949) 476-1180
Fax: (949) 476-1209
www.simpletech.com
Memory, Flash, and Storage Solutions

Symantec Corporation
20330 Stevens Creek Blvd.
Cupertino, CA 95014
(800) 441-7234 or (408) 517-8000
www.symantec.com
Norton AntiVirus, and More

Synthetik Software Inc.
Seven Waterfront Plaza
500 Ala Moana Blvd.
Suite 400
Honolulu, HI 96813
(866) 511-9971 or (415) 762-9452
Fax: (808) 261-1837
sales@synthetik.com
www.synthetik.com
Creative Imaging Software

Wacom Technology Co.
1311 SE Cardinal Court
Vancouver, WA 98683
(800) 922-9348
Fax: (360) 896-9724 (main) or
(360) 896-9814 (sales)
www.wacom.com
sales@wacom.com

**Winsor & Newton
c/o ColArt International
Holdings Ltd.**
11 Constitution Avenue
Piscataway, NJ 08854
(732) 562-0770
Fax: (732) 562-0941
www.winsornewton.com
www.colart.com
Art Supplies

Resources

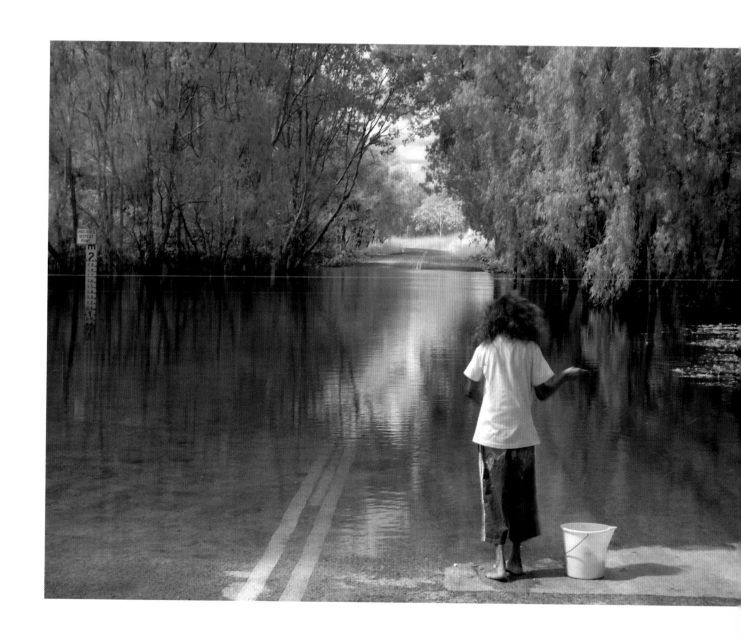

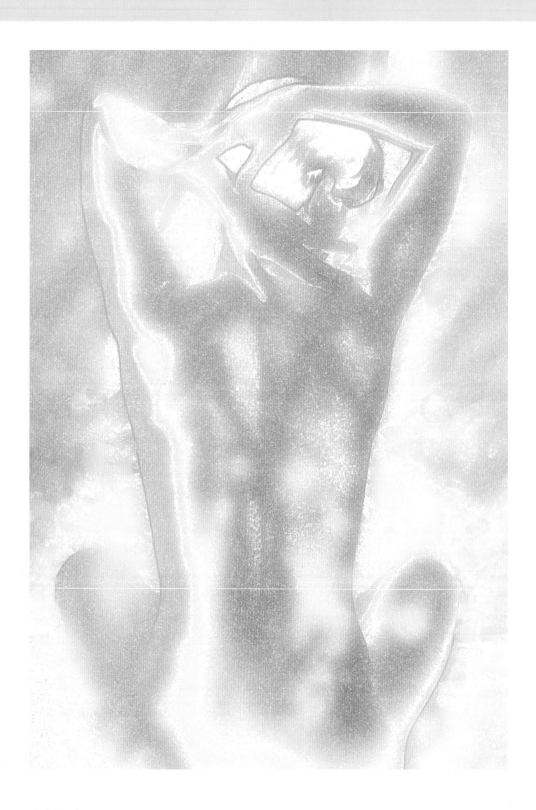

Index